HERBS

The Complete Gardener's Guide

WITHDRAWN

FIREFLY BOOKS

HERBS

The Complete Gardener's Guide

Text by **Patrick Lima**

Photographs and Illustrations
by **Turid Forsyth**

A Firefly Book

Published by Firefly Books Ltd. 2001

First Printing 2001

U.S. Cataloging-in-Publication Data
(Library of Congress Standards)

Lima, Patrick.
 Herbs : the complete gardener's guide / Patrick Lima;
and Turid Forsyth. – 1st ed.
[224] p. : col. ill. ; cm.
Includes index.
Summary : How to grow herbs and use them in cooking
and teas.
ISBN 1-55209-624-6 (pbk.)
iSBN 1-55209-602-5 (bound)
1. Herbs. 2. Herb gardening. 3. Cookery (Herbs).
4. Herbal teas. I. Forsyth, Turid. II. Title.
635.7 21 2001 CIP

Published in the United States in 2001 by
Firefly Books (U.S.) Inc.
P.O. Box 1338, Ellicott Station
Buffalo, New York 14205

Produced by
Bookmakers Press Inc.
12 Pine Street
Kingston, Ontario K7K 1W1
(613) 549-4347
tcread@sympatico.ca

Design by
Janice McLean

Printed and bound in Canada by
Friesens
Altona, Manitoba

Printed on acid-free paper

**National Library of Canada Cataloguing in
Publication Data**

Lima, Patrick
 Herbs : the complete gardener's guide

Includes index.
ISBN 1-55209-624-6 (pbk.)
ISBN 1-55209-602-5 (bound)

1. Herb gardening. 2. Herbs. 3. Cookery (Herbs).
I. Forsyth, Turid. II. Title.

SB351.H5L553 2001 635'.7 C2001-930456-0

Published in Canada in 2001 by
Firefly Books Ltd.
3680 Victoria Park Avenue
Willowdale, Ontario M2H 3K1

*The Publisher acknowledges the financial support of the
Government of Canada through the Book Publishing
Industry Development Program for its publishing activities.*

Dedicated to John Scanlan, keen gardener,
willing taster, gentle critic and constant companion.
Without him, there would be no Larkwhistle;
and without the garden, no book.

—PL

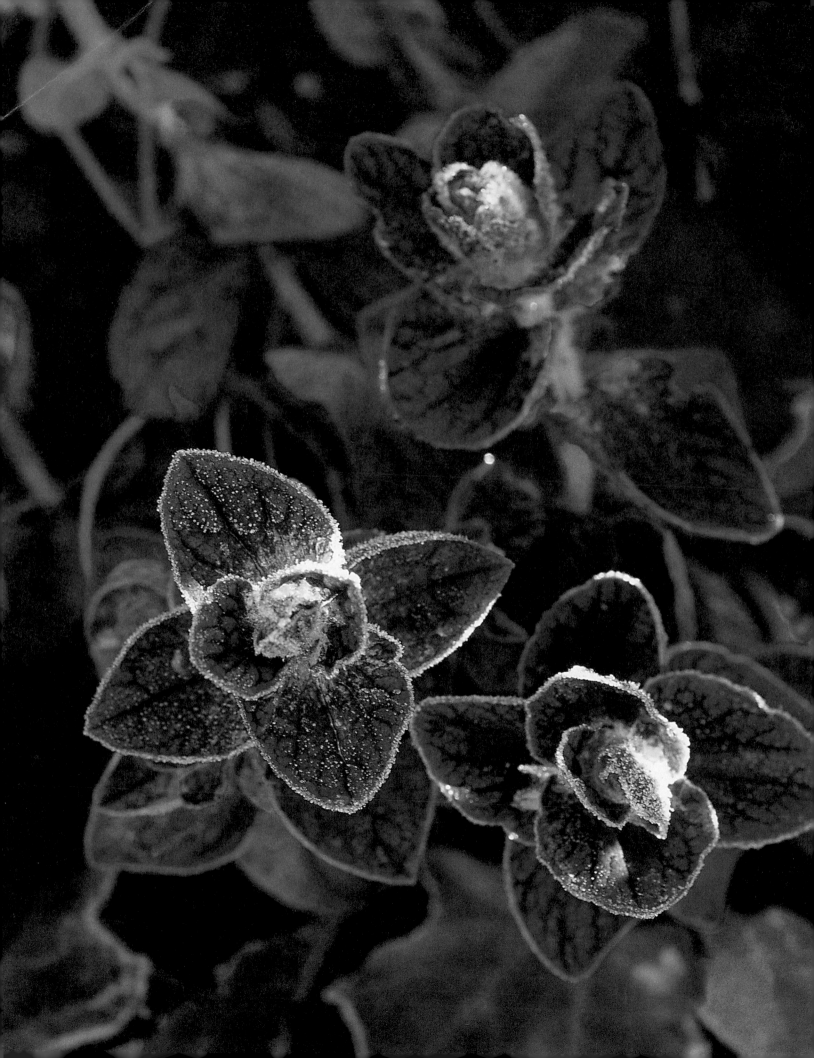

Contents

Acknowledgments

The authors wish to acknowledge the contributions to this book
of Margaret Adelman, Margot Barnard, Christine Devai, Margaret
Dinsdale, Luise Fenzl, Jane Good, Rachel McLeod, Marg Phelan
and new herbal friends Tina Chladny and Graham Thomas and to
thank the people at Bookmakers Press, art director Janice McLean,
editors Tracy Read and Susan Dickinson, proofreader Catherine
DeLury and indexer Mary Patton for their work on the project.

Starting Out

Herbs in the landscape

Most visitors to Larkwhistle, the rural western Ontario garden I tend with my partner John Scanlan, finish a tour with a handful of aromatic leaves and seeds, scented souvenirs of an excursion into one of the most fascinating fields of horticulture. As they stroll the paths, our guests are intrigued to find herbs of many kinds growing in perennial beds next to irises, lilies and daisies and also among lettuce, beans, carrots and such in the kitchen garden. Some of the herbs are simply green or quietly silver, while others have decorative foliage splashed with yellow, purple or cream. Many display modest flowers of white, lavender or greenish yellow; others are quite colorful; and a few are flowerless. Some are as ornamental as any flower, others as useful as any vegetable.

Meanwhile, on the other side of the province, in a sunny clearing on a 130-acre property of woodlands and meadows, photographer and artist Turid Forsyth has been tending a herb-filled garden for more than 20 years. Turid's love of plants and gardens grew out of necessity. Struggling to survive in postwar Germany, her family was compelled to supplement limited food supplies with herbs, greens and mushrooms from the wild. As a young child, Turid gathered boletus mushrooms and sweet woodruff in shady woods, picked corn salad in sheep pastures and collected watercress along streams. The family's large (and vitally important) garden yielded vegetables of all kinds, and in the shelter of trellised runner beans and tall lovage grew parsley, dill, borage and chervil.

"One of my most vivid memories," says Turid, "is of hauling buckets of water home from a nearby brook. Afterward, we rolled ourselves a 'lettuce cigar,' a big lettuce leaf stuffed with fresh herbs." Almost every day during the growing season, her mother would prepare an enormous salad for lunch. Turid or one of her siblings would be sent into the garden to pick a fistful of fresh herbs; each child had a different preference for spicing up the salad. Turid often added dill, savory, borage and lovage, herbs that remain favorites to this day.

Because bedrock surfaces throughout Turid's garden site, she brought in topsoil to create raised-bed gardens. A fan of xeriscaping—gardening with minimal watering—she plants sunflowers, shrub roses and her old standby lovage to cast shade for plants that need it. "Herbs and wildflowers are the best choice for this natural setting," says Turid. "They seem to withstand wild visitors better: snapping turtles digging their nests in spring, deer browsing through, chipmunks filling their cheeks or flea beetles perforating leaves."

Turid's garden is also her studio. As an artist, she needs to know one place well—its seasons, moods, changing light and shadows. Often, she will plant with a specific project

The best choices for a garden on the bedrock of the Canadian Shield, according to Turid Forsyth, are herbs and wildflowers.

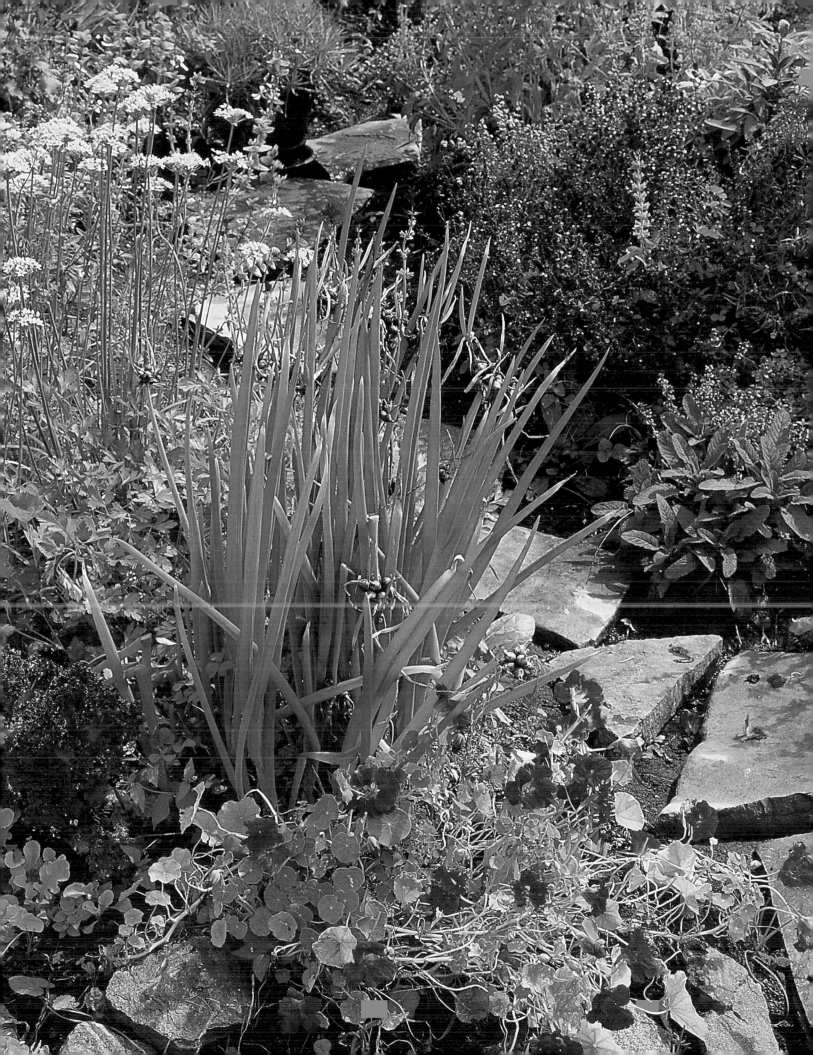

in mind: a herbs calendar, a photo workshop on herbs or pictures for the revision of this book. Her garden inspires paintings and photographs and, like every well-loved garden, feeds body and soul.

A Lively Definition

To define what we mean by the word herb, I can quote a dry three-liner from the dictionary—"plant of which leaves, seeds or roots are used for food, medicine, scent or flavor" —or I can take you on a garden tour, pausing at the herbs to find out firsthand what makes each unique. Getting to know herbs calls all our senses into play: sight, of course, but also touch and smell as we rub foliage and inhale scents;

Lemon-scented herbs, below, have many culinary uses: in teas, salads, main dishes, soups and desserts. Above right, a bee visits a borage plant.

taste, too, as we nibble leaves and seeds; and maybe even hearing, since the incessant whir of a humming-bird's wings and the drone of bumble-bees are often heard among the herbs and may draw us to some of them.

And so, into the garden. Tumbling over a warm rock at the edge of a flowerbed is a low, wiry bush, its small green leaves sprinkled with tiny lilac flowers. If bright color attracts you, this modest plant might well go unnoticed. But pick a sprig, crush it, and inhale deeply. The scent is warm and sweet, a mingling of spice and lemon. In the bed itself, pressed against a bushy peony, is a sturdy plant with pebbled, heart-shaped foliage; a whiff reveals a mild hint of citrus—lemon tea, perhaps. Yet a third leafy lemon grows in a pot by the kitchen door; its narrow, pale green leaves have the most citrusy fragrance of all, like a lemon drop.

Down the path stands an impressive plant, almost a cross between a giant fern and Queen Anne's lace. Its leaves and seeds both taste sweetly of licorice and might be good baked into cookies or cake. At the end of the raspberry bed is another green giant resembling celery; its leaves smell and taste strongly of celery and would nicely complement a pot of homemade soup.

We have just begun to pick and nibble and crush and sniff our way around the garden but now have an idea of what may be hidden in a leaf. The scents and flavors of the herbs just described—lemon thyme, lemon balm, lemon verbena, sweet

cicely and lovage—suggest culinary uses: a special salad or main dish, a pot of soup, a fragrant tea or dessert. Having taken only a few steps, we have already confirmed that a herb is any plant used primarily for flavoring.

For many gardeners, the seasoning, or culinary, herbs are the most familiar, often the first to be tried. In our case, an interest in culinary herbs was sparked when we began to grow vegetables. Homegrown beans are better with a sprinkling of summer savory. Tomatoes and basil seem made for each other; new potatoes call for chives, cucumbers for dill. Vegetable soup needs bay leaves and a sprig of lovage, while green salads are delectable dressed with fresh tarragon vinaigrette. Once initiated into the pleasures of cooking with fresh herbs, you eagerly await the months when you can step outside and pick handfuls of parsley and spearmint for tabbouleh or sprigs of coriander for bean soup or guacamole. And you'd miss that pot of rosemary and those bulbs of fresh garlic when lamb and roast potatoes are on the menu.

But the world of herbs is wide, and our tour has just begun. A turn of the path reveals a corner where a thorny shrub heavy with old-fashioned roses hangs over a blur of purple lavender—fragrant favorites from the past, potpourri on the bush. Just to breathe here is delicious—and remedial too, say the old herbals. "Sweet perfumes," wrote Ralph Austen in his 1653 *A Treatise of Fruit Trees*, "work immediately upon the

spirit for their refreshing; sweet and healthfull ayres are special preservatives to health and therefore much to be prised." And so our definition of a herb widens to include any plant appreciated primarily for its scent, one whose aromatic leaves or perfumed petals figure in any of those articles made "for use or for delight": sachets, potpourris, pomanders, fragrant bath mixtures and delicately scented oils.

In the flower garden, the definition expands once more. Among the perennials are two silver-leaved plants. The finely cut foliage of one is almost white, with downy hairs and a strange smell—strong, acrid and bitter. The elegant blue-green leaves of the other shine with metallic lights, and its scent is no more appealing. Nearby grows a knee-high shrub with narrow, dark leaves

Not welcome in the kitchen, rue was once recommended as an antidote to poisons and plagues.

and small ink-blue flowers; crush a leaf of each, and catch a hint of mint, an underscent of turpentine and...is that a whiff of skunk? Their scents are far from sweet, and we don't want these three—wormwood, rue and hyssop—in our cooking. Yet all have been valued at one time or another as medicinal herbs. In his *July's Husbandry* of 1577, Thomas Tusser, a teacher, musician, poet and farmer, rhymed: "What saver be better, if physick be true, For places infected than wormwood and rue."

And one Old Testament prophet prayed, "Purge me with hyssop."

But not even a spoonful of sugar would tempt a contemporary gar-

den writer to take her herbal medicine. "How terrible," she remarked, "must have been that cough syrup, once much in vogue, of rue and hyssop boiled in honey."

All the "virtuous" plants once employed or currently in use as medicines must be included as herbs. Woods, fields and meadows—and one's own garden—teem with plants reputed and, in many cases, proved to be remedial. Although a few simple medicinal applications are included in this book, the healing herbs per se are not the focus. But for centuries, curious gardeners have grown certain medicinals for the beauty of their foliage and flowers. Everyone appreciates tall foxglove spires hung with freckled bells in June; August brings showy purple coneflowers to perennial beds. And if we're aware that foxgloves are the botanical source of digitalis, a powerful heart stimulant, and that the roots of coneflowers, or echinacea, yield a proven antibiotic, we may see these ornamentals in a new light and identify them as herbs in good standing. Having grown calendulas and bergamot for color, some gardeners may wish (after a bit of study) to try their hand at a simple calendula ointment or a pot of stomach-soothing bergamot tea.

A herb is as a herb does—utility is of the essence. A gardening friend of ours is as involved with herbs as anyone I know. In April, she begins gathering wild leeks for soup and fat bundles of chives—first of the fresh-herb season—to give a lift to soups and boiled potatoes. Each year, she brews a batch of rosehip sherry, blends the leaves and flowers of 20 garden-grown and wild herbs into a one-of-a-kind tea and braids her harvest of lavender with ribbon. That is, when she's not developing quilter's thumb from pushing sharp-

edged cloves into oranges to make drawer-freshening pomanders or twisting stems of artemisia, thyme and oregano with yellow yarrow and crackling strawflowers to create pretty wreaths a cook can snip for winter seasoning.

Herbs in the Garden

Presented with a "medium-height, shade-loving, hardy perennial," most gardeners know how to proceed. But what does the label "herb" convey? Beyond suggesting some potential for seasoning, scent or medicine, "herb" tells us nothing about growing the plant in hand. Herbs range all over the horticultural map. Some are fiercely hardy; others are tender in the extreme. Many are perennials; quite a few are biennials or annuals. Hundreds love the sun; dozens more crave shade. Both the shortest and the tallest perennials I know—creeping thyme and lovage—are herbs. We are not dealing with a homogeneous group, but it is just this diversity that makes herbs so adaptable as garden plants, so matchless for many parts of the landscape.

We once toured an elaborate English garden where herbs of many kinds were grown in and around a raised, stone-paved circle, centered on a handsome piece of statuary. Subtle in color, with variegated mints near shimmering artemisias, varied in shape and texture, where bushy thymes spread at the feet of pleated lady's mantle in front of feathery bronze fennel, the garden was both interesting as a collection of herbs and lovely in its own right. "But it's so far from the house," one visitor remarked, "must be just for show."

Although a segregated herb garden

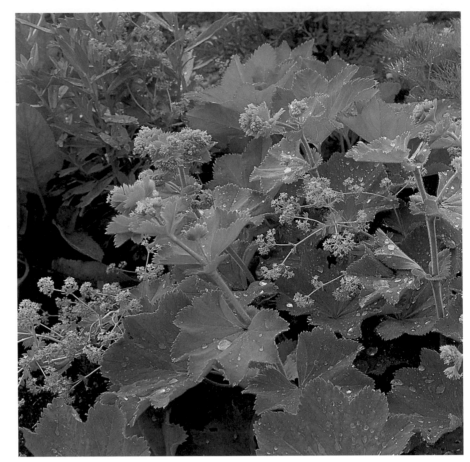

Handsome foliage can rescue a herb garden from scruffiness. Good candidates are lady's mantle, above, and nasturtium, below.

"just for show" is a modern notion, there is a long tradition of growing herbs by themselves in special beds and enclosures. In the past, herbs were gathered for 101 uses: for medicines, fabric dyes and perfumes; as flavoring for foods, wine, beer and liqueurs; for strewing on floors or hanging in closets to suppress unpleasant smells and to repel ants and moths. When you are harvesting herbs all the time, you want them together in one spot.

Today, an exclusive herb garden may appeal to growers with a singular passion and the zeal to collect everything from the

ordinary to the oddball or to those who still want to harvest herbs in quantity for various crafts and preparations. But for many gardeners, an area devoted solely to herbs may be too quiet and subdued, which is a nice way of saying that exclusive herb gardens may appear dull and scruffy, unless care is taken to include plenty of good foliage (lady's mantle and artemisias) and a number of colorful herbs (bronze fennel, bergamot and the like). And yet it is not at all necessary to make a distinct herb garden in order

to have a garden filled with herbs.

At Larkwhistle, herbs in their hundreds are integrated into the overall scheme. Against a sunny stone house wall a few steps from the kitchen door, a narrow bed holds a dozen perennial culinary herbs. Where you might expect a planting of evergreens, herbs conceal the foundation and yield a harvest of tasty leaves from April to November. Here, you find three kinds of sage, five different thymes, clumps of chives, garlic chives and tarragon, spreads of 'Greek' oregano and winter savory and a tall lovage snugged in a corner. Near the house sit six half-barrels made of wooden slats held by metal hoops. Planted anew each spring with parsley, basil, summer savory, leaf celery, nasturtiums and wildly suckering peppermint, the barrels soon spill over with

aromatic greenery handy for picking.

In our kitchen garden, at the ends of permanent beds of various shapes and sizes, additional perennial herbs grow: For cooking, we have tarragon, winter savory and more chives; for beauty of leaves and flowers, there are 'Golden' oregano, Russian sage and apple mint. Consorting with self-sown California poppies, calendulas and alyssum, the herbs add to the garden's diversity, and their mingled scents may well chase insects from the vegetables. In odd spots among the vegetables, coriander, dill and chervil pop up each spring from seed, a welcome harvest for no work.

In a shady border of daylilies and daffodils, sweet cicely expands its ferny anise-scented foliage and follows its lacy flowers with seeds like green licorice. At its feet spreads sweet woodruff, a pretty ground-

Adventurous gardeners may find more than a score of thyme varieties, including mother-of-thyme, woolly thyme, lemon thyme and flowering common thyme, shown above from left to right.

cover and a delightful flavoring for May wine. In sunny flowerbeds, pungent wormwood, an ingredient in the once outlawed liqueur absinthe, contributes silver to the color scheme—and may do double duty as pest control. Along the edge of a hot, dry flower border, a collection of thymes is interrupted by bushes of creeping savory. And in the Quiet Garden, where foliage plants set off white and blue flowers, a white-flowered version of common cooking sage has pride of place.

Diversity

In a garden, as in nature as a whole, diversity is a hallmark of health and balance. Anything that reduces diversity—growing a strictly limited number of plants, for instance, or using chemicals that deplete soil organisms or spraying to wipe out insect friends and foes alike—invites trouble down the road. In contrast, planting a variety of herbs about a garden promotes diversity in both

The herb garden large and small: the lush growth of lady's mantle, costmary, indigo, viola and chamomile, right, and a monarch visiting a purple coneflower, below.

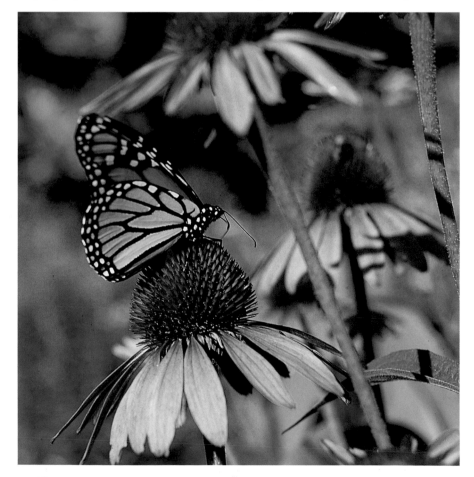

subtle and obvious ways. Beneficial parasitic wasps are drawn to the flowers of lovage, sweet cicely, dill and other umbelliferous plants. Hummingbirds arrive to sip nectar from crowns of tubular bergamot flowers, while swallowtail, admiral and monarch butterflies flit among purple coneflowers or land on the great cartwheel blooms of angelica. Essential for pollination, bumblebees and honeybees seek out nectar from herbs such as lemon balm, lavender, mints and hyssop and busily gather pollen from opium poppies. Where conditions are right, frogs, toads, bats and ladybugs will inhabit a garden and eat their share of aphids and mosquitoes. Having admired frogs sitting placidly on their water-lily pads, you may be discomfited on occasion to come upon a garter snake—or, in these parts,

a massasauga rattlesnake—with its mouth full of web-toed amphibian, but it's all of a piece. In late summer, twittering goldfinches fly in to feast on sunflower and mullein seeds.

I can't imagine our garden without its herbs, plants that enchant us somehow and elicit contact and response. When I think of herbs, I think of essence, intensity and strength: pervasive aroma; flavors pungent or sweet but always distinct; essential oils concentrated to a degree that gives a plant character. Working with herbs brings us in touch with intertwining traditions of gardening, cookery, brewing, folk medicine and home-based crafts. So many simple pleasures are associated with herbs: picking fresh leaves for the kitchen; making a pot of fragrant tea; traveling down memory lane on a whiff of costmary or rue; tousling the lavender as you stroll by and breathing in its calming scent.

Herbs encompass a huge variety, and our aim is to be as inclusive as possible. Something that shows up as a herb here may well be another gardener's weed, vegetable or flower. In the chapters that follow, herbs are grouped according to common characteristics and uses: annual and perennial culinary herbs; tea herbs; the various thymes, sages and alliums; herbs grown primarily for fragrance; and old-time medicinals that remain excellent ornamentals for sun and shade. Look around the piece of earth you tend. There are places in every landscape where herbs of one kind or another will thrive, adding their varied appeal of scent and savor, utility and tradition—creating a garden full of interest and beauty by any definition.

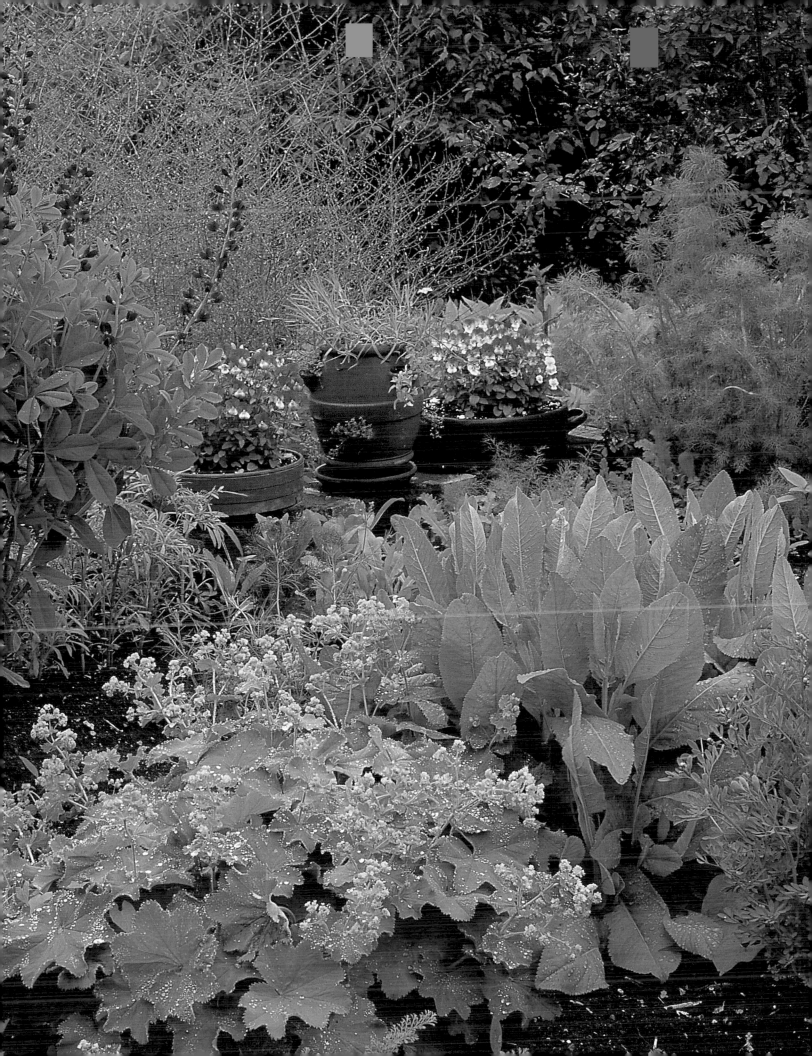

Family Ties
Getting to know herbs

"How I got my herbs," wrote Louise Beebe Wilder in *My Garden* in 1916, "would make a chapter in itself." At Larkwhistle, too, and in every garden, different herbs arrive by different routes. Visitors bring treasures: a special peony, later identified as *Paeonia tenuifolia*, with fennel-like foliage and single crimson flowers, blooms weeks before the rest; a piece of gray-leaved "mousy thyme" (*Thymus serpyllum lanuginosus*) that soon cascades in a small way over a shoulder of limestone edging a flowerbed; a wedge of red bergamot that, in time, is split to form part of colorful July pictures. Trips to other gardens often yield new plants, and back-road wanderings can lead to the unexpected. In a long-abandoned farm garden, we found 50-year-old clumps of Florentine irises, meadowsweet and costmary holding their own against quack grass and twining nightshade. Seeds and plants arrive in the mail, and established plants are further increased by division, cuttings and layering.

When introducing a new herb into the garden, you need to know a few things about it. Its name, for one—it sometimes boasts half a dozen, since over ages of association with people, many herbs have picked up a string of common names. Southernwood, one of the artemisias, for example, is also known as old-man, kiss-me-quick-and-go, lad's-savor, lad's-love, maiden's ruin (am I seeing a connection here?), sweet-Benjamin and sloven-wood.

The citrus-flavored lemon thyme, which is illustrated at left, is just one of the score of thymes from which the herb gardener can choose. Facing page, a few of the many faces of herbs (clockwise from bottom): the apothecary rose, dill, rosemary, scented geranium and garlic chives, centered by golden marguerite.

Living Latin

Common names may change, but Latin, or botanical, names almost always remain constant. How many times, after telling someone a plant's Latin name, have I heard, "Well, I'm none the wiser" or "That's Greek to me." Many good gardeners balk at Latin names, finding them tongue-twisting and intimidating. And, in truth, they are often unnecessary. A vegetable gardener may grow fine carrots and tomatoes and never learn the words…wait while I look them up…*Daucus* and *Lycopersicon*. A flower grower might do without the Latin for half of her posies (the 'Sarah Bernhardt' peony; the 'Peace' rose; the 'Beverly Sills' iris). I am not a snob about botanical names —they are hard to pronounce and harder to remember—but I do recognize the utility of Latin.

Many vegetables and flowers bred from natural species have been worked on by horticulturists, so the common English name may suffice. Herbs, by contrast, are often "unimproved" species, plants "as God made 'em," growing in our gardens just as they exist in the wild—and under the same names. Besides being a sure means of identification, Latin names link us with gardeners everywhere and through the ages. The names can also be interesting and fun. I love the grand churchy sound of *Angelica archangelica*; and the name *Papaver somniferum* reminds us that powerful narcotic properties are hidden in a pretty poppy.

A botanical name often tells us something about a plant: where it

The Labiatae family, which includes sage, above, has 1,800 genera and 3,500 herb and shrub species, some of which are familiar seasonings in our kitchens. French tarragon, top right, is part of the 200-species-strong genus *Artemisia*, as are the nonculinary herbs shown at bottom right, clockwise from top: *A. absinthium, A. abrotanum, A. stellerana* and *A. ludoviciana*.

grows, who discovered it and a word of description about its stature, leaf shape, color and such. Since English is rooted in part in Latin, similarities crop up, and you can often puzzle out the information. All mints, for example, are *Mentha*. There is *M. aquatica*, which (as you'd suspect from the Latin) grows in or near water. *M. rotundifolia* has "rotunder"—rounder— foliage than most, while its *variegata* form is mottled green and white. *M. spicata*, spearmint, has spiked, or spear-shaped, leaves. *M. piperita* is peppermint, while *M. citrata* is citrus or orange mint. It would be a good guess, too, that menthol—the cooling, soothing ingredient in pain balms and throat lozenges—is derived from mint.

Family, genus, species. Each plant is identified from its broadest family connection down to its most specific individual name. All plants have a Latin name of at least two parts: first name *genus*, second name *species*. Southernwood is

Artemisia abrotanum, a species within the genus *Artemisia*, named for Artemis, the Greek goddess of the hunt. Within this genus are about 200 other species, including tarragon (*A. dracunculus*). Curiously, *dracunculus* means little dragon, perhaps in reference to tarragon's sharp bite.

Extending the botanical name-tree, every genus and all its species belong to a larger plant *family*. The family connection is based on shared characteristics. Artemisias are one branch of the family Com-

positae—the composite, or daisy, family—all of which have flowers made up, or composed, of a number of small flowers forming a central disk. At first glance, you may not see the family resemblance between sunflowers, the grandest of the composites, and artemisias. Sunflowers clearly show their individual disk flowers, packed together by the hundreds in an interwoven spiral arrangement surrounded by yellow rays. But you'd need a magnifying glass to see the tiny flowers that compose the insignificant rayless disks of most artemisias. Once you twig to a family's defining trait, though, you begin to recognize its various members. Whether they are as small as chamomile blossoms or as big as sunflowers, all variations on the daisy form—that simple

flower shape drawn by young children—are composites.

Although herbs are found in every plant family, three families are notably rich in useful aromatics. Name four herbs off the top of your head. How about parsley, sage, rosemary and thyme? Three out of the four belong to the family Labiatae, a name that comes from the Latin word for lips. All family members are characterized by flowers that resemble little open mouths with the lower lip extended. The sheer number of herbs under the Labiatae family banner—different genera (plural of genus) and many species within each—is astonishing. Counted among the labiates are all mints, thymes, oreganos, savories and sages—and there are more than 750 sages, or salvias, worldwide—

Many venerable herb-garden inhabitants, such as lavender, above, are sweetly scented.

as well as anise-hyssop, basil, bergamot, catmint, catnip, hyssop, lavender, lemon balm, rosemary and more. No other family encompasses so many herbs. Besides lipped flowers, labiates are known by the shape of their flower stalks, which are square in cross section rather than round.

Second place for most plants in the herbal landscape goes to the family Umbelliferae. The Latin sounds like umbrella, and members of the family typically send up *umbels*—flattish clusters of small flowers arrayed at the ends of thin stems that radiate out from the top

Flowering herbs, above, include Compositae family members feverfew, echinacea and chamomile, while dill, top right, is in the Umbelliferae family. The opium poppy (*Papaver somniferum*), bottom right, is a member of Papaveraceae.

of a stalk—like an umbrella's spokes at the end of its handle. Given this description, you can mentally begin to gather herbs into the Umbelliferae family: angelica, anise, celery, chervil, coriander, cumin, dill, fennel, lovage, parsley and sweet cicely. Virtually all the umbels concentrate flavor not only in their leaves but also in their seeds, many of which are used as seasonings. (See Chapter 7, Going to Seed.)

The third important herbal family is Compositae. Herbs in

this family don't jump out at you. There are few familiar flavoring leaves, but there are a number of medicinals—anthemis, artemisias, echinacea, feverfew, yarrow—and at least two good tea plants in chamomile and costmary.

As might be expected, the onion genus *Allium* (part of the Amaryllidaceae family) includes some pungent culinary herbs: chives, Egyptian onions, garlic, scallions and shallots. For the rest, herbs fall into a grab bag of families. The poppy family, Papaveraceae, holds the opium poppy, innocuous when its seeds are gathered for baking, important in medicine as the source of morphine and destructive when refined into heroin. In the mallow family, Malvaceae, there are several old-time medicinals. Musk mallow (*Malva moschata*), for instance, is

a settlers' garden flower that now decorates the roadsides and jumps back into our gardens, where its pale pink or white blossoms, like small hibiscus, are always welcome. Cheeses (*M. neglecta*) are pesky low weeds that my grandmother used to leave among her vegetables and pick occasionally to make a stomach-soothing tea. Roses, which belong to the Rosaceae family, have always been loved for their fragrance, and the powdered roots of Florentine iris (Iridaceae family) yield a fixative that helps hold the scent of roses in potpourri. It is probably safe to say that every plant family has at least one species which could be called a herb.

More to Know

It is also helpful to know a herb's origin before welcoming it into your garden (whether it is from the frozen North or the mild Mediterranean, from mountains or lowlands) and, more specifically, its local habitat (sun or shade, dry soil or streamside). The nearer you can duplicate a plant's native environment, the better the results. Is your potted basil just poking along? Maybe this heat-loving Southerner is sitting where cold drafts blow in from the North. Shifted to a sunny south-facing site, sheltered from cool winds, it may well take off. Does your thyme die out every winter? Perhaps the soil is heavy and rich, where thyme would feel more at home in gravelly sand.

Is a new herb hardy or tender, annual, biennial or perennial? Hardy and tender refer to a plant's ability to withstand cold, ranging anywhere from a light frost to a hard freeze or a full-blown, five-month Northern winter. Plants that shrivel at a breath of frost are, understandably, termed tender. Tender annuals grow only during the frost-free months. Tender perennials—bay, ginger, lemon verbena, pineapple sage, rosemary and scented geranium are the most familiar—may spend the summer outside but, like some people, need to winter indoors. These herbs are perfect for large, portable pots.

Annual herbs never see more than one summer. Everything they must do—sprout, grow, flower and seed—is accomplished in a single season. But like perennials, annuals may be tender, half-hardy or hardy. Sweet basil, the best-known tender annual, withers at a mere hint of frost and sits still even during cool spells. Coriander withstands light frost but perishes if frozen. Chervil, at the hardy end of the annual spectrum, thaws out from a hard freeze and grows on despite cold.

Each spring, a gardener must start most annual herbs anew from either seed or nursery plants. But certain annuals see to their stay in the garden by sowing hardy seeds in late summer and reappearing with the robins in May. At Larkwhistle, self-sowers include three of the best culinary herbs: dill, chervil and coriander. Chamomile comes up on its own, and a handful of colorful herbs—borage, calendula, painted sage and blue annual woodruff—also volunteer to decorate corners of the vegetable garden every year. Some perennials, too, self-sow, creating either pleasant surprises—more mats of creeping thyme between the paving stones, more foxgloves among the roses—or extra work weeding out a forest of lovage seedlings or well-anchored lemon balm.

While I would not be without such annual culinary herbs as basil and coriander, I've come to appreciate plants that can get through winter on their own, without time-consuming moves or protection. Hardy perennials stay in place for years, the self-same plants sprouting each spring to repeat the pattern of leafing out, flowering and seeding. Winter-hardy herbs become a little like old friends, welcomed back each spring for a seasonal visit. Perennial culinary herbs include such indispensables as chives, oregano, sage, winter savory, tarragon and thymes, some of the best tea herbs and a host of time-honored medicinals that today pass muster as ornamentals.

Perennial herbs are best grouped together with other permanent plants, part of a garden picture that can be refined over the seasons. From a practical standpoint, it is easier to carry out rounds of maintenance—weeding, top-dressing, cutting back—if perennials are contained in beds and borders. When some thought is given to relative heights, neighboring plants and the overall effect of flower colors and foliage texture, the end result will be a garden that reflects the tastes and imagination of its maker.

The more you know, the better you grow. As you expand your herbal horizons, take a little time to find out something about each plant's family ties—"who its people are," as a neighbor would say—its hardiness and the conditions of site and soil that will make it feel at home. The following chapters will (we hope) tell you much of what you need to know to avoid false starts and frustration. But there is no teacher like experience; the finer points will come from the particular place that is your garden.

The delicious, decorative dill.

The Garden Pantry
Perennial kitchen herbs

Fresh herbs of one kind or another are available from our Zone 5 garden for at least seven months, typically from early April through November. In earliest spring, we begin to harvest leaves for the kitchen. Perennials come first. Chives, garlic and other hardy alliums have been busy sprouting under snow. Thyme, sage and winter savory are in good condition if they have been protected by snow or evergreen boughs. Lovage is one of the first to stir, with sorrel and tarragon not far behind. Sweet cicely is another early riser. At the fall end of the season, many herbs persist until the going gets very rough indeed. High summer, of course, brings a lavish bouquet of annual herbs—dill and coriander, basil and summer savory—to flavor the seasonal abundance of fresh produce.

When it comes to choosing which culinary herbs to grow, I encourage cooks who garden to check their spice racks to see which herbs they use the most. The jar of Italian seasoning used frequently to perk up spaghetti sauce or sprinkle over pizza is a blend of oregano, thyme, marjoram and basil. The list is started. You notice that red pepper flakes, rosemary, dill and caraway seeds are quickly depleted and are expensive to boot. Why not grow them? You taste something unfamiliar but delectable in a Middle Eastern or Mexican restaurant—fresh coriander leaves, the waiter says. Your list expands. A corner of the garden or a few large containers will grow all of these in abundance.

What would I grow if pressed to choose only half a dozen herbs? Of annuals, I would not be without basil and dill; among perennials, I use chives and lovage often and could not cook without garlic. Just one more? Let it be parsley…but I'd miss tarragon. Okay, seven, then. Not counting tea herbs—so we'll have peppermint and lemon verbena. What a silly game.

Where should one grow culinary herbs? In theory, herbs should be grown as close as possible to the door nearest the kitchen—nothing encourages use as much as accessibility. In a country garden, it is a mistake to hide herbs at the bottom of the vegetable patch. A special bed of culinary herbs is a handy way to go if space and exposure are suitable; but the plants themselves do not need that sort of splendid isolation. There are many nooks in the landscape where they are at home: annuals at the sides of vegetable beds, dwarf herbs edging perennial beds, taller herbs among the flowers, chervil allowed to seed under shrubs. In a city garden, any place is close at hand, so choose a spot for herbs that meets their need for sun or shade. Grow tall lovage against a fence; try winter savory and thymes on a sunny slope of a rock garden or among paving stones; parsley might share a hanging basket or a window box with nasturtiums; and

'Greek' oregano, above, is peppery and pungent. Once established, tarragon, facing page, is a tall, leafy stalwart of the perennial bed.

feathery dill will find a foothold on its own. A couple of wooden half-barrels on a sunny deck or patio will grow a surprising quantity of seasoning herbs. An eclectic lot, herbs may be sited wherever good growing conditions, garden aesthetics and convenience intersect.

HORSERADISH
Armoracia rusticana

When my partner and I first began to clear portions of an old farmstead for a new garden, we uncovered a patch of unfamiliar leaves in the grass under the lilacs. They were large, glossy, oval and sharply serrated. A bit of digging unearthed fat roots, and a few neighborly inquiries identified the plant as horseradish—if we had nibbled it, we might have guessed. This hot herb had been robust enough to survive the tide of quack grass and weeds that had flowed over the untended farm garden.

Horseradish grows itself. It's sufficient to plant pieces of crown or chunks of root in any out-of-the-way corner. A root from a grocer or a farmers' market will usually sprout. Starting horseradish is not a problem, but you may have a devil of a time getting rid of it. Never till or haphazardly dig a patch; every severed root will come up again. The most succulent horseradish grows in ground deeply prepared with compost or manure. If you have a permanent compost bin, consider planting horseradish beside it. Its lush leaves will screen the pile, and its roots will feed on the extra nutrients. A permanent mulch can mean next to no maintenance.

During the early centuries of horticulture, horseradish had medicinal

applications only. Taken internally, it was said to stimulate the appetite, aid digestion and improve liver function. A source of vitamin C, horseradish was also used to prevent or cure scurvy. Since some of the chemicals in this fiery herb are identical to those in mustard seed, a poultice of grated horseradish applied externally heats the skin like a mustard plaster. Said 17th-century writer Nicholas Culpeper, "If bruised and laid to a part grieved with sciatica, gout or joint-ache, it doth wonderfully help them all."

At some point, however, Europeans decided that horseradish, for all its remedial uses, tasted good enough to eat as a condiment. Calling it *Raphnus rusticus*, the rustic radish, John Gerard recorded that horseradish "stamped with

Horseradish, above and below, is robust, pungent and tenacious.

a little vinegar is commonly used among Germans to sauce fish and such like meates as we do mustarde." In the early 1600s, the habit began to catch on in Britain. But considering that horseradish sauce is as necessary as Yorkshire pudding to that quintessentially English dish of roast beef, it is curious that in 1640, John Parkinson of England still considered "coarse-radish too strong for tender and gentle stomachs" although quite fit for "country people and strong labouring men."

LOVAGE
Levisticum officinale

One of the best culinary herbs, at least to my taste, is lovage. But I know one gardener who disagrees and has taken lovage out of her herb bed entirely. "Too strong," she says, "and takes up too much space." Growing to a height of 5 feet or taller and widening eventually to several feet around, lovage is the green giant among herbs, handsome enough to go at the back of a flowerbed or to stand sentry by the kitchen door. It is also well placed in an area given over to bulky food plants, such as horseradish, rhubarb, Jerusalem artichokes and asparagus. One of our lovage plants does just fine in competition with raspberries. Locate this heavyweight carefully, though, as it is not easy to move once established. If you must shift a large clump, divide it into smaller portions in the process, and (unless you are making a hedge or supplying the village) plant just one piece.

The quickest start comes with a young plant, but lovage grows easily from fresh seed sown in late summer or fall. If you buy seeds in spring, freeze and thaw them to break dormancy. (For seed requiring freeze/thaw treatment, I sow in March or early April and simply leave the container outside for a week or so, where it's bound to freeze.) Lovage from seed takes a full season to fatten up but returns faithfully—and bigger than before—every year thereafter. Divisions can be cut from the outside of an established plant, without lifting the well-anchored clump, and set out in any reasonably good soil. A single plant supplies an eight-month har-

vest of leaves, and a few branches hung in an airy, shaded place become crisp in a few days and stay nicely aromatic for winter. There is no way you'll use even a fraction of the leaves that one lovage plant produces, but no matter—it's a stately, willing thing, easy to grow and pleasant to have around the garden.

Even if you seldom use it, lovage serves a useful role in the garden. Its blooms are typical wasp flowers, attracting hosts of tiny, beneficial parasitic wasps that prey on garden pests such as cutworms, spruce budworms and tent caterpillars. Organic gardeners often send for trichogramma wasp eggs without realizing that the emerging wasps need certain types of nectar—the kind supplied by lovage and several other umbelliferous plants. In the absence of nectar, the young wasps will either starve or head for the fields in search of Queen Anne's lace. So let lovage's 6-foot flowering stalks stand. We cut them back just before the seed ripens and falls, to avoid having to root out a small forest of tenacious lovage seedlings. If hung to dry, the huge dill-like seedheads

Lovage serves double duty as a soup herb and a breath freshener.

add interesting cartwheel shapes to dried-flower bouquets. Dry seed can be harvested and used as a substitute for celery seed.

Lovage is the preeminent soup herb, just the thing to simmer in chicken broth with the requisite onions and carrots. But I like to flavor almost any savory dish with its dark green leaves, which taste sharply of celery and parsley with a spicy depth. Use lovage sparingly at first to season bean, pea and lentil soups, slow-cooking chilies, beef stews, chicken pies and tuna casseroles. The taste of lovage does not dissipate with cooking. A snippet spices an omelette, and the tenderest leaves, finely chopped, go into green, grain or potato salads, alone or with dill, basil, spearmint and other milder herbs. With garlic and ginger, lovage deliciously flavors stir-fried vegetables, especially bland summer squash. And lacking celery, use a little lovage in tuna or salmon salad. Then there is the novel use of sipping a bloody Mary (or other tomato-based beverage) through a hollow lovage stem instead of a straw. If I'm going out for the evening after a dinner laced with garlic, I always pluck a breath freshening lovage leaf to chew on the way.

Known as Maggikraut in Europe, the plant imparts its tang to the liquid or dry-cubed flavoring extract called Maggi. Fresh leaves are traditionally used with potatoes in all forms: mixed with sour cream to spoon onto baked potatoes; added with marjoram to potato soup; flecking buttery mashed potatoes; or in a white sauce poured over boiled potatoes (parsley and dill are also good here).

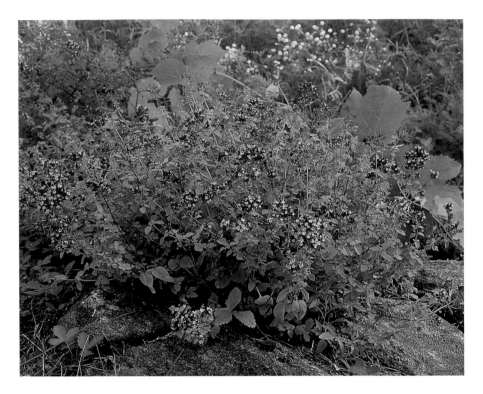

OREGANO
Origanum spp

There is no such thing as oregano pure and simple. One catalog lists 'Greek,' 'Wild Greek,' 'Italian,' 'Golden,' 'Showy,' 'Beautiful,' 'Woolly' and 'White' oregano. Another assures the reader that it sells the "true oregano collected wild in the mountains of Greece." Few herbs suffer such a confusion of Latin and common names. Let me spare you the tangled taxonomic details and say first that oregano grown from seed labeled *Origanum vulgare*, wild oregano, is likely to be a sprawling, scentless disappointment. Far better to pick up plants in person. This is a herb, like lemon thyme, that ought to be pinched, sniffed and nibbled so that you can be sure of its potency.

Currently in our garden, we have five plants labeled oregano, only one of which we use. 'Showy' oregano, which looks more like thyme than oregano, has pretty magenta tubes for flowers and no scent. 'Golden' oregano looked sickly (as many yellow-leaved plants do) and had sat

'Golden' oregano: a visual splash.

still for so long that we were ready to show it the garden gate or dump it unceremoniously onto the compost heap. But on the advice of another gardener, who reported that 'Golden' oregano "romps freely and is very decorative," we let it be. Now it forms a bright patch of foliage in the kitchen garden, a fine contrast to the dark green winter savory and silvery sage. Not aromatic enough for cooking, dark-leaved 'Herrenhausen' oregano is very decorative in the front row of perennial beds, where its late-summer violet flowers set off the small light yellow daisies of *Aster luteus*.

'Italian' oregano resembles the 'Greek,' but its scent and flavor are mild to the vanishing point. Laurels must go to the herb labeled, mysteriously, first name only—*Origanum* spp, 'Greek' oregano—whose leaves are properly pungent to the nose and peppery on the tongue. 'Greek' oregano was said to be half-hardy—another herb to pamper in a flowerpot indoors over winter—but ours has lived outdoors, in a gravelly

For success in the garden, plant wild oregano seedlings, not seeds.

pocket of a stone-paved patio, for more than a decade. The secret may be to situate this sun- and stone-loving herb in a hot, dry, perfectly drained corner, conditions approximating its Mediterranean home. Mulch around the plant with gravel or small pebbles, and in the absence of snow, protect it during winter.

Oregano dries in a twinkle when the branches are hung in a warm, airy, shaded place. Strip the dried leaves from the stems, and store them in a jar. This is one herb I use more of dried than fresh, the robust flavor being appropriate to heartier fall and winter dishes. Dried oregano is sprinkled over pizza and added to sautéing onions, celery and garlic as the base for spaghetti sauce or minestrone soup (it's now that you appreciate your own bottled tomatoes). Oregano is a natural for meat loaf, chili and bean or lentil soup.

SALAD BURNET

Sanguisorba minor;
Poterium sanguisorba

A perennial pretty enough to edge a flowerbed or decorate a rock garden with its low rosettes of lacy blue-green foliage, salad burnet, or pimpinella, remains evergreen through a snowless winter. Only the youngest leaves go into salads or "green sauce," a specialty in northern Europe, where market-square vendors sell bundles of mixed fresh herbs wrapped in damp paper. The contents of the bundles change with the seasons, but besides borage, chervil, chives, dill, parsley and sorrel, there is usually salad burnet in a supporting role. Shoppers snap up the green-sauce ingredients and, once home, finely chop the herbs to fold into *quark*, a dairy product akin

In Europe, salad burnet, shown below and at right, is also commonly known as pimpinella.

to yogurt mixed with fresh cream cheese. This fast and flavorful sauce is traditionally served over boiled potatoes and hard-boiled eggs for a nourishing lunch.

Young burnet leaves have a subtle flavor: mildly cucumber, a bit tart, a little hot. Older leaves are as stringy as grass and taste about the same. In early summer, up come slender reddish stems topped with small balls of crimson blooms that make decent cut flowers. In any case, cutting flower stalks encourages new leafy growth.

Burnet does not transplant well. Sow seed in the open garden around the last spring-frost date, and thin the seedlings to 6 inches apart. Alternatively, start seed indoors in 2-inch pots a few weeks earlier. This elegant little herb tolerates dry ground and shade but does better with a bit of fertility, moisture and sunshine. If left to seed itself, little burnets are sure to appear. Burnet is one salad herb that seems to have been overlooked despite the current interest in unusual greens. History repeats itself. As long ago as 1934, Maud Grieve noted in *Culinary Herbs and Condiments*: "Burnet, once in every herb garden of older days, has now gone out of fashion and, as a kitchen herb, is much neglected." But heed the words of an old Italian proverb: *L'insalata non e buona e bella, ove non e la Pimpinella*—"the salad is neither good nor fair, if pimpinella is not there."

Sorrel, a culinary herb that has scaled the heights of haute cuisine, is at its best in early spring.

SORREL
Rumex acetosa

The species name tells of the acidic bite of this herb, called *Sauerampfer* by the Germans and sourgrass by the English. Having scaled the heights of haute cuisine, it is also known as French sorrel, with cultivars such as 'Blonde de Lyon' and 'Nobel.' Easily grown from seed sown outdoors a month before the last spring frost or indoors about four weeks earlier, a few plants provide a long harvest of young leaves. Sorrel is at its best in the cool days of spring. Removing flower stalks prevents seeding and encourages tender leaf growth for a little longer, but during the heat of summer, sorrel grows stringy and strong. Space the plants 8 inches apart in humus-rich soil in a sunny corner where they can remain undisturbed for years to come. Like tarragon, the same sorrel plants return perennially in our garden, but one writer says that sorrel is "grown as a hardy annual throughout most of the North." Experimentation is the essence of good gardening—try it and see.

Besides giving a tang to sorrel soup, acidic sorrel tarts up a lettuce salad or, with the addition of any of the "licorice herbs"—anise, fennel, sweet cicely or tarragon—seasons a creamy sauce for poached fish. It is also good finely chopped with lovage and stirred into thick yogurt to dress boiled or baked potatoes.

TARRAGON
Artemisia dracunculus sativa

Another culinary herb adopted by the French as their own fills out the corner of perennial essentials: French tarragon (*A. dracunculus sativa*), "little dragon," or estragon. Tarragon seed is always suspect, producing a tasteless sprawler of no use in the kitchen or garden. True French tarragon, of more moderate growth and simple linear lines, has a sweet taste of anise and a brief analgesic (numbing) effect on the tongue when nibbled alone. If your tarragon lacks scent and savor, I'd say fork it out of your garden; the plant is in no way decorative.

A clump in the garden keeps a cook in fresh tarragon for at least six months, and branches freeze or dry easily for winter use. Tarragon responds to sun and moderately rich but very well-drained soil in a warm, sheltered site. While some gardeners claim that tarragon's hardiness is not ironclad, this herb has lived in our garden for more than 20 winters. No doubt the persistent snow protects it; snow often arrives so early that the ground beneath never freezes to any depth.

When the tarragon patch grows crowded and weak, we spend an hour one spring morning, just as new leaves are showing above ground, to divide the plants, both for renewal and for sale. Clumps are pried out of the ground with a spading fork, and the spaghetti-like runners are split by hand or with a small knife into three-to-five-shoot segments. Divisions are replanted right away, and the roots of those destined for pots are trimmed to fit. Fresh green shoots soon sprout. But

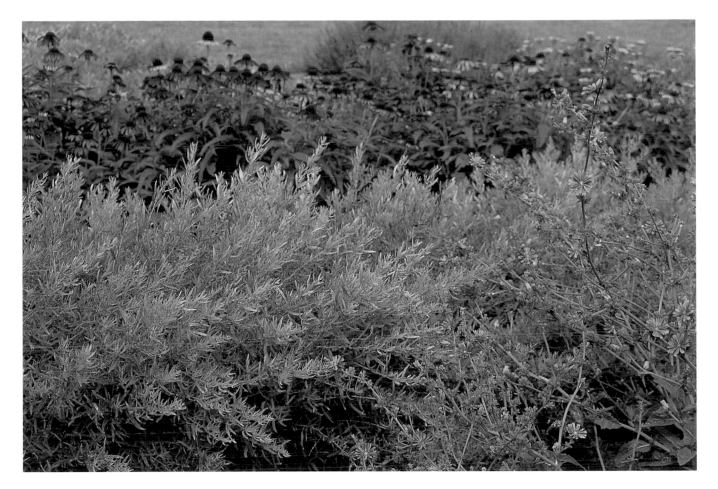

tarragon seldom needs dividing; as long as it is thriving, let it be.

The taste of tarragon is sometimes featured in a recipe: tarragon chicken, eggs à l'estragon, omelettes, and tarragon mayonnaise, hollandaise or tartar sauce. Tarragon vinegar is a pricey but delicious culinary cliché easily concocted by anyone with a plant. Push a little bundle of fresh tarragon tops into a bottle of cider, wine, malt or white vinegar, and leave it to steep for a week or so—*c'est ça*. Forget instructions that call for heating the vinegar, shaking the bottle twice daily or straining out the herbs.

Combine oil, salt and pepper and tarragon vinegar to produce the simplest of salad dressings. Stretch and elaborate the dressing with yogurt and mayonnaise (in proportions that suit your taste and diet), and stir in plenty of chopped chives or green onions. Dollop over sliced cooked beets, halved hard-boiled eggs or warm boiled potatoes arranged on a bed of crisp lettuce, and garnish with tarragon leaves. Such a salad might well include chilled cooked green beans, chickpeas and crunchy steamed cauliflower.

Tarragon butter seasons vegetables wonderfully. And try this for a nice change from regular tomato juice: To 2 cups tomato juice, add 1 teaspoon each of minced tarragon, chives and basil, ½ teaspoon lemon thyme, a generous squeeze of fresh lemon or lime juice and a dash of cayenne pepper. Allow the mixture to stand for a few hours or overnight in the fridge, and strain before serving.

True French tarragon, below and above (with echinacea and chicory), has been embraced by the French as an essential cooking herb.

WINTER SAVORY

Satureja spp

Two perennial savories belong at the edges of a herb garden or flowerbed. Winter savory (*S. montana*, "from the mountains") is a slowly widening, low-growing counterpart to the annual summer savory. Branches are clothed in dark green needlelike leaves, hot-tasting and aromatic, and the small-lipped white flowers are faintly flushed with mauve. The loveliest of the dwarf herbs is creeping savory (*S. repandra*), which looks like a trim little heather when the

Winter savory returns year after year and is usable from early spring until December.

green nests bristle with tiny white flowers in late summer. Creeping savory tumbles gracefully over the edge of a raised bed or sprawls in a rock garden, where it likes to bask in the sun for at least six hours a day. One of our neighbors is so enthusiastic about this herb that she has turned a single plant into 20 in three years; the soft mats now festoon the length of a 30-foot herb-and-flower bed raised with railway ties. Often, the savory is still in full bloom at Thanksgiving—something to be thankful for, indeed, during the season of frost and farewells.

Gardeners with sunny places to furnish ought to investigate these two savories, both of which are persistently green, dwarf, decorative in a quiet way and useful for seasoning. As long as they are not crowded, shaded or sitting in soggy ground, they will look after them-

selves. Seeds are offered for each, but started plants are a shortcut. Winter and creeping savories are also easily propagated from slips and layering. The first method involves "slipping" a small rooted piece from the parent plant without having to lift it. Fingers are the right tool for easing soil away from a plant's crown, where you'll find shoots emerging from the outside of a clump. These slips, each with some roots attached, can be severed with a pocketknife and potted up or planted elsewhere, away from strong-growing neighbors.

Branches of perennial savories layer nicely if held to the ground with a hairpin or a bit of bent wire and further anchored with earth. They will often layer themselves, rooting where a low branch touches the ground. If a clump is large enough, I sometimes slice a little wedge of crown and roots with a sharp knife and ease it out with a narrow trowel, an operation that must be done carefully or one is left with a mangled plant and no division.

Purists insist that the flavor of winter savory is inferior to milder summer savory. Agreed, but the winter sort returns year after year and is usable from early spring until December, while summer savory is around for a few months only. But there need be no competition between them. Turid tells me that in Germany, winter savory is called *Bohnenkraut*, the bean herb. I associate summer savory with fresh green beans and winter savory with hearty soups and casseroles built around dried peas, lentils and beans. In my cooking, fresh or dried winter savory pinch-hits for both oregano and thyme.

BAY LEAF
Laurus nobilis

In ancient times, celebrated poets, war heroes and winners of Olympic Games were awarded a crown of laurel, or bay leaves. Poets, warriors or athletes content with their accomplishments, too tired to continue or merely lazy, would quit the fray and rest on their laurels. Berries of the bay tree are *bacca-laureus,* and today, those who successfully complete university studies earn their baccalaureate, or bachelor's degree.

Another tradition: Whoever gets the bay leaf kisses the cook. Aromatic bay leaves belong in many savory dishes—tomato sauces, stews of all kinds, hearty soups. Perennial in its native Mediterranean, where it may grow into a four-story-tall tree, bay is a frost-tender herb suitable only for large pots in the North. Ideal as a patio plant in sun or partial shade, it must be shifted indoors in fall to a spot that is both bright and cool. Once, as an experiment, we buried our bay tree, pot and all, on its side in a shallow trench in the garden over winter. Resurrected in spring, it had lost all its leaves and was not obviously alive or dead. But after a week in a sunny shed window, it began to sprout and grow slowly. Wherever it grows, bay is virtually care-free.

Spring is the time to buy a small potted bay tree from a nursery. Soon thereafter, repot in ordinary potting or garden soil in a container at least 10 inches across. Susceptible to sunburn, bay should sit in dappled shade in hot gardens; plants moved outdoors for the sum-

mer are especially prone to sun damage. While fresh bay may be plucked for summer seasoning, the thick leathery leaves dry easily when laid on a rack or screen, elevated slightly to allow airflow.

A young bay tree from a nursery should cost only a few dollars more than a package of dried bay leaves. Even when we are unable to bring bay in for the winter, I find it worth growing as an annual. In fall, I pick and dry all the leaves and always end up with enough organically grown bay to last until the next season.

Although it does not root as readily as rosemary, bay is best propagated (like rosemary) from cuttings. Snap cuttings of new growth, about 4 inches long, from the main stem; strip away all but the top two leaves, and dip the ends in a rooting hormone powder. Plant

Bay produces shiny evergreen foliage on a neat-looking shrub that can, given enough root space, become several feet tall. But when confined to a 6-inch pot and pruned, bay will stay at a convenient 12-inch height.

1 inch deep in damp vermiculite or a mixture of half sand and half damp peat, and cover cuttings and container with clear plastic before setting it in a warm, shady spot. Keep the medium damp but not soggy during the few weeks it takes the cuttings to root.

GINGER
Zingiber officinale

A flavoring indispensable to Oriental stir-fry dishes and desserts, ginger is easily grown from pieces of living root purchased at the supermarket. Shriveled specimens may not sprout, but you can often find a batch of fresh plump roots bristling with obvious sprouts. If in doubt about their vitality, buy several roots and plant them all; and have patience—ginger may not produce its first green spikes for a month or more.

Fill a foot-wide container with nourishing soil—equal parts compost or old manure, potting soil or garden loam and peat moss—and plant the roots horizontally just under the soil surface. Keep the soil damp. Eventually, fat grasslike spears should emerge, break into leaf and grow to a height of 3 feet. After six months, dig down into the pot with fingers or a trowel and sever a piece of root for use. Alternatively, tip out the entire plant annually, slice away chunks of root for cooking, and replant the remainder.

Like bay, ginger can spend the summers outdoors, provided it is gradually exposed to more intense sunlight after a period of rest in the shade. It will, however, do perfectly well without ever seeing the full light of day outside; an eastern or western window will keep it green and growing.

The cool, resinous scent of rosemary evokes the tastes of Mediterranean cooking.

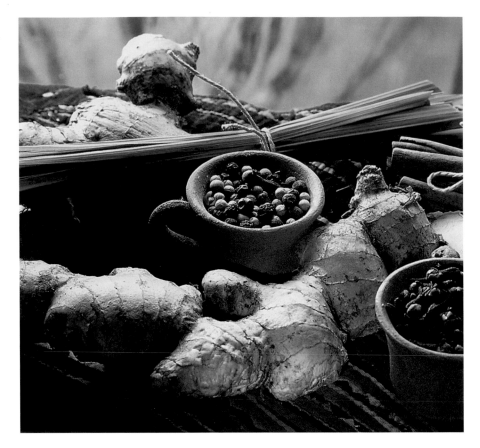

A selection of the raw materials necessary to create any number of delectable dishes with an Asian influence: ginger, cloves, lemon grass and peppercorns.

ROSEMARY
Rosmarinus officinalis

Rosemary is neither a hardy perennial nor a tender annual but a tender perennial shrub that, in Northern gardens, can overwinter outside only on the West Coast. However, rosemary adapts well to pot culture. I know a few gardeners who go to great lengths to transplant this herb from an indoor pot to an outdoor bed each spring, then back again in fall. But for better results with less work, set a small starter plant directly into nourishing soil in an oversized pot—12 inches in diameter or larger—and leave it there year-round. Winter rosemary in a sunny but not overly warm place indoors. Several gardeners have told me that rosemary routinely dries up and loses much of its foliage after a move indoors. The problem is lessened if it is not transplanted at this stage, but indoor air can be dry.

Rosemary is a seaside plant—its name comes from *ros-marinus*, meaning dew of the sea. In deference to its origins, give an indoor rosemary plant a biweekly misting,

or set it in a saucer of pebbles filled with water that will evaporate and create an envelope of humidity around the plant. Rosemary often blooms prettily, indoors or out, in a flurry of small sky-blue flowers typical of the Labiatae family.

Rosemary withstands light frosts but must not be frozen hard. Set it outside in good sun from mid-May to October. If a potted rosemary on the patio or porch is drying out too quickly, sink it into the ground up to the pot rim. An annual pruning, before going out for the summer, keeps the shrub shapely and dense; shorten the winter-spindly stems by at least one half.

After three or four seasons, it may be necessary to start again with a new small plant, as the original

Rosemary is an attractive tender perennial whose fragrant gray-green leaves, whether fresh or dried, complement roasted potatoes and other oven-cooked foods.

grows lanky, woody and leafless along the lower stems. Cuttings are a sure and simple means of renewal, and the instructions given for bay leaf (see page 35) apply equally to rosemary.

The scent of rosemary's narrow gray-green foliage is cool and resinous, a little piney or camphoric. I find it invigorating just to tousle a bush and breathe in the scent deeply.

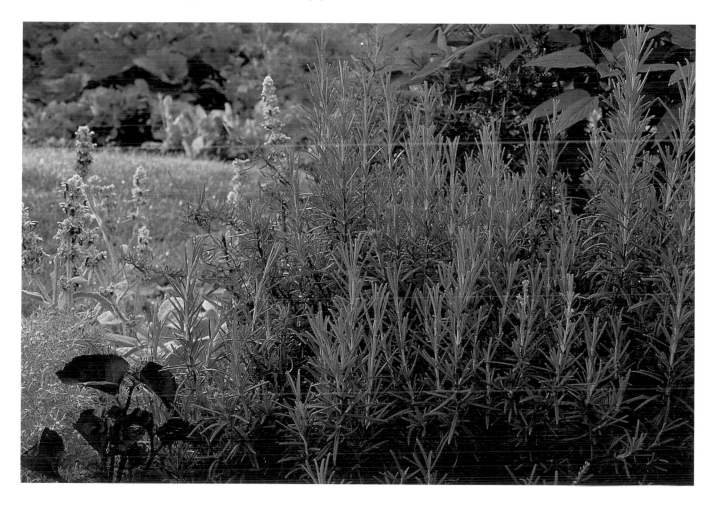

Summer Seasonings

Annual and biennial kitchen herbs

Annual plants grace our gardens for a single summer. Biennials, in theory, grow leafy ground-level rosettes during their first year, then flower and set seeds the following summer; in practice, though, biennials such as parsley are grown as annuals. It is my impression that these temporary herbs are more succulent, more deli- cate in scent and savor than most perennials. Compared with strong-tasting winter savory, annual summer savory is mild, almost sweet. Dill has a cool, refreshing quality not found among hardy herbs. Cooks often use basil and parsley by the handful with delicious results—pesto and tabbouleh, for example—where perennials such as sage, lovage or thyme used as lavishly would ruin a dish. Fewer of the annuals dry as well as the more pungent perennials; dried basil is fine in a pinch but is different from the fresh, and few gardeners bother to dry dill. Annual herbs belong to summer; they are quick-growing and light-tasting and are among the best for fresh use. Many of the recipes in Chapter 17 feature the "sweet" herbs described here.

All annual herbs are excellent choices for containers, since they can be positioned to catch the summer sun and cleared away at the end of the season. The secret to growing container herbs is to use good big pots.

A typical annual, lemon basil, left, grows from seed to flower in a single season, yielding a three-month harvest of tangy leaves. Right, purple and sweet basil grow in front of lovage, next to marjoram (at left).

BASIL

Ocimum spp

"With basil then I will begin, whose scent is wondrous pleasing," wrote English Renaissance poet Michael Drayton. The herb takes its name from the Greek *basileús*, meaning king—basil has always been held in high esteem. Sweet basil is the essence of summer, with a uniquely complex scent and flavor: a hint of cinnamon and cloves, with the mildest mint, a little licorice and parsley and a bit of citrus. One of the best herbs for containers and window boxes, basil thrives equally well in big country gardens and in city yards, on balconies, rooftops or window ledges. Any basil lover with a scrap of space in the sun can easily cultivate a summer-long supply.

Since I grew up in a downtown Italian neighborhood, basil was the first herb I knew. Every summer, my grandmother's garden—a small triangle of earth wedged between the driveway and a wire fence—grew into a tangle of tomatoes, runner beans and Swiss chard. But room was always left for bushy plants of *basilico*. Fresh leaves were sprinkled over thick slices of perfectly ripe tomatoes and soft mozzarella cheese dressed with olive oil and salt—still one of the best ways to use basil— and a leaf was added to every jar of homemade stewed tomatoes before it was sealed and stored for winter sauces. Some basil was dried for pizza, but several plants were allowed to flower and set seed. In September, my grandmother would cut the seed-filled stalks and lay them on a sheet of paper in the cool back shed. When the time was right, she'd shake out the seeds and dry them for a few more days. Stored in a small jar, the seeds were sown the following spring to complete the cycle. The original seed may have come from Italy, for as far as I know, my grandmother never bought basil seed.

I have learned a secret for growing good basil—patience. In years past, eager for an early harvest, we used to seed basil indoors in the first part of April. In the pale spring light, growth was weak and slow, and plants from a May sowing always caught up with and outpaced the earlier ones. Now we time basil as for cucumbers, seeding indoors in early May and setting plants outside a month later, with an ear to the long-range forecasts. Basil not only succumbs to a mere whis-per of frost but sits still during cool weather. Seed can also be sown directly in the garden when the danger of frost has passed and both air and soil are warm. If basil seeds are reluctant to sprout, you might adopt a tradition from the ancient Greeks, who uttered curses as they sowed basil to ensure its germination. Hence the French *semer le basilic*, which means to use foul language. For seed-shy gardeners, nurseries (and some city greengrocers) sell boxes of nicely started basil and even full-grown bush basil in spring. Since I hate ripping apart bunches of enmeshed seedlings, I look for basil growing one per pocket in divided cell-paks.

Native to India and Africa, basil loves sun and heat above all. A vigorous plant, it grows lush and leafy in organically enriched earth. My grandmother added vegetable scraps to the soil as well as the leftover residue from bottling tomatoes. These she buried in holes or shallow trenches about her small garden—a tidy version of compost that city gardeners might consider. A dressing of compost, old manure and balanced natural fertilizer is all that basil requires. More important is a warm, sunny site sheltered from cool winds; a spring chill can set basil back and make it susceptible to insect damage.

"Something always eats my basil —it gets all lacy and full of holes" is a familiar complaint. Earwigs are the likely culprits. Drawn to the aromatic leaves, they can chew the basil back to stubs in one night. One spring, in an effort to outwit voracious earwigs at ground level, we planted

Dark and decorative, purple basil is a culinary herb in good standing.

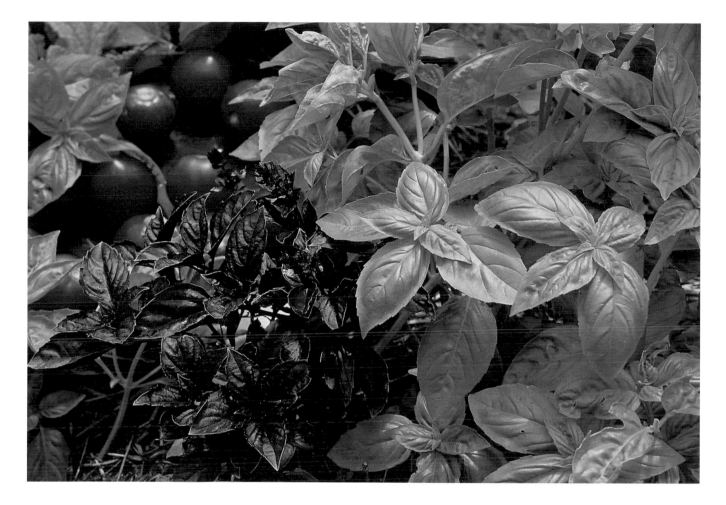

basil, summer savory and parsley in a wooden half-barrel filled with garden soil and compost. The result was both beautiful and convenient, and herb barrels became a permanent feature in our landscape. In time, though, earwigs sniffed out the basil in the barrels and took up residence in cracks between the wooden slats, doing their dirty work by night—like vampires, they feed only in the dark. Big (expensive) terra-cotta pots or (cheaper) plastic replicas give earwigs no shelter.

The best remedy I know for an infestation of earwigs is a soap solution. Commercial insecticidal soap kills earwigs, but a teaspoon of ordinary liquid dish soap with water in a plastic spray bottle works as well. Spraying plants themselves does no good, and it might actually do

some damage. You must hit earwigs directly with the soap, a job that entails fumbling around with a flashlight after 11 p.m. "At least they die clean," quipped one visitor. Spraying soapy water into the gaps between the wooden slats of half-barrels often dislodges a mess of earwigs.

More than 150 species of basil grow wild around the world. Only a fraction have become garden plants, but the choices can still be confusing. One company lists 15 different kinds. For "curious seekers after outlandish things"—an old but apt description of gardeners—there are sweet basils of many kinds and others with the scent of anise, camphor, cinnamon or lemon. For summer seasoning, any sweet basil will do. Little-leaf bush (or globe) basils are dwarf-to-medium-sized plants,

For some, fresh sweet basil, whether 'Opal' or 'Lettuceleaf,' above, is the taste of summer, especially when served with ripe tomatoes.

ideal for smaller pots, window boxes or trim little hedges in front of flowerbeds. One friend insists that only bush basil (*O. basilicum minimum*) makes proper pesto. Purple basil, in particular the new 'Red Rubin,' is dark and decorative, while 'Green Ruffles' and 'Purple Ruffles' taste as good as they look. 'Lettuceleaf' basil is big and crinkly, with a stronger undertone of licorice. Perhaps for sentimental reasons—and because it's associated with northern Italy, where pesto is best-o—I keep coming back to 'Genovese' basil, a simple leafy plant that might have

been the one my grandmother grew.

Of the oddball basils, lemon is one we always tuck into the basil barrel just for its scent. A slender herb sharply redolent of citrus, lemon basil is fine for flavoring salads, chicken and fish; it also rings a change on pesto and brews a superior herb tea, as does the aptly named and very spicy cinnamon basil. "The most sacred plant in all of India" is *O. sanctum*, holy basil, or *tulasi*. Consecrated to the Hindu gods Vishnu and Krishna, this herb is grown next to almost every Indian temple and dwelling as a protective talisman. Hindu dead are washed with basil-water and carry a leaf of basil with them on their afterlife journey through the corridors of transmigration.

The fantasy of actually picking cupfuls of basil for a February pesto is probably just that—it requires indoor light conditions that are nearly perfect. It is possible, however, to extend the fresh season for several months. Unless you have extra-fine specimens already growing in portable containers, do not try to transfer basil from the garden to the house; by summer's end, the plants will be picked over, seedy and insect-chewed. What you want are vigorous young plants, and a second seeding is the way to go. In early August, sow a dozen seeds of large-leaved basil in a 10-inch pot and water well. In the heat, the seeds will be up and growing within a week. Before they crowd each other, thin plants to five, evenly spaced around the pot. By mid-September, and definitely before the first frost, bring the basil pot into the sunniest spot indoors. Harvest leaves as needed without stripping the plants. Some sort of artificial lighting may be needed to bring basil through the dark days of December and into the new year.

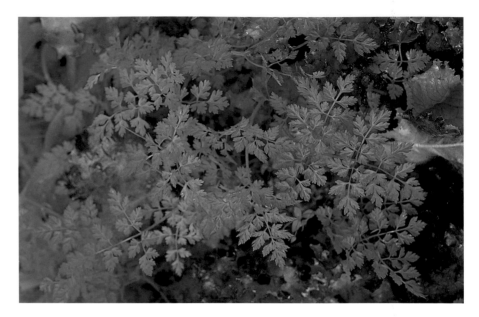

With its delicate leaves and lacy flowers, chervil is a graceful member of the herb garden.

CHERVIL
Anthriscus cerefolium

Chervil is so delicate, it never appears in markets. To have chervil in the kitchen, you must grow it in the garden. But once established, this pretty annual sows its hardy seeds and reappears gratis every season. Chervil does not transplant. To start a patch, scratch the long black seeds shallowly into decent loam in sun or light shade. Keep the ground moist until the seeds sprout, thin the seedlings to 6 inches apart, and harvest the outside leaves, always leaving the central crown to continue growing. Lacy umbels of pinkish white flowers—"like exquisite bits of enamel work," says one observant writer—are followed in midsummer by seeds. Allowing chervil to seed down saves you the work, but be prepared for new plants to pop up in odd places. When chervil is left to its own schedule, its seeds sprout in early fall, forming a small rosette that winters over and begins to grow first thing in spring.

"The leaves put into a sallet give a marvellous relish to the rest," wrote John Parkinson in his 1629 "speaking garden," *Paradisi in Sole*.

Later, in the 1699 *Acetaria*, John Evelyn added his assent: "The tender tips of chervil should never be wanting in our sallets, being exceedingly wholesome and cheering of the spirits." Indeed, the herb's name comes from the Latin *chaerephyllum*, "a joy-giving leaf"; chervil equals cheerful.

A close cousin to the robustly perennial sweet cicely, chervil holds a milder anise flavor in its soft curly leaves. Given its early growth, chervil is a natural with chives and dill to season spring dishes; try the three in cottage cheese or dips. Chervil butter flavors asparagus, and later on, minced chervil and chives go into lettuce salads and warm potato salad. I often use up to one-third chervil with parsley for tabbouleh. The French fines herbes always include chervil and chives with two others chosen from thyme, savory, basil or tarragon; in any combination, they make a splendid green-

flecked omelette. Chervil is best fresh and may be added at the last minute to cream soups such as carrot, asparagus or puree of green pea. In fact, this is all the cooking that the chervil's subtle flavor will withstand.

CHILI PEPPERS
Capsicum spp

I am a fan of hot herbs. I like the breathtaking rush of heat from jade-green wasabi with sushi; I like hot herbed mustards and head-clearing curries. For day-to-day fire, my favorite herb is cayenne pepper, which I sprinkle on everything from eggs to fruit—tastes acquired during a visit to Mexico, where salsa Tabasco spices *huevos rancheros* (fried eggs) and street vendors smear slices of pineapple and papaya with a cut lemon dipped in ground chili and salt.

Those who grow their own chilies know that degrees of heat range from pleasant to blistering. The first season we grew hot peppers, I brought to the table a few red-ripe 'Ring of Fire' peppers, the first of what promised to be a bumper crop. During lunch, I took a big bite out of an innocent-looking little fruit and immediately went into a fit of gasping and tears. Water, I had the presence of mind to remember, does not extinguish this kind of fire; bread or other starchy foods help absorb the oils responsible for the heat. Thereafter, I treated the little devils with cautious respect. The seed catalogs had not been indulging in the usual hyperbole when they described 'Ring of Fire,' a "short, smooth, pencil-thin cayenne type," as "very hot."

Most nurseries sell sweet-pepper plants in May, but not all have chilies or cayenne. Growing plants from seed is easy in a warm, sunny window. Choose early varieties bred for Northern gardens; besides 'Ring of Fire,' our list includes 'Chile Grande,' 'Golden Cayenne,' 'Super Chili' and 'Crimson Hot.' Starting with 4-inch pots filled with a light soil mix, sow a few seeds in each about eight weeks before the last frost date. Keep pots in a warm place until germination occurs, then shift them to your sunniest window —we routinely move our indoor peppers from a southeast to a southwest window around midday. Thin eventually to the best single seedling in each pot, and grow on until warm weather arrives. After acclimatizing the young peppers to outdoor conditions over a few days, transplant them into the garden in full sun, in a place sheltered from cool winds. Anything you can do in early summer to maximize heat— black-plastic mulch, a row cover, hot caps, a position near a warm south wall—will show in improved growth.

Caveat emptor: When choosing chili peppers, it is wise to take such cultivar names as 'Riot,' below, seriously.

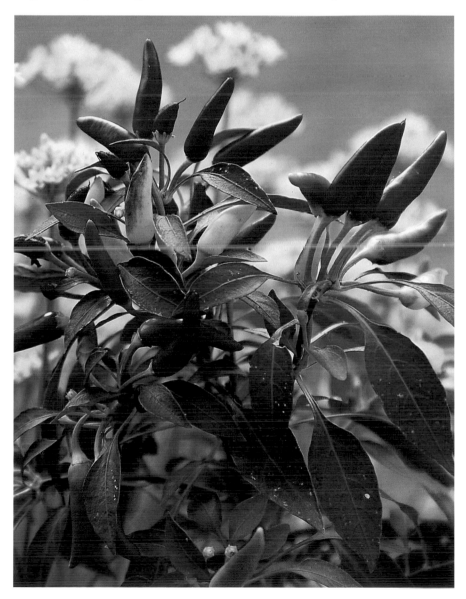

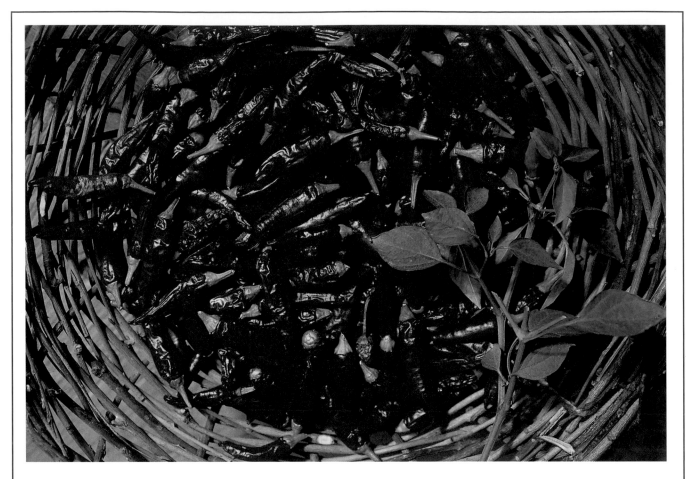

DRYING PEPPERS

Long and thin, chili peppers dry easily. Skewer whole peppers through the stem end (or the stems themselves) with a darning needle threaded with strong thread, or run light fishing line through the peppers, then hang the necklaces against a sunny outdoor wall (preferably under the eaves), in a sunny window indoors or above a woodstove—northern equivalents of the sun-drenched adobe roofs and walls of Arizona and Mexico. Dried peppers can be left on the thread, where they'll be decorative but dusty, or removed and stored in jars. Wait until the peppers are crackling to the touch before removing them from the thread. At this stage, I often spread them in a single layer on a pizza pan with holes in the bottom and slip them into the oven, with the pilot light on, for a few hours or overnight. Preheating an electric oven and then turning it off should also work. Grind dry peppers in a blender to make your own pepper flakes or powdered cayenne. Again, I spread ground peppers in a thin layer on a cookie sheet and set it in the sun or the oven for a time to be sure that all the moisture has evaporated. Whether whole or ground, peppers that are not thoroughly dry will mold in jars.

Traditional uses for hot red peppers are in chili, tomato sauces, barbecue sauces, relishes, chutneys, summer ratatouilles and Oriental stir-fries. Add dried chilies to simmering spaghetti sauce, and sprinkle over pasta dishes, pizza, lentil soup and the like. With garlic, onions, ginger and soya sauce, hot peppers (fresh or dried) add spark to stir-fried tofu and vegetables.

In his classic (if somewhat cranky) 1939 book on herbal medicines, *Back to Eden*, Jethro Kloss devoted 14 pages to *Capsicum* (from the Greek *kapto*, meaning I bite). Calling it "one of the most wonderful herb medicines we have," Kloss praised cayenne's curative properties for external wounds—"smarts a little [but is] very healing instead of irritating"—stomach ulcers, chills, coughs, colds and congestion, cramps and stomach pains, cold feet—"a little capsicum sprinkled in the shoes will greatly assist"—and hangovers. Virtually every other treatise on plant medicines echoes Kloss's enthusiasm. "There are many languid people," says one, "who need something to make the fires of life burn more brightly. Capsicum…is the thing to do it."

A Pepper Frame

Hot peppers need hot weather to grow well. After seasons of setting out seedlings in early June, only to watch them poke along for the next month and seldom ripen fruit, my partner devised a simple heat-holding pepper frame. Basically a mini-greenhouse made of storm windows, the frame holds six to nine plants from late May until well after the first frost, which is at least a month longer than they'd grow in the open garden.

A pepper frame is a bottomless glass box made by fastening four old wooden storm windows—two matching pairs—together at their edges with nails, wood screws or some kind of angle iron. Pairs need not be the same length as long as their heights are all equal. Four identical windows make a square frame, two matching pairs a rectangle. A vertical dimension of 2½ to 3 feet is best—the peppers will easily grow that tall. A cover, important to

In one of nature's typically elegant relationships, an ant feeds on and pollinates a coriander flower.

hold heat, is either a single large storm window or several smaller ones. If nothing on hand provides a suitable lid, cover 1-by-2-inch lumber with clear plastic or rig up something with a sheet of rigid, clear acrylic. Such lightweight lids must be hooked down, however, or they will be gone with the wind.

Orient a rectangular frame so that its long side faces as close to south as possible. Like any cold frame, this oddly shaped one warms both soil and air, buffers chilly breezes and creates a microclimate of tropical humidity, making a world of difference to peppers in the North. The enclosed plants grow waist-high and set plenty of fruit, most of which ripens red from mid-August through September. Lately, we have been growing peppers inside a garden shed, in large pots on a bench in front of wide windows; windows in the roof— yes, they leak—let in more sun, and the plants do wonderfully well out of the wind and weather.

CORIANDER
Coriandrum sativum

As Mexican restaurants open their doors and as cooks try their hand at Latin-American cooking at home, many Northerners are tasting cilantro, the leaves of coriander, for the first time. On the tables of every Mexican eatery are several small ceramic saucers containing coarse salt, wedges of green-skinned

A staple in Mexican cooking, cilantro— the leaves of the coriander plant—has been embraced in the North as well.

limóns, salsa picante and chopped onions mixed with cilantro. No taco—a soft tortilla rolled around bits of beef or chicken, cheese or refried beans— is complete without a sprinkling of cilantro and onions and a splash of salsa. A friend suggested tucking cilantro into a grilled cheese sandwich, which, come to think of it, is just a variation on a *taco de queso*.

Coriander leaves are traditional in Latin cooking, while Egyptian cooks use the seed to flavor bread and soup. As early as 75 A.D., Roman botanist Pliny the Elder wrote that the best coriander came from Egypt. In India, coriander seeds go into curry powders, and in Russia and Scandinavia, into liqueurs. But not everyone has a taste for this herb; like garlic, it seems to provoke either raves or an emphatic thumbs-down. The name is derived from *koros*, Greek for bedbug, "in reference to the foetid smell of the leaves," wrote Mrs. Grieve in *A Modern Herbal*. Having never sniffed a bedbug, I find the scent—not the taste—of coriander is a little like french fries or the smell that hangs in the air of a greasy-spoon restaurant, but hardly "foetid."

As a garden plant, coriander presents no difficulty. Insects turn up their noses and move on to the cabbages. Coriander seeds sown in

While coriander leaves are used in Latin cooking, the ground seeds of this plant are an essential part of Indian cuisine.

early May sprout with encouraging speed and grow quickly to usable size. Too quickly for those intent on an extended harvest of leaves; before long, lacy white flowers appear, and the plant runs to seed. Coriander is native to lands close to the equator, where day length remains fairly constant all year, and its internal clock is thrown off by the drawn-out days of a Northern summer, a phenomenon that triggers its rush to seed. For an extended harvest, sow seeds in succession every three weeks. Or let nature take its course: The surest way to have lots of coriander (with no work) is to let it seed itself. Most of the seeds that ripen and drop in August will sprout the following spring (and run to flower by early July), but there are always late-sprouting seeds that extend the picking into August. Giving plants 8 inches of space all around delays flowering a little, and good garden soil promotes lush leaf growth. If coriander seed is in your spice rack, you can easily harvest your own once the seeds turn hard and brown. I often add the intensely flavored unripe green seeds to fresh tomato salsas or home-canned chili sauce.

DILL
Anethum graveolens

Dill, on the other hand, often seems to be in short supply. Some gardeners will disagree as a tide of green and yellow sweeps over the garden. But even though dill sows its hardy seed everywhere and feathery seedlings spring up in vegetable beds and among perennials, the plants insist on running right back to seed, producing only a few sparse leaves. And it is the leaves I want. Others may gather flowers and seedheads for pickles, but cool, aromatic dill foliage, often called dill weed, is among my favorite fresh herbs.

For some perverse reason, dill

does better if left to find its own way around the garden. Year after year, we carefully seed a patch, usually with the improved tetraploid 'Aroma,' in hopes of having a dense harvest of dill weed in one spot. But each year, half-wild dill appears in outlying corners of the garden, while the planted seeds, for all their extra chromosomes, often amount to very little. My suspicion is that like angelica, sweet cicely and other members of the Umbelliferae family with short-lived seeds, dill grows best from fresh seeds that fall to the ground in late summer, the pattern the herb follows on its own. But last year, surprisingly, a packet of

Brilliant green and yellow in the summer sun, a healthy stand of flowering dill can become the herb garden's centerpiece.

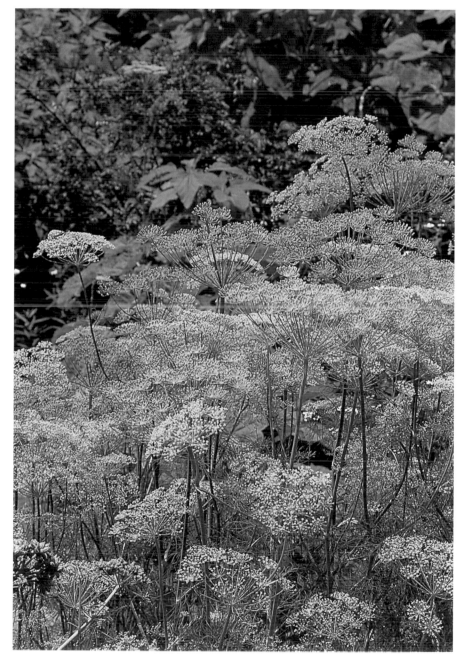

seed from a nursery that was sown in June yielded a dense row—so we keep trying.

A friend tells me that in Ukraine, the appearance of dill seedlings signals the arrival of spring, like the first robin here. The tiny leaves are eagerly harvested, along with blades of chives, and the two are sautéed in sweet butter for a sauce "to pour over everything." My taste buds imagine pasta, potatoes, baked fish and especially asparagus. I toss finely chopped dill by the handful into green salads and coleslaw and use it with lovage and Spanish onions for potato salads dressed with yogurt (see recipe on page 195). Along with parsley, dill seasons buttered new potatoes and can be blended with lemon thyme and chives in cream cheese to spread on crackers. Dill and baked fish are a perfect match, and Greek tzatziki is a dill-laden summer salad of cucumber, yogurt, pressed garlic, olive oil, salt, pepper and a pinch of cayenne, the whole left to marry until it is redolent of garlic and green with dill (see recipe on page 203).

FENNEL
Foeniculum vulgare

Among licorice-sweet herbs, there are two kinds of fennel. One is Florence fennel, or finocchio, an aromatic vegetable ready to cut in fall from an early-July start. Rich garden soil, sun and abundant water are all that Florence fennel needs to plump up its bulbous base, like fat celery, with overlapping leafstalks forming a crisp, pale green heart which tastes subtly of anise. Not well known in North America, Florence fennel is almost a staple

vegetable in Italy, where it appears in open markets piled high alongside mounds of radicchio and artichokes.

Boiled fennel is bland and soggy, but chunks baked in a creamy chicken casserole are a tasty vegetable accompaniment that pervades the dish with a mild flavor of anise. Slivers of fennel stir-fried with onions, garlic and any other fresh vegetables, but especially red bell peppers and broccoli, make a delightful pasta primavera. But raw is how many prefer Florence fennel, sliced thinly as a salad or rounding out a plate of crudités to be dipped in any number of herbal sauces.

Common sweet fennel (*F. v. dulce*) is skinny and nonbulbous and is grown as a perennial in milder climates but as an annual in Northern gardens. Thread-fine leaves are minced into salads and butter sauces to drizzle over steamed carrots, cauliflower or bland summer squash. Fennel and fish are often paired, either using fresh leaves to stuff fish before baking or adding leaves and stalks to

The graceful fernlike foliage of Florence fennel is anchored by tasty licorice-flavored bulbs that can be eaten raw or cooked.

the water for poached fish. According to the starstruck Nicholas Culpeper, a 17th-century herbalist and astrologer, fennel suits fish "because it is a herb of Mercury, and under Virgo, and therefore bears antipathy to Pisces and consumes the phlegmatic humor which fish plentifully affords."

Fennel seeds, whole or crushed, are used like aniseed. An aunt of mine adds a teaspoon of fennel seeds to a kettle of homemade spaghetti sauce with the usual basil and oregano. I put all parts of sweet fennel—leaves, stalks, flowers and seeds—into the teapot with lemon balm and spearmint for a good-tasting herbal brew that is meant

to calm nerves and aid digestion. Fennel tea, according to one herbal, "stayeth the hiccup and taketh away wind, nausea or an inclination to sickness." The seeds also form part of a sweet breath-freshening mixture served following an Indian meal.

Once, in an English herb garden, we saw a beautiful 6-foot fennel with feathery foliage tinted dark red and plum. The gardener identified it as bronze fennel and kindly shared a handful of seed. Ever since, this handsome herb has sprung up here and there around our kitchen garden, each plant returning for three or four years and spawning a few seedlings to carry on. Infused with a mild anise scent, bronze fennel is not only useful in the kitchen but also extremely decorative. For years, I've intended to dig up a few volunteer seedlings and group them in a perennial bed, but so far, this

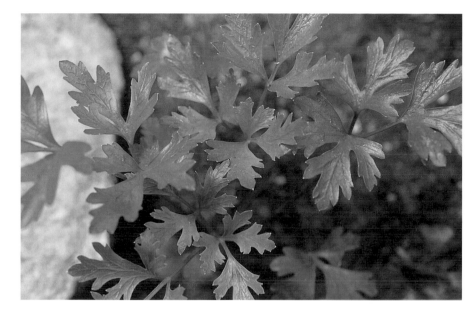

tall herb gets away with blocking traffic at the edge of a path because its foliage is so soft and pretty and its wheel-like yellow flowerheads make such a fine show waving above the dark leaves in July.

Incidentally, if you see an impressive caterpillar—tiger-striped green, cream and black with some orange spots—on any of the Umbelliferae, including fennel, let it be. The so-called parsley worm is the larval stage of the swallowtail butterfly, a species that is becoming scarce. It is worth planting a patch of anise, dill, fennel, lovage or sweet cicely, to encourage butterflies to visit.

LEAF CELERY
Apium graveolens secalinum

Notoriously difficult to grow in the average garden, real celery demands rich soil, constant watering and the right temperatures. But for flavoring purposes, leaf celery, an annual herb we always grow, is an excellent substitute. Starter plants are seldom available, but like parsley, leaf celery is easily grown from seed. Every

A handful of chopped leaf celery perks up a summer potato salad and can likewise enliven canned soups of any kind.

May, we transplant six seedlings into a 12-inch-wide clay pot set in a sunny spot near the back door. Watered regularly and fed once or twice with dilute fish emulsion, leaf celery grows lush and thick, which is just as well, because I pick it often. Once the container of leaf celery is in full production, I stop buying celery stalks until sometime in November. Leaf celery is minced in quantity into all the cool salads favored in summer: potato, egg, tuna, salmon, tabbouleh. A handful goes in with the onions and garlic at the start of stir-fries or soups; frost-hardy leaf celery is available well into the fall for cool-weather minestrone or chicken soup. Fresh herbs are an easy way to liven up canned soups. Cream of mushroom and tomato soups—those old standbys—are much better for a generous toss of minced leaf celery as you heat them up. Dill and lemon thyme might flavor canned tomato soup as well; pars-

ley goes with vegetable or chicken noodle; caraway seeds and savory complement split pea soup; and so on.

MARJORAM
Origanum majorana

Although closely related to oregano, marjoram is frost-tender and very different in scent and flavor. I've always liked to smell this herb but am just beginning to appreciate its taste. The fragrance is piney and sweet—I don't get the "blend of mint and nutmeg" that one writer suggests. A little too perfumy for foods, I thought, even before reading that it is used in French soaps and pomanders. In the past, marjoram was an ingredient "in all odoriferous waters and powders that are for beauty and delight," wrote one herbalist—more of a cosmetic than a culinary herb, perhaps.

But the German *Wurstkraut* says

Minced marjoram is vital in German sausages and soups as well as Italian chicken stuffing.

that marjoram is the sausage herb, and according to one knowledgeable herbalist, Ontario's Waltrout Richter, "It is a must in German potato soup." Italians use marjoram in sweet spinach fritters and in a stuffing for chicken; and lately, I've been mincing marjoram with rosemary and thyme to strew over parboiled potatoes before roasting them crisp (see recipe on page 202). Tea made from marjoram, mint and lemon balm is a pleasant way to avail oneself of the reputed antiseptic power of the herb.

A Mediterranean native, marjoram grows from spring-sown seeds that sprout in 10 days in a warm place. Set the seedlings (or nursery plants) in a sheltered, sunny part of the garden, in average well-drained soil, about the time you set out your tomatoes. A dwarf sprawler, marjoram might tumble over the edge of a large container or a raised bed. As an indoor winter herb, it is better than most if grown in a pot of light loam in a sunny window. Snipped occasionally for use, it is a sweet little houseplant that may go on for several seasons. In mild climates, sweet marjoram is a perennial.

PARSLEY
Petroselinum spp

Intensely green and always vigorous, parsley looks every bit the nutritional powerhouse it is. Don't make the mistake of relegating this herb to the role of garnish—eat it. According to Rodale's *Encyclopedia of Organic Gardening*, one tablespoon or a good-sized sprig of parsley supplies the daily minimum requirements of vitamins A and C. If I am feeling a bit enervated after a long day's gardening, I pick a few stalks of parsley, shake off the sand and graze on the tonic greens.

There are three types of parsley, including root parsley. Most common is the curly-leaved variety that shows up on the side of plates in restaurants. Italian, or flat-leaved, parsley looks more like a small-leaved celery. In her admittedly "cantankerous and opinionated" book *Green Thoughts*, Eleanor Perényi commented, "Today, no food snob would consider using any but the flat-leaved parsley." I'm with her in preferring the tightly curled, jewel-green mossy sort—more my idea of what parsley should be— but Italian parsley is full of flavor and as easily grown. Some seasons, it may bolt to seed in mid-

Sweet marjoram, at far left, is well suited to soaps and pomanders, as is wild oregano, left.

summer if dry or crowded, while curled parsley is always biennial.

Parsley seed is notoriously slow to germinate, traveling, according to legend, to hell and back in the three-week process. Some gardeners suggest soaking the seed in water overnight. "But," notes one author, "you end up with a gelatinous mess that sticks to fingers and everything else and is impossible to sow properly." Freezing the seed briefly helps to break dormancy by signaling that "winter" is over. Another approach is to soak the seeded flat or furrow with a kettleful of boiling water. And then there is patience: I generally seed a 4-inch-deep flat or pot indoors around April 10 and leave it someplace warm—near the woodstove— for the few weeks it takes the tiny green backs to show through. Grow the slow seedlings, thinned to an inch apart, in the sunniest window (though they are less light-demanding than tomatoes or peppers). In mid-May, or two weeks before the last frost, transplant parsley into the garden on an overcast day, spaced 8 inches apart; light frosts leave it unharmed. For vigorous growth, parsley needs fertile soil and adequate water. Compost or manure is a good start, a weekly soaking a must, and twice during the summer, drench parsley with dilute fish emulsion, followed by clear water to wash any fishiness off the leaves. Insects apparently don't know what's good for them and generally leave parsley alone.

"I haven't planted parsley in years," one gardener told me, "and the same plants keep coming back." The same patch, perhaps, but not the same plants. Biennial parsley stays green and usable late into the fall; wise gardeners leave the parsley row undisturbed during the October cleanup. The hardy plants often survive winter and resprout at spring's

first encouragement. If left to flower and set seed, parsley perpetuates itself, but the original plants die away after seeding. We use new leaves from last year's plants until the current crop thickens up—an eight-month harvest.

There are many ways to bring the goodness of parsley to the table. The easiest is simply to mince and toss it into mixed salads, coleslaw and potato salads. Tabbouleh, a cold Lebanese salad that starts with cooked bulgur wheat, is green with parsley (see recipe on page 192). Egg or tuna salads can be well flecked; most sauces are better for parsley, as are sautéed mushrooms. Stir sweet butter, minced parsley and chervil into plain cooked rice, and season with freshly ground pepper and Parmesan cheese; a garnish of sweet red pepper and slivered almonds

makes this easy dish festive. I add a generous sprinkling of freshly minced parsley to most soups just before serving.

PERILLA
Perilla frutescens

Also known as beefsteak plant and shiso, perilla is an aromatic annual that is native to India and China, with something of the decorative foliage value of coleus. The cinnamon-scented leaves, either green or maroon-red, are broadly heart-

Below, direct-seeded in May, 'Garland' parsley (front) and Italian parsley can both be harvested in June. Right, the aromatic perilla.

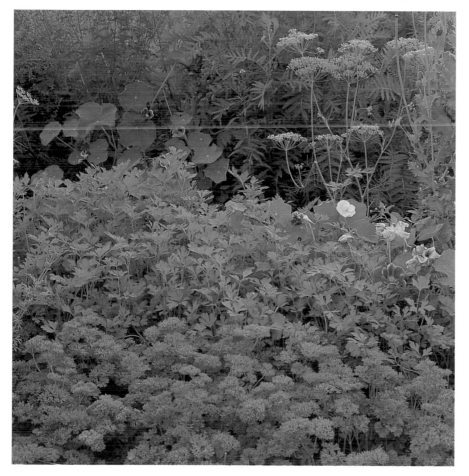

shaped, deeply veined and cut and waved along the edges. In Japan (and Japanese cuisine), shiso flavors sushi, bean curd, tempura and pickled vegetables; the red-leaved variety imparts its color to preserved ginger and other pickles.

Toward the back of a herb border, perilla is a striking accent, growing tall, lush and leafy. For color contrast, the purplish red variety (*P. f. akashiso*) might be chosen in preference to the green. Both are easily grown from fresh seed. Chill the seed in the refrigerator in a small container of damp sand for three days before sowing. For a head start, plant seeds three weeks before the last frost in small pots indoors—three to five seeds per container, thinning in time to the strongest one—and set seedlings out, 12 inches apart, around the frost-free date. With luck, the plants will show their white flowers in August and, soon after, mature seeds, which may be either collected for sowing next spring or (better yet) left to drop

and come up as they will the following season.

SUMMER SAVORY
Satureja hortensis

Although it does not self-sow, this annual quickly grows from spring-sown seed into wiry branching bushes up to 12 inches tall, with narrow, warmly aromatic leaves. Start seeds in small pots in early May to get plants past infancy indoors, then set them out, 8 inches apart, when frosts are over. Some people believe that all herbs thrive in poor ground. This may be true of the thymes and gray-leaved herbs native to stony, sun-baked slopes, but last season, we planted summer savory in a new bed prepared with generous amounts of old manure, compost and bonemeal. The plants grew to great size, supplying fresh leaves all summer. As flowers appeared, I pulled up several whole bushes and hung them to dry.

Savory green beans are a snap to prepare and are at their delectable best when made with beans picked fresh from the garden. Cut the beans on a sharp angle, and put them in a pot with a fraction of an inch of salted water and a branch of summer savory. Cook the beans until nicely tender—soft but not soggy — stirring or shaking the pot to redistribute them. Check during cooking, and add a little more water if necessary, but the aim is to have little or no water left in the pot when the beans are done. Drain the beans. In the same pot, sauté pressed garlic and minced fresh savory in olive oil or butter (or a combination) for a minute. Return the beans to the pot and

toss, adding a squeeze of lemon and salt and pepper to taste.

Besides its classic role with fresh beans, dried summer savory is as good as oregano or thyme in all hearty fall and winter dishes: vegetable and pea soups, lentil casseroles, chili, scalloped potatoes, tomato sauce, Cheddar cheese sauce for vegetables or with dried lovage in stews. The flavor is pungent and, well, savory, but never overpowering.

Purple perilla, facing page, is an eye-catching accent toward the back of a herb border, where its lush, leafy growth adds texture to the garden. When dried, summer savory, above, is a perfect seasoning for hearty winter dishes.

On Thyme

This herb, too, is of the essence

"Nature," wrote Louise Beebe Wilder in *What Happens in My Garden* (1935), "would seem to have been in one of her kindliest and most gracious moods when she created the Thymes. They are of the earth's most fragrant and pleasant greenery."

Some years ago, a friend handed me a catalog listing 27 variations on the theme of thyme. No kid in a candy store ever surveyed the inventory as eagerly: lemon, lavender and orange-balsam thyme; 'Moonlight' and 'Silver Needles'; thymes flowering pink, crimson and white; some with golden leaves, others silver; thymes flat, bushy or spreading. Our sunny, sandy garden is made for thyme; winter may pose a problem for some, but you never know until you try. If a new species appears in a nursery, I bring it home; if I spy an unfamiliar thyme in another garden, I am not too proud to beg.

Thymes do not gobble up garden space in the manner of mints or artemisias. At present, we grow 18 different types. Some decorate the edge of a hot, dry perennial bed, where they sprawl over shoulders of limestone to fine effect. Others creep between paving stones and carpet the ground in front of a garden bench. I've even seen a "garden bench" fashioned of sandy soil and flat stones, planted with mat-forming thymes destined to cover it completely—in time.

When it comes to knowing which thymes are which, botanists agree on one point: They are a hard lot to pin down. Even England's august Royal Horticultural Society, champion of botanical clarity, concedes that thymes are "notoriously difficult to classify and identify; and as specific limits are not well defined and local variants are numerous, accounts by botanists disagree widely." Let the botanists puzzle. I never met a thyme I didn't like. Something about thyme encourages contact. Visitors invariably stroke the mossy spreads of creeping thyme or the furred backs of woolly thyme;

few can resist tousling lemon or silver thyme and inhaling their scents, sweet or pungent. For gardeners, it is enough to know whether the thyme in question is good to eat—all are edible, but some are better—and how it will grow, so we know where to put it.

Thymes grow in one of three ways. Creeping thymes hug the ground closely, sending out little searching shoots that root as they go to form pools of minute gray, green or gold leaves. Other thymes form low mounds of wiry branches clothed in larger green or variegated leaves; lax outside branches tend to root where they touch the soil. A third group grows into small upright shrubs, up to 12 inches tall, which develop a woody trunk and side branches that rarely root unless

Making a place for thyme (clockwise from top): silver thyme, lemon thyme, golden thyme and woolly thyme.

Thyme's irresistibly tactile foliage begs to be tousled: Here, variegated silver thyme (also below) nestles beside lime thyme.

given the hint of a stone or a bent wire holding them to the ground.

Whatever their habit, thymes cannot cope with crowding; pressed by pushy neighbors, they either die or send stringy runners into the light in an effort to survive. The new corner of herbs that looks so well ordered and spacious in May can grow tangled and crowded later on. By July, thymes will be scrambling for their little lives to get out

from under shoving sage or toppling tarragon. A sunny rock garden would be their idea of home, but wherever thymes grow, take care that neighboring plants are in scale.

Thyme has a time-honored reputation as a potent antiseptic. The herb takes its name from the Greek *thymon*, meaning to fumigate, since it was once burned as a fragrant, disinfecting incense. In ancient Egypt, thyme was incorporated into embalming ointments, and during the Middle Ages, lords and ladies walking the "foul streets" clutched to their noses aromatic herbal bouquets, thyme

included, to fend off stenches and germs. So powerful is thyme's antibiotic action that its oil can kill certain bacteria in less than a minute. Thyme's healthful properties may be imbibed in a tea made by steeping a few fresh sprigs of leaves in a cup of boiling water for five minutes. A stronger decoction, cooled and gargled, ameliorates mouth sores, while the same brew may be dabbed onto scrapes, cuts and rashes to speed healing.

COOKING THYMES
Thymus vulgaris

The shrubby thymes include the common cooking thyme of spice racks: French or English thyme. Usually the first to find a place, cooking

thyme grows quickly and easily from seed started indoors about a month before the last frost date. Set out in late May (in Zone 5), plants are usable by midsummer of the first season. A good thing too, because this Mediterranean herb, safe only in perfectly drained soil, may not winter as well as others. Even in gritty ground, the small woody shrub, evergreen in its native land, does not take kindly to four months in a deep freeze or under soggy snow; in our garden, it proves short-lived. Every other spring, we raise a few fresh plants from seed or bring several home from the nursery.

Another version of cooking thyme, a chance seedling found years ago in an English cottage garden, is orange-balsam thyme (*T. v.* 'Fragrantissimus'). But intense scent seems to have come at the expense of hardiness, and the "most fragrant" specimen perished over the first winter. Much hardier, and excellent for cooking, is silver thyme (*T. v.* 'Argenteus'), its gray-green leaves edged with white. Planted in gravelly soil among rocks in our garden, the small bushes come back year after year. This decorative herb may be the culinary thyme to grow (with fingers crossed) where winters are severe.

Rodale's *Encyclopedia of Organic Gardening* calls cooking thyme "the universal herb" and suggests using it with fish, poultry, meats, vegetables, egg dishes, soups, stuffing, cheese sauces and chowders. The small, arrow-shaped thyme leaves are pungent and peppery, similar to but milder than oregano and winter savory. Tie together some thyme sprigs, parsley sprigs and bay leaf (and I would also add lovage) to create a classic bouquet garni to simmer in soup stock and stews. Thyme dries easily, its flavor becoming more pronounced as moisture evaporates, leaving the aromatic oils undiluted. One can usually be lavish with fresh herbs, but with dried herbs, it is easy to tip the balance from pleasant to overpowering.

LEMON THYME
Thymus x *citriodorus*

Lemon thyme is best fresh; the delicate bouquet of citrus and spice is lost through drying or long cooking. Some people recoil from a whiff of mint eau de cologne or rue or even sage, but almost everyone reacts with a surprised smile to the fruity fragrance of lemon thyme. Our garden grows three variants: lemon thyme (*T.* x *citriodorus*) is upright and busy, uniformly green, with a sprinkling of lavender flowers throughout the summer; golden lemon thyme (*T.* x *citriodorus* 'Aureus'), its leaves flecked along the edges with cream, is shorter and more prone to sprawl in a small way; nicest of all may be 'Doone Valley,' its small leaves marbled with yellow, cream and red. Seeds will not grow lemon thyme, and I have seen plants tagged with the name that gave no hint of citrus. If possible, let the nose judge before buying lemon thyme—and you might do other gardeners a favor and advise nurseries if they send you "lemon thyme" minus the lemon.

Lemon thymes are ideal small plants for sunny spots among rocks, along the edge of a flowerbed or spilling over the sides of a raised bed or half-barrel. Once settled and sprawling nicely, lemon thyme is easy to increase. The plant often does the preliminary work for you, its side shoots sending out tentative roots where they touch the ground.

Ideal for sunny corners and decktop containers, lemon thyme displays a sprinkling of mauve flowers throughout the summer.

Like parsley, chives and chervil, fresh lemon thyme is a pleasantly mild herb that can be used to season a wide variety of foods. All summer and into fall, we harvest lemon thyme for kitchen use. I encourage experimentation.

❖ Sprinkle finely chopped lemon thyme and parsley over any soup; the full aroma is released when they hit the hot broth.

❖ Stir minced lemon thyme and chives into cottage cheese, blend them with cream cheese, or toss with buttered boiled potatoes; chervil is a good third.

❖ Whisk together lemon thyme, tarragon, chives, a snip of lovage, crushed garlic clove, vinegar, olive oil, a dollop of mustard and salt and pepper, then drizzle over green salads.

❖ Add lemon thyme to a topping for baked fish (see recipe on page 194).

These branches may be snipped off and planted elsewhere. To hasten the layering process, press any number of shoots against the ground and anchor them with small stones, hairpins or hoops of bent wire. Soil laid over the contact point is a help. When roots have formed, the new plants are ready. I have turned a single straggling plant into six thrifty new ones by layering branches around the plant's center, like the spokes of a wheel, and burying them so that only their tips were poking above the ground. Like all bushy thymes, lemon thyme grows more compact and winters better if sheared back by about half—but not into the woody framework— in midsummer. Sharp scissors are less cumbersome than garden shears for this work.

CARAWAY THYME
Thymus herba-barona

Like the baffling scented geraniums that mysteriously take on the fragrances of pine, rose, nutmeg, lemon, mint and other plants, thymes, too, have learned the trick of mimicry. When crushed, the tiny, pointed, dark-green leaves of *T. herba-barona* smell of caraway. The name is derived from the plant's traditional use in seasoning a baron of beef. This is a lax, low species that creeps slowly in our garden and usually winters well. In full rosy flower, it is a conspicuous ornament at the front of a sunny bed. I'm not in the habit of picking caraway thyme for cooking, but it is perfectly edible and pleasantly aromatic.

CREEPING THYMES
Thymus praecox; T. serpyllum

Seldom used in the kitchen, creeping thymes play a valuable role in the landscape. Years ago, my partner and I built a raised porch of flat stones laid over several feet of well-tamped sand across the front of our house. A flight of low stone steps, also set in sand, leads up to the porch. When the work was done, we tucked slips of the lowest creeping thymes in the steps. In short order, a stream of green was following the cracks between the stones, and by June, the flat greenery had become a flowery patch of lilac humming with honeybees—lovely.

The next spring, bits of green tracery, new self-sown plants, appeared between the stones and spread out to soften the rock-hard lines; again in early July, green was lost under lilac. A perfect picture, and all the better because it happened on its own. Maintenance consists of extracting the few weeds and grasses before they grow large enough to damage the thyme mats.

Creeping thymes hug the ground closely and expand in all directions by means of rooting runners. Although they prefer spreading over soil rather than bare rock—it's easier to root in earth—plants trailing over stones make a kind of compost under themselves as they go, a rubbly substance composed of their own spent leaves and twigs. This meager ration is apparently all they need; our porch thymes are otherwise fed by sand and stone.

It is no wonder that creeping thyme, shepherd's thyme or hillwort (*T. serpyllum*)—the French *serpolet*— is also called mother-of-thyme. This nonculinary species has given rise to a whole tribe of trailers. Grown from seed, the species is a 2-inch-high sprawler with round, glossy green leaves and a sprinkling of pale flowers. The scent is resinous, suggestive of turpentine, but not unpleasant. Mother-of-thyme, and especially its crimson variant *T. s.* 'Coccineus Majus,' is pretty enough for edging a bed or festooning a rock wall but too tall for places that get a lot of foot traffic. Better for planting between paving stones are the tiny-leaved, flat-as-a-rug varieties of *T. praecox*, which grow into wide green mats that, in season, are transformed into blooming carpets of pink, lilac or white.

Also low to the ground, gray-leaved woolly thyme (*T. pseudolanuginosus*)—christened

"mousy thyme" by a neighbor—
spills over a rock-edged bed or
sheets the driest, sunniest soil. We
had trouble with this herb until
we moved it to a hot, sandy border
that bakes in the afternoon sun.
Here, it grows thick and springy but
blooms sparingly—a twinkling of
mauve here and there over a patch;
still, as one writer observed, "its sil-
very soft foliage is somehow flower-
like in appearance." Ants and ear-
wigs like to build their mazes under
creeping thymes—Who can blame
them?— but they should be dis-
couraged, lest they undermine the
mats and kill the roots.

Our best patch of creeping thyme
spreads out at the foot of a garden
bench. Green year-round, it forms
a lovely setting for wild tulips and
tiny crocuses poking through in
spring and hums with bees when

covered with mauve blooms in
summer. Here, too, is a low, green
tuft labeled *T. doerfleri* 'Bressingham
Seedling.' Coming from Allan
Bloom's magnificent English garden
and nursery, a plant bearing the
Bressingham name is usually a
good bet. While not as "spreada-
cious" as other creeping thymes,
Bressingham makes up for slower
growth with lavish flowering.

Pretty in contrast with the green
and gray thymes is golden creeping
thyme (*T. s.* 'Aureus'), a tough non-
culinary herb sometimes sheared
into miniature hedges woven
through with silver santolina and
green germander in a knot garden
or trained to spell something in
a formal park bed. Clipping in
spring and again in August keeps
it shapely, tight and leafy, but other-
wise, golden creeping thyme is un-

**By early July, self-sowing and
ground-hugging creeping thyme
becomes a luxurious mat of deli-
cate lilac-colored flowers.**

demanding; pushing 20 years old, it
is the longest-lived thyme in our
garden. Growing up to 5 inches, the
green-gold mounds persist from
spring until the snow flies and, in
milder climates, through the winter.

Although creeping thymes carpet
the ground thickly, they are no
match for grasses, clovers and other
weeds that sometimes get a root-
hold. Before thymes are planted, the
ground should be thoroughly cleared
of all perennial weed roots. Neglect
this step, and you set yourself up for
extra work and frustration. Wind-
borne seeds will sprout through
thymes, so go over the mats once

in a while to extract weeds before they do damage. If a patch does become infested, the only recourse may be to lift it entirely out of the ground and break it apart to pluck at the offending roots with your fingers. Replant as soon as possible; sometimes, we simply press the mats firmly into loose soil—step on them, to be precise—and then soak them in. A cover of newspapers or even an umbrella left in place for a few days helps them regrow roots before facing the sun once more. Out of the ground, thymes will survive for a few days in the shade, well watered and under cover of a damp blanket. Very early spring or late summer is the best time to tamper with thymes.

Rural gardeners often need to cover dry, sunny slopes—the sides of a septic tank, for example—that are hard to reach with the lawn mower. Strong-growing mother-of-thyme, from starter plants or seeded for economy, along with golden creeping thyme will create a dense, drought-resistant cover. Although these bulkier thymes compete fairly well with weeds once established, the area should be thoroughly dug and cleared of weed roots at the start. If patience allows, take one full season to do the preplanting preparation, digging the soil over several times as each fresh batch of weeds sprouts.

I have heard of thyme lawns—for these, the lowest creepers are used—and think they might work nicely, with a few caveats: The soil must be well drained and free of perennial weeds; the patch should be in full sun and not too extensive; a few flagstones (or something else to step on) ought to be sunk level with the ground along the most-traveled route. And a gardener must be prepared to get down on hands and knees and weed. Creeping thymes are tough, but they will not suffer the abuse of constant traffic, kids playing or dogs digging.

Thymus Miscellaneous

To inveterate collectors, thymes call out. 'Silver Needles' thyme aptly describes a wee herb smelling to my nose of artemisia. Like a miniature spreading juniper in appearance, it reaches out in all directions and roots as it runs. 'Highland Cream,' a variety of *T. praecox*, stays low to the ground, spreading a shawl of tiny pale green and butter-yellow leaves, very bright, even without its summer flurry of pink blooms. Dark and densely leafy, lavender thyme (*T. thracicus*) grows up and out like a little evergreen; the scent is both sweet and resinous—like lavender —while the dusty foliage of fruit thyme, a hardy creeper, smells only sweet. Moonlight thyme (*T. leucotrichus*) is an upstanding small shrub, 10 inches tall, densely clothed with narrow, silvery, sweet-scented leaves; it looks at home on the sunny side of a rock.

All of the bushier thymes—and any newcomers of unproved hardiness—benefit by a light covering of evergreen boughs laid over them, like a thatched roof, in November (or even after Christmas). Thymes that have been protected all winter by boughs and snow will usually emerge fresh and lively-looking in April, but they are not out of danger. Cold spring winds may desiccate them, and the sudden exposure to sun can turn a green thyme brown in short order. Since these Mediterranean natives will not begin growth until the weather settles and turns warm, it is best to leave boughs in place until spring gets past the fickle stage.

I can hardly picture our garden without this group of modest herbs. While some are not as perennial as we would like (here in Zone 5), we're always willing to replace the casualties of winter. These small, friendly plants grace the garden with simple charms, drawing passing bees to their tiny blossoms—thyme honey is a rare treat—and imparting gifts of fragrance as you work with them outdoors or in the kitchen. And as Louise Beebe Wilder noted, "All this chanciness and uncertainty doubtless add to the zest the collector feels, keeping him in a healthy state of curiosity and activity."

Creeping thymes, above left, spread by rooting wherever they touch the ground. Facing page, flowering creeping thyme follows stepping-stones toward a late-blooming hosta. Overleaf, frost-edged lemon thyme amid fallen sugar maple leaves.

Sage Advice
Salvias useful and decorative

Around the globe, close to 500 different sages grow in wild places. Almost everybody has made the acquaintance of at least two—possibly without making the connection between them. At holiday tables throughout the land, cooking sage is the traditional seasoning for the festive bird. In geometric flowerbeds fronting public buildings, after ranks of tulips have been removed, scarlet salvia burns the summer away. Same genus (*Salvia*), polar opposites: The first is a hardy perennial, quiet in its gray leafage and lavender bloom; the second is a tender annual, its brilliance undimmed until doused by frost. Between them are numerous sages that, like thymes and alliums, may entice a gardener to start a collection: aromatic sages for herb beds; colorful sages for hardy borders; sweet-scented sages for summer containers and sunny windows. These plants offer many gifts—benefits to health, flavoring for the kitchen, colors both saturated and subdued, diversity of form—and ask only for ordinary soil and sun in return.

COOKING SAGE
Salvia officinalis

The gardener who grows a bush of cooking sage maintains a fragment of horticultural history: Common sage (*S. officinalis*) has lived in gardens since the late 1500s. Native to the sunny hills above the Mediterranean Sea, cooking sage has remained in favor as a seasoning over the centuries. Our garden would be incomplete without a sage bush—it just belongs.

Like lovage and sweet cicely, common sage is as decorative as it is useful; in several of our beds, it serves a purely ornamental role. One old-time writer spoke of sage growing "at the top of a retaining wall with fine effect, holding its own with more newfangled decorations; here, where it can indulge in a tendency to lounge, the slurred softness of gray-green leaves and violet flowers makes sage a herb of real beauty."

Sage leaves are narrow and softly gray below crowded spikes of lavender flowers. Many people are surprised to see this herb in full flower; some don't recognize it as sage. A few inquiries usually reveal that these gardeners cut their bushes back severely in spring, an action which removes potential flower buds. Although it is tempting to take the pruning shears to it in spring, sage flowers with extraordinary exuberance when left alone. Like lavender, a fellow Mediterranean, sage is a low shrub that often looks the worse for wear after winter. Rather than hack it back, do some judicious pruning once new growth has started. Cut away dead and broken stems, and shorten gangly branches back to fresh green —then watch it bloom in June.

An easy herb to grow from seed

Red-top, or painted, sage is among a handful of colorful herbs that annually volunteer to decorate corners of the vegetable garden.

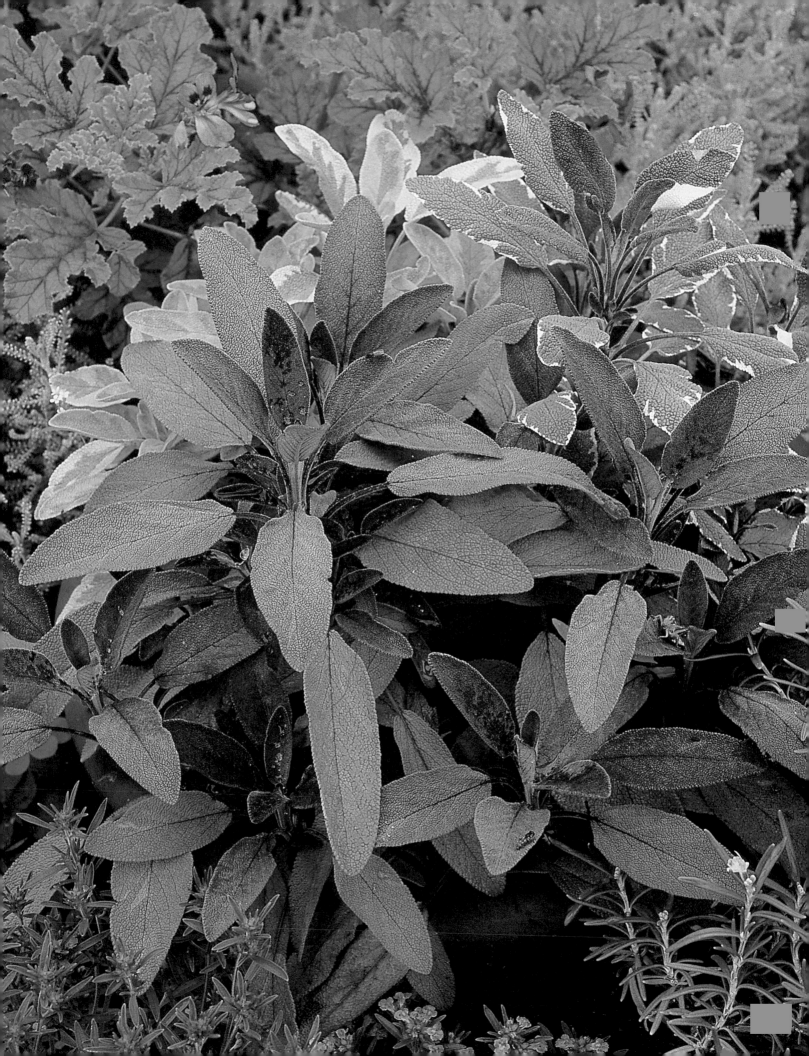

sown indoors in March or April, sage can also be propagated from cuttings; the bushes do not divide well. Layering is perhaps the easiest way to renew a plant, and sage will often start the process for you. Where lower branches touch the ground, new roots begin to form. This natural layering can be encouraged by anchoring the branches to the earth with a piece of bent wire or a hairpin and packing a few handfuls of soil over them. Allow a month or more for roots to form before clipping the branch away from the original bush and planting it elsewhere.

Cooking sage appears in several pretty variants. With narrow, very silvery leaves, white-flowering common sage is a beauty in full bloom. The pebbled blue-gray leaves of the newer cultivar 'Berggarten,' which means mountain garden, are large and rounded on a vigorously branching bush; we use this robust foliage plant prominently at the front of herb gardens and flowerbeds. Golden sage ('Aurea') sports foliage marbled green and yellow, while 'Tricolor' is splashed with cream and purple; reddish violet suffuses the sage-green leaves of 'Purpurea,' especially near the tips. All three of these colorful sages grow quickly into handsome container plants over a summer. Planted in sunny beds, they do as well, but winter survival is not a sure thing north of Zone 6. In our Zone 5 garden, they have come through the cold months nicely against a west-facing house wall, where snow banks up. A loose winter covering of fall leaves or evergreen boughs is a help in Northern gardens, but be prepared for winterkill. Sooner or later, even the hardier gray-leaved sage may need replacing. In our garden, the bushes grow lanky and woody after four or five seasons and may succumb to a hard winter. Other gardeners tell me that sage goes on and on for them. They must be living right; legend says that sage follows the fortunes of the household, dwindling during evil days and reviving miraculously when things are bright again.

All herbal literature holds sage in highest esteem as a medicinal plant. The name salvia comes from the Latin verb *salvere* (to heal), root of our words salve, salutary, salvation, sage (wise) and the French toast *salut* (to your health). The sagacious Chinese once valued the herb so highly that they willingly exchanged three pounds of black tea with Dutch traders for a pound of sage. The reputed link with long life and glowing health is illustrated in *The Virtues of British Herbs* (1776) by English herbalist Sir John Hill, who recounted the story of "a woman so old that for that reason alone, she was called a witch. About five yards square of ground before the door of her little habitation was planted with sage, and 'twas not only her account but that of all the village that she lived on it. Her *exact age was not known*, for she was older than the church register, but people remember their fathers calling her the 'old woman.' "

Nowadays, sage is better known for its role in turkey dressing—this herb seems a necessary complement to fatty poultry and other meats. Unlike mild-mannered basil or dill, sage is too potent to be used with a lavish hand. I like to tear a leaf into bean soup or minestrone; a little

Decorative as well as useful, common sage, facing page and above, will fill out a flowerbed and can be harvested to add to seasonal stuffings.

goes a long way in cream cheese. The taste of fresh sage is balsamic and slightly bitter (but much less so than the dried herb), making a tonic spring tea blended with lemon balm and spearmint. If I'm feeling a mid-afternoon energy slump, a cup of sage and green tea—three to five leaves of fresh sage with a pinch of green tea—is a refreshing pick-me-up. At one time, English peasants ate fresh sage with their bread and butter and cheese. A simple way to appreciate the flavor of many culinary herbs is to spread a thick slice of fresh bread with sweet butter and lay on a few whole leaves or a sprinkling of minced herbs, or melt cheese over bread under the broiler and press fresh herbs into the top. Whole herb leaves—try basil, coriander, lovage, parsley and sage—can also be cooked as tempura, coated with a flour-and-egg batter and sizzled in oil.

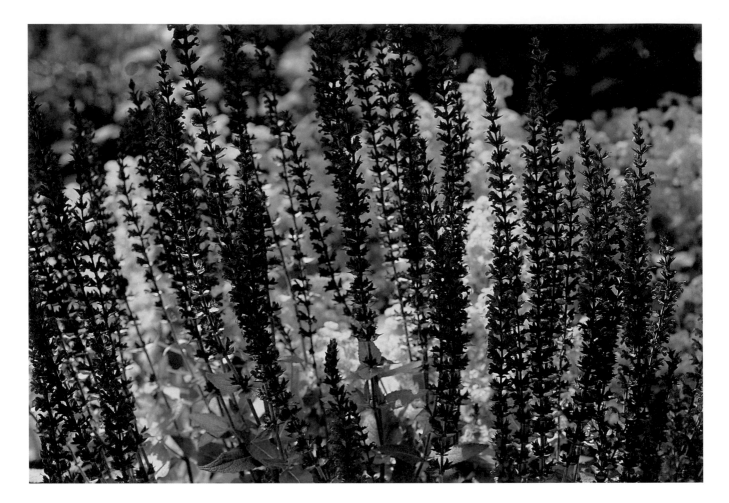

The deep purple flowers of *Salvia* x *superba* 'East Friesland' are an elegant foil for the yellow lady's mantle (*Alchemilla alpina*) in the summer garden.

CLARY SAGE
Salvia sclarea

Clary sage has resided in gardens even longer than has cooking sage. Today, however, it is seldom seen. This is a tall, handsome herb. Its broad, textured, heart-shaped leaves, silvery with fine hairs, are topped by 4-foot pyramidal flower spikes with pearly parchmentlike bracts as decorative as their lipped violet flowers. It is probably clary's biennial nature—leaves the first

year, flowers the next, then gone—that keeps it from being better known. But clary is easily grown from seed initially and usually self-sows. I find the gray rosettes useful to tuck into beds in spring where less stalwart plants have succumbed to winter. Clary begins to bloom in July, in time to complement clumps of lilies. Even after the flowers fade, the conspicuous silver-pink bracts keep the herb presentable into September. Visitors always react with enthusiasm to this unusual sage, and considering that it practically grows itself, clary ought to find a home in more gardens.

Clary is also known as clear-eyes: An infusion of its seeds yields a mucilaginous liquid used as an eye-wash to remove foreign particles safely from the eyes. The herb once flavored

homemade wines and ales; tops of clary give a bouquet of muscat grapes to wines of Germany's Rhine region, where the herb is called *muscateller*. In kitchens of the past, clary had its uses too: Both John Evelyn and John Parkinson published 17th-century recipes using young clary leaves and flowers in batter-dipped fritters, in soups and "in our cold sallets yet so as not to domineer."

HARDY SALVIAS
Salvia nemorosa; S. pratensis

A number of nonculinary, winter-hardy ornamental sages compete for space in herb gardens or flowerbeds. Valuable drought-defying plants, all love the sun and need warm, well-

drained, organically enriched soil. Since naming in nurseries is not always accurate or consistent, we experiment with any new hardy sage we happen upon. Best of the perennial sages come under the banner of violet sage (*S. x superba*, or sometimes *S. nemorosa*), classic members of herbaceous beds, where their slender spiry growth adds valuable vertical lines.

When planning a new bed or renovating an old one, I often cast about for a medium-tall plant for the front or middle row—something self-supporting (so I won't have to bother with stakes or string), drought-resistant, long-flowering, bugproof and hardy. A tall order, but cultivars of *S. nemorosa*, more compact and richer in color than the species, fill the bill. The 2-foot-tall salvia 'East Friesland' is my favorite, as it returns year after year with no designs on more garden space. In June, glowing deep violet spikes begin to color with the irises and poppies and last into July, when they contrast strongly with the lemon yellow of 'Moonshine' yarrow. Like clary sage, much of this salvia's color is in its reddish purple bracts, modified leaves under each flower; after flowers have faded, the bracts continue to be decorative. 'Blue Queen' and 'Blue Hill' hoist medium blue spikes, not quite as effective as the dark violet. Once established in the garden, these sages can be split into three- or four-shoot divi-sions in early spring for purposes of propagation or renewal. They are best in groups of three or more, spaced 18 inches apart, and while not herbs in the strictest sense, all have aromatic foliage.

Also aromatic, meadow sage (*S. pratensis*) is a kin to clary in medicinal use. Flowering in long spikes of washy purple-blue, this British native grows to 4 feet and, in time, forms a sturdy clump. Crossed with violet sage, it has spawned a bevy of beautiful, hardy medium-height salvias. The flowers of 'Plumosa' are soft in both color and texture, plum-purple and feathery, a gorgeous contrast in front of the apricot torch lily (*Kniphofia* 'Shining Scepter'). The variety *S. p. tenorii*

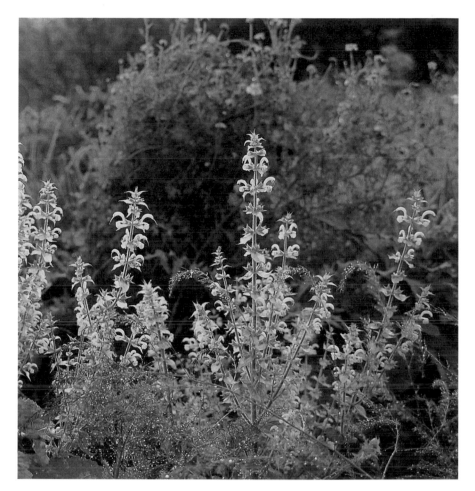

Its flowers faded, clary sage, above, retains silver-pink bracts that keep it presentable into September. Below, meadow sage.

leans to blue, and 'Baumgartenii' is a rich violet. 'Mainacht' provides deep indigo-blue in early summer, lovely with Oriental poppies, yellow irises and the first peonies or when spiring up behind lady's mantle. 'Miss Indigo' sends up tall, branching flower stalks of deep purple at peony time —the 'Miss' came to us as a tender perennial but has returned for five seasons with no special treatment. Meadow sage and its varieties have the merit of being the first salvias to bloom.

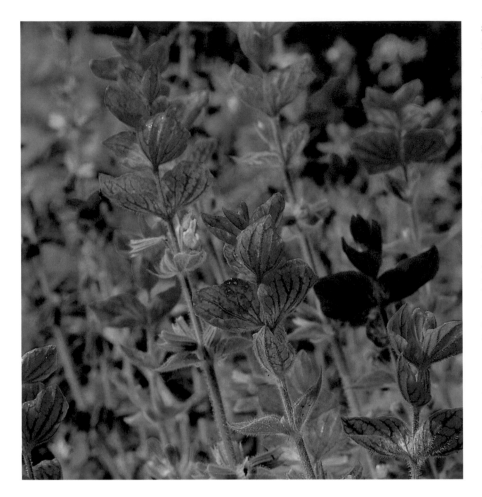

The colorful bracts of red-top sage (*Salvia viridis*) make a striking visual statement for a single summer. The plant may reseed.

AZURE SAGE
Salvia azurea grandiflora

At the tail end of summer—August and September—comes azure sage, a lovely 4-foot species described by 1930s writer Louise Beebe Wilder, a woman who knew her perennials, as "a truly grand hardy plant." Its aromatic grayish leaves are narrow and glossy all the way up the tall stems. But the plant's chief glory is its clear gentian-blue flowers, a pure hue rare at any season. Native to the southeastern United

States, this sage may not be ironclad hardy north of Zone 5, but nothing ventured, nothing gained. Choose your warmest, sunniest spot, give the herb a helping of compost and a little elbowroom, and hope for the best. In windy locales, some inconspicuous staking is necessary.

RED-TOP, OR PAINTED, SAGE
Salvia viridis, syn. *S. horminum*

Most of the interesting salvias are perennials. Red-top sage, however, is a knee-high annual hardy enough to act like a perennial if allowed to self-sow and choose its own place in the garden. Leaves are simple and sagelike, flowers small and in-

significant. The plant's beauty lies in conspicuously colored bracts, modified leaves that hang protectively over the tiny blooms and sprout on top. Pinky red, purple or violet forms spring up from a package of mixed seeds. Like regular sage, an infusion of red-top leaves is said to ameliorate mouth sores and scratchy throats. A curious property of the herb, according to the old books, is its ability to heighten the intoxicating properties of alcoholic brews when added during the fermentation process. You wonder how folks figured out these things.

TENDER TROPICAL SAGES
Salvia rutilans; S. dorisiana

Delicious scents pervade the foliage of two tender tropical sages. The big, fuzzy arrowhead leaves of fruit sage (*S. dorisiana*) are sweetly redolent of mixed fruit. Pineapple comes through strongly when a leaf of *S. rutilans* is rubbed. Shrubs from the south, pineapple and fruit sage thrive in heat and sunlight but struggle and grow spindly in chilly low-light places. It is best not to attempt the tender herbs if you have only north-facing shade, but one is tempted for the sake of their ambrosial scents. Both tropical sages have downy, slightly sticky leaves and can be used fresh as seasoning or dried for potpourris. We enjoy them simply as smelling herbs, rubbing their leaves as we pass by. When mixed with lemon-scented herbs in cold summer teas (see recipe on page 207), they add delightful fruit flavors.

Tropical sages do best in 10-to-12-inch pots of light soil set outside in the warm sun during the frost-free

From Mexico comes cardinal, or Mexican red, sage (*S. fulgens*), a handsome, heat-loving shrub of pungent-smelling leaves, topped with spikes of brilliant scarlet flowers toward the end of summer. In a cool greenhouse or a frost-free porch, this sage winters over quite easily. When cut back hard in autumn and allowed to dry down, it goes into dormancy for the winter and revives when the days turn warm and water is applied. So treated, cardinal sage grows into a showy 3-foot container plant over the summer—and saves us from having to start a small nursery plant each year.

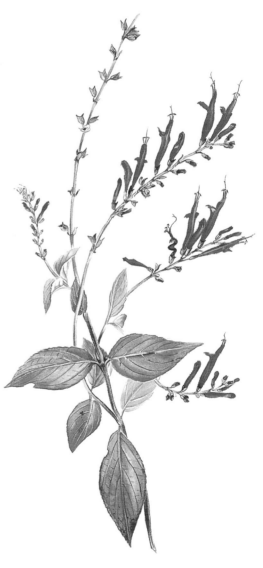

months; if the season is long and hot, they will flower pink and red by summer's end. Frost finishes off growth, so these salvias must live indoors for eight or nine months. Wintering them in the house presents few difficulties provided you have the requisite sunny place—a sun room, heated greenhouse or large south-facing window—and enough room to accommodate their eventual bulk. All things considered,

Both cardinal sage, above, and the perennial pineapple sage, right, can be grown as container plants and will safely overwinter in a sheltered porch or greenhouse.

we treat tender tropical sages as annuals, buying new starter plants each spring and enjoying them for the summer. When frost hits in October, we say good-bye until next year.

Going to Seed
Seeds for flavoring and sprouts

Culinary herbs are almost synonymous with aromatic leaves—basil, rosemary, thyme and the like. But some herbs concentrate scent and flavor in their seeds as well. Flavoring seeds are widely used in Europe and points east, the native lands of many, but less so in North America. Caraway rye bread is as ubiquitous in eastern Europe as sliced white is here; Italian cooks appreciate the licorice sweetness of anise and fennel seeds in baked goods and tomato sauces; and both Middle Eastern and Indian dishes lean heavily toward ground cumin and coriander seeds.

Cooking with seeds requires a little forethought—you don't just toss them in at the last minute as you do with fresh leaves. Seeds are often ground to release more flavor and stirred around in hot oil with onions, garlic, ginger and such at the start of a savory dish. Special seed mills are handy for crushing seeds, and an ordinary salt or pepper grinder works reasonably well. I usually pulverize seeds into tiny

bits on the cutting board, using a large, sharp knife with a good rocking action. Compared with leafy herbs, seeds add greater depth and intensity of flavor. Some may be an acquired taste: I didn't take to cumin seeds at first but now use them regularly, chopping the seeds as described before adding them to a mini food processor that quickly purees chickpeas and other beans, along with olive oil, lemon juice and garlic, into tasty dips and spreads (see recipe on page 197). The flavor of freshly ground cumin comes through strongly in curry variations, whether with fish, chicken, tofu or vegetables. Once you get into the habit of using seeds, you may find yourself reaching for the jars frequently.

Flavoring seeds practically grow themselves. Your job is to wait until they mature and dry, then intercept them before they fall to the ground. A caveat, though: Some seed herbs originate in hot places with a long growing season; in cooler Northern

gardens, they may not ripen properly before hard frosts. But nothing ventured, nothing gained. All seed plants are easy to grow; and some self-sow with vigor, coming up in odd spots around the garden year after year—a bonus harvest.

ANISE
Pimpinella anisum

Homegrown anise seed is far more potent than the stuff of the spice racks and is worth the bit of work to grow it. An annual herb native to Greece, Turkey and Egypt, anise sown outdoors will mature a crop of seeds in about four months. Choose a warm, sunny spot where the soil is well drained and moderately fertile. Scatter seeds in mid-

The seeds of brown mustard, in back, and of white mustard, in front, will sprout on a piece of damp cloth or even paper towel.

May or about a week before the last spring-frost date; cover lightly, and thin seedlings to a hand span apart. Toward the end of summer, as the seedheads turn gray-brown, cut

The natural licorice flavor of anise seeds is more pronounced when they are harvested from a home-grown plant (a self-seeding annual), seen here in full flower.

them and lay them out on paper in a warm, dry place to finish drying. Alternatively, hang seed stalks upside down over a large bowl; seeds will drop into the bowl as they dry, and you can finish the threshing process by hand, rubbing the small pods between your palms to dislodge seeds, blowing gently as you do to remove the chaff—a simple action as old as civilization. Leave a few plants standing as you harvest,

and with any luck, seeds will drop and spring up on their own next season. Save a few seeds for resowing, just in case.

In ancient Greece, anise seed flavored those two basic comestibles: bread and wine. Today, anise seed can be found in variations on those themes. A respected digestive, anise imparts its characteristic licorice taste to liqueurs such as anisette, Pernod, ouzo and sambuca. Baked into cakes and cookies, anise seed imparts a delicate savor and a hint of sweetness; at our Christmas family reunions, homemade anise-flavored *biscotti* always end the festive meal. Anise also brings out the sweetness of tomatoes; I often add half a teaspoon of crushed anise seed to spaghetti sauce with onions, garlic and oregano at the start. For minor gastric disorders, anise tea is a traditional (and tasty) remedy. Simply crush 1 teaspoon seeds, pour 2 cups boiling water over them, and steep for at least 5 minutes; drink hot or cold.

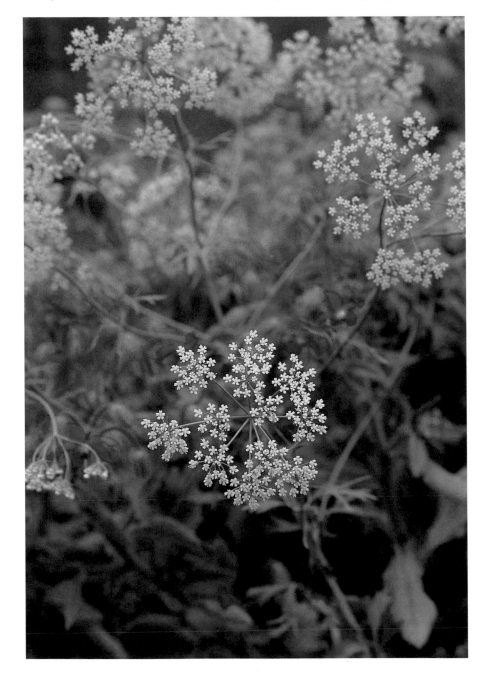

BLACK CUMIN
Nigella sativa

From the East comes black cumin, the seed of *N. sativa*, a feathery blue-flowered annual worthy of a bit of garden space. Tasting of nutmeg, fennel, coriander and cumin, this unusual spice is known in France as *faux cumin*, or *quatre épices*, four spices. There, the seeds are powdered and used as an aromatic black-pepper substitute. In India, the somewhat oily seeds are used in flat breads and curries, and in Egypt, they are treated much like poppy seeds, adding richness and flavor to baked goods.

Black cumin is not something

The seeds of black cumin, above, and of caraway, below, lend a memorable flavor to food.

found in the spice section of the supermarket. It is, however, easily grown. Some gardeners may know *N. damascena* (love-in-a-mist), with its pretty blue, white or lavender flowers, each on a spidery green ruff, floating through wispy foliage —the effect is airy and transparent, one of the "see-through" flowers. Conspicuous horned seedpods, like small, puffed, green-and-purple-streaked balloons, follow the blossoms.

At 12 inches tall, black cumin is a shorter plant than *N. damascena* but just as decorative, and its seeds are superior in flavor. Scatter nigella seeds over nicely worked soil, in a sunny spot, a week or two before the last spring frost is anticipated. Thin seedlings to 6 inches apart. Flowers appear in July and may continue into September. As the pods turn to parchment, snip them

for further drying before emptying them of their stock of black seeds. Some seeds are sure to spill to the ground and sprout the following spring, or you can save your own seeds for resowing.

CARAWAY
Carum carvi

Like parsley, caraway is a hardy biennial that grows a leafy rosette the first season and runs to flower and seed the next. As much as I appreciate its flavor, I'm often tempted to banish caraway from the garden. Every seed left unpicked falls, sprouts and grows into a well-anchored rosette of carrot-like foliage, giving rise to yet another crop of seeds. "Weed," I say, extracting the interlopers from vegetable and herb beds.

Turid grows caraway in a segregated, shaded spot behind an unused henhouse, where it fights (like any weed) with grass and nightshade. "Thrives on competition," she says.

The only trick to growing caraway is getting it started in the first place. Typical of umbelliferous plants— dill, carrots, parsley, sweet cicely and others—caraway seed is viable for a short time only and may not sprout if it has been badly stored over winter. Putting seeds in the freezer for a few days before sowing may wake them up. The hardy seeds are then sown at the same time as spring lettuce and radishes; three or four plants will be enough. To harvest the following summer, cut the heads when the first seeds turn brown; hang the stalks upside down over newspaper or a large bowl, or enclose the seedheads in a paper

bag; any seeds that do not fall are easily rubbed off by hand. Leave one or two unharvested seedheads in the garden to perpetuate the crop —if you dare.

There is evidence that caraway seeds have been used in cooking as far back as the Stone Age. Like dill, fennel and anise, caraway has a long-held reputation as a stomach herb, used to sooth upsets and relieve flatulence. I wonder whether some herbal intuition prompted me to add caraway seeds to split pea and lentil soups—beans, beans, good for your heart and all. Northern Europeans enjoy caraway seeds in cheese, sausages, cabbage dishes, sauerkraut, breads and dumplings.

According to an article in the 1945 *Herbarist*, the journal of the Herb Society of America, "The queen of pot herbs to all Norwegians is Karvekal, caraway; and in Norway, it is the commonest weed—first thing to sprout from last year's withered grass." The article described harvesting "some 2 inches of the fleshy taproot with the rosette of leaves—a lovely way to spend some hours of a sunny May morning." The brown skin is scraped from the roots, and the plants are carefully rinsed, then finely chopped and tossed into hot broth that is kept just under the boiling point for five minutes. The soup is thickened with leftover meats, rice, noodles or cubes of fried bread before being ladled over a poached egg in each bowl. "We may have Karvekal soup every day as long as the plant is in season until early June," the author concluded, "when the leaves grow coarse."

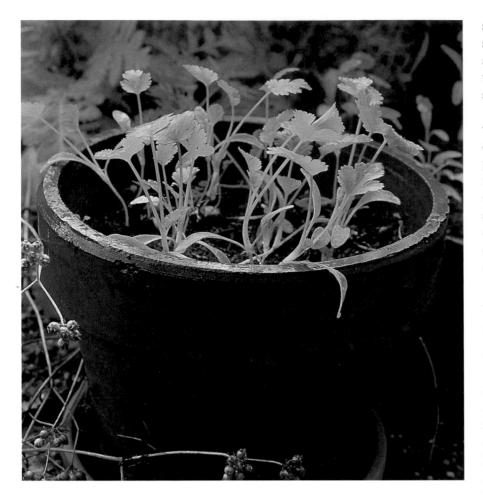

Seedlings of coriander can be cared for in containers outside the kitchen door, conveniently at hand. The leaves are an essential ingredient in fresh salsa.

CORIANDER
Coriandrum sativum

Another seed herb of the distant past, coriander was used in China as early as 5000 B.C. and has been found in the tombs of ancient Egypt; the Old Testament mentions coriander seeds as a herb appreciated by the Hebrew people. Today, coriander leaves—better known as cilantro, or Chinese parsley—may be more popular, but coriander seeds remain an essential ingredient in curry powders and other Indian spice mixtures. They also turn up, unbeknownst to those who partake, as a flavoring in liqueurs, gin and vermouth.

Coriander is an annual herb, but once established in a garden, it may return perennially from fallen seeds. We count on it to come up on its own every spring—and so it has, for over a decade. The best coriander grows in fluffy, enriched loam, but "volunteers" do nicely along the edges of our vegetable beds, rooting down in the compacted paths. Gardeners who want lots of leaves often complain that coriander runs to seed too quickly. The solution is to sow seeds in succession or to let the plants do the job and drop seeds where and when they may—self-sown coriander seems to stagger itself naturally.

Coriander seeds are ready to pick when they turn from shiny green to dull gray-brown. Leave seeds on the plant as long as possible—the flavor mellows and improves with time. Once harvested, the seeds should be spread out in a single layer on a flat dish and left on the counter for several days to dry thoroughly. Store dry seeds in a glass jar.

CUMIN
Cuminum cyminum

Cumin comes from the eastern Mediterranean, especially the upper reaches of the Nile. Understandable, then, that it was known to the Egyptians and Persians of old and still features in Middle Eastern cooking. Around the time of Christ, cumin seed was so valuable, so the story goes, that it was negotiable as payment of taxes. Cumin has been embraced by cuisines of the East but, for some reason, has never become popular as a spice in northern countries.

In the North, the garden culture of cumin seed is a bit dicey—plants need four warm months to mature a crop of seeds. It is best, then, to start seeds indoors in peat pots or other small containers about a month before the last spring-frost date; then set plants out in a sunny location once frosts are past and the ground has warmed up. Delicate in its early stages, cumin must be kept weed-free. Seed ripens in the fall. As the seedheads turn brown, cut them and finish the drying process indoors.

Free of the narcotic that has earned the opium poppy its notoriety, poppy seeds add a delicate flavor to breads and strudels.

OPIUM POPPY
Papaver somniferum

In northern and eastern Europe, poppy seeds, harvested from the plump seedpods of the opium poppy, are an important ingredient in many baked goods, whether sprinkled over breads and rolls or ground with sugar and used as a filling for cakes and strudel. But the opium poppy sends a mixed message, one not lost on the ancient Romans. Sheaves of wheat and bunches of poppies appear in depictions of the earth goddess Demeter: wheat for bread and poppies for their sap, which could magically allay pain, and for their pods, which brimmed with countless seeds, a potent symbol of fertility. The poppy had darker associations,

too, with sleep and death, making it sacred to Morpheus, son of the lethargic god Somnus. The paradox is still with us: Derivatives of the opium poppy, such as morphine, provide respite from the pain attending severe illnesses, while the illicit and often deadly trade in heroin creates its own suffering.

Growing opium poppies may be illegal in some quarters, but you'd never know it to look around. Masses of them spring up spontaneously in many yards from seed spilled by those fat, fecund pods. It was for seeds that opium poppies were first planted in North American gardens by European immigrants. Oddly enough, poppy seeds themselves contain no trace of the narcotic that infuses the rest of the plant. To harvest your own poppy seeds, look for the cultivar 'Hungarian Blue,' a name that refers to the color of the seeds rather than the flower, or plant whatever variety you can find—the pepper-shaker pods of all are filled with seeds.

The opium poppy is a beautiful, hardy annual with broad, sharply scalloped, blue-gray foliage and flowers like scaled-down versions of the flamboyant Oriental poppies. These may be white, pale lilac or all shades of pink, with darker central blotches. Single-flowered poppies show four simple petals around a center of straw-yellow stamens, while doubles are packed to bursting with hundreds of petals. Grow any three different opium poppies, and you'll be surprised by the many variations that appear the next year as if by magic—all poppies share pollen and interbreed with alacrity.

Seeds are the best way to get started—with luck, you can pinch a ripe pod from a friend's garden— and October is the best month to sow them (although April will do).

Scatter seeds over a patch of ground in the sun, and rake them in lightly. If seeds sprout "thick as hair on a dog's back" (as our old neighbor used to say when his carrots came up on top of each other), they must be thinned to about a hand span apart. Nobody likes pulling perfectly good seedlings out of the ground, but the alternative is weak, spindly growth, and, no, the seedlings do not transplant. Once started and thinned, opium poppies look after themselves, flaunting their showy flowers in the summer garden and scattering fresh seeds for next year's show—and harvest.

Sprouted Seeds

The young sprouts of many seeds are tasty and nutritious, just the thing in winter and early spring when a body craves something green and lively—something just picked. Two sprouted seeds—mung beans in stir-fries and alfalfa sprouts for salads and sandwiches—have be-

Sprouted seeds, such as those of broccoli, satisfy a taste for fresh, crunchy greens beyond the growing season. Sprouts are easy to grow and are packed with vitamins.

come commonplace in kitchens and restaurants. But other seeds sprout as quickly and, like herbs, add concentrated flavor and a fresh lift to many dishes.

Sprouting seeds is a simple matter: All that's needed are water, warmth and some sort of container. Three-tiered stackable plastic sprouting trays are convenient and efficient. Seeds are sprinkled in an even layer over the trays, one tray every second day. Water poured into the top tray twice a day drains through, irrigating the trays below.

The demands of sprouting seeds are simple: water, warmth and a medium. Below, sprouting seeds on a paper towel and seeds in soil. Facing page, opium-poppy seedheads. Overleaf, dill seeds.

Lentils are my favorite seeds to sprout this way. I find it neat that a tasteless seed, so hard you could break a tooth on it, turns crunchy and almost sweet in such a short time; it takes four days for the flat brown seeds to send out tiny shoots with the start of leaves. In early spring, when chives, chervil and lovage are beginning to grow outside, I often make a sprouted-lentil salad, combining the sprouts with grated carrot, diced celery and minced herbs and dressing the salad simply with oil, cider vinegar and tamari.

The British love their "mustard and cress," a peppery sandwich filling or salad, picked when the greens are mere sprouts. In 1869, Alexandre Dumas wrote about curly cress in his *Dictionary of Cuisine*: "...the healthiest of the fines herbes. It is rarely found on the

markets of large cities, since it begins to wilt as soon as it is picked, and in cultivation, it goes to seed too quickly. Children and old maids amuse themselves by growing this decorative cress in dampened cotton." Both curly cress and mustard seeds will sprout on a piece of damp cloth or even paper towel, but a bit of soil gets them off to a better start. Fill a bulb pan—a shorter-than-usual flowerpot made for forcing bulbs—or a shallow tray or flat with sterilized potting soil or damp peat. Sow mustard and cress seeds thickly in separate pots or on different sides of a flat. Rather than covering the seeds with soil, lay a sheet of glass or clear plastic over the seeded containers to retain moisture; place the containers in a warm, bright spot indoors. When the seeds germinate, remove the covering and dampen the growing medium once more. Begin cutting the greens when they are several inches tall—and in the meantime, you might want to get another pot or two started. Two parts cress, one part mustard with chopped apple make a traditional English "small salad" dressed with oil and vinegar.

At summer's end, every gardener has leftover garden seeds that can be sprouted through the winter. Soil sprouting works well for many of them. For variety, try arugula, spicy fenugreek and sunflower seeds. Both chives and onions send up pungent blades; and cole crops, such as kale, cabbage, radish and broccoli (if the seed has not been treated with chemicals), yield tasty, highly nutritious sprouts. Gather up extra herb seeds, such as dill, chervil, basil and coriander, and sow them mixed over a pot of soil; snip them small to bring the scents and tastes of summer to the table in the dead of winter.

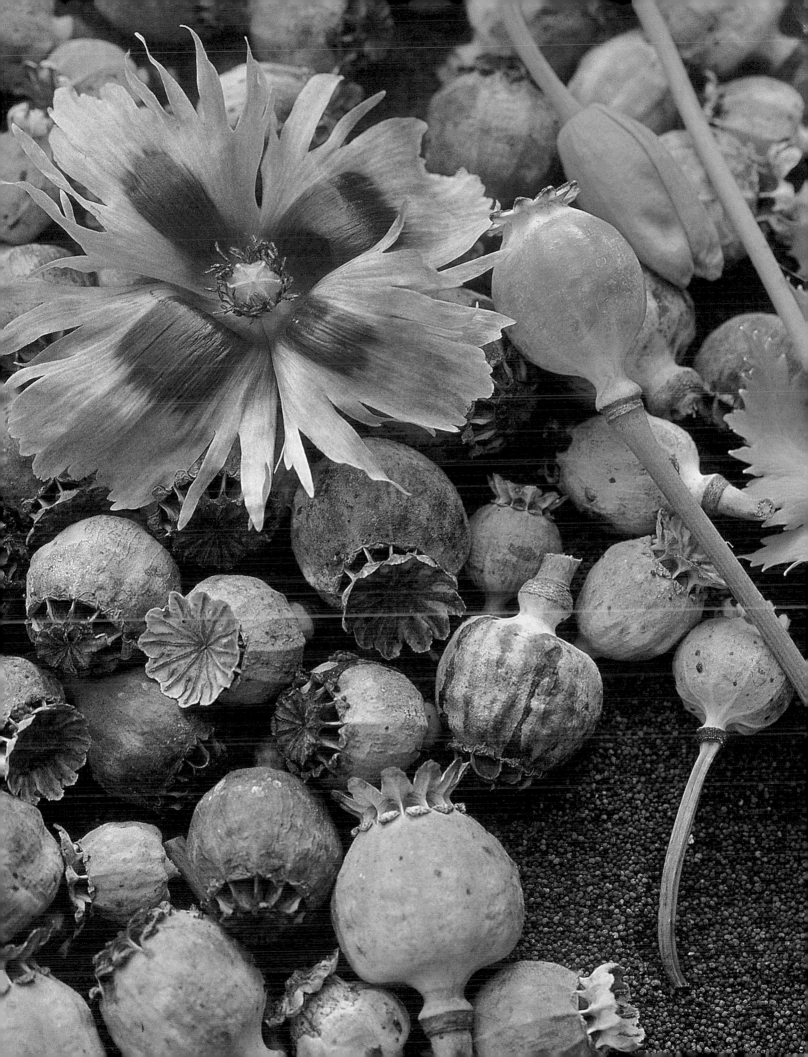

All About Alliums
Onions for flavor and color

You plant an onion, you get an onion. Most gardeners first encounter an allium—even before they know the name—as they push papery onion sets into the cool soil of a spring vegetable bed; a few weeks later, we're pulling tender scallions, and by August, plump hard globes are ready for harvest. The ordinary cooking onion (*Allium cepa*), staple of kitchens around the world, is the best known of the alliums, a vast and varied race of more than 300 species. Among their ranks are three of the best seasonings—garlic, chives and shallots— a few tasty oddballs, such as the Egyptian onion, one exceptionally good wild thing and a number of lovely flowering plants. This is an undemanding genus generous with both flavor and color.

Alliums of one kind or another flourish all through the temperate regions of the northern hemisphere. In the wild, some species grow on grassy mountain slopes, from China to California, while others spring up in stony, sun-baked meadows in the Middle East and southern Asia. Some hide under the olive and citrus trees of the Mediterranean, and others cluster among maples and birches in the woodlands of North America.

Although they vary in height and appearance, alliums share a family resemblance in root, leaf, flower and scent—even some of the ornamentals exude a whiff of garlic. All are hardy bulbs, pea-sized to grapefruit-sized. From them grow simple straight leaves, flat or round, as narrow as blades of grass or as broad as tulip leaves. One sign of allium kinship is the star-burst flowerhead, a perfect sphere or loose umbrella of star-shaped blooms, often hundreds, radiating from a central point. In some species, small bulblets appear amid the flowers, and in others, flowers give way entirely to clustered top bulbs. Rosy purple is the predominant color, but alliums also bloom white, crimson, grayish lavender, blue and yellow. The majority of alliums are partial to a light-textured, organically enriched soil, warm and well drained; as a rule, they thrive in full sun. But I have dug the bulbs of wild leeks from the dense clay of nearby woods, and pretty golden garlic (*A. moly*) shines in light shade.

CHIVES
Allium schoenoprasum

Anyone's herb in perpetuity for little effort, chives are the best known and most often grown of the seasoning alliums. To start a patch, simply scatter a few seeds in a pot of soil in spring and wait until the stripling onions have filled out a bit before setting them 12 inches apart in nourishing loam outdoors. Alternatively, avail yourself of a chunk of chives from a nursery or a friend's garden—a bundle of tightly packed

Set in a raised bed, a stand of garlic chives is protected by a deep covering of summer mulch to discourage weeds.

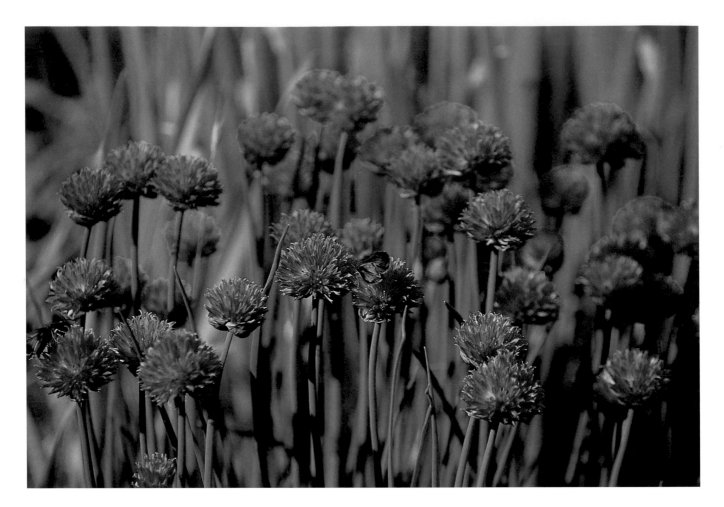

The cheery rose-pink flowers of chives lure butterflies such as this skipper to the early-summer garden. Hardy perennials, chives are as lovely as they are reliable.

bulbs cut away from an established clump will soon settle in a new garden. Our six fat clumps have descended from skinny seedlings started years ago and miles away. Chives are among the most perennial and portable of plants.

Once in the garden, indestructible chives—"a good sawce and pot-herb," as 16th-century English herbalist John Gerard wrote—will be in constant demand for flavoring any dish improved by a mild tang of onion. In Ukraine, the appearance of dill seedlings and shoots of chives signals spring, like the first robin here. The minced herbs are briefly sautéed in butter, "as a sauce to pour over everything." Along with chervil, parsley and tarragon, chives are part of the classic French fines herbes so good for omelettes. Chives enhance simple dairy products; snip them into cottage cheese and yogurt-based salad dressings and dips. I often use chives with other fresh herbs to flavor green or grain salads, potato salads and frittatas. Pink vinegar tasting mildly of onions is easily made by steeping a handful of chive blossoms in a quart of white vinegar; add a sprig of tarragon for extra flavor.

With their lush spiky leaves and showy lavender flowers, chives look at home in a perennial bed or a rock garden. The newer cultivar 'Fore-scate' sends up larger heads of deep mauve-pink. Always, there is a drone of honeybees and a flutter of butterflies around the nectar-rich flowers. When blossoming is over, we scissor chives back to about 2 inches from the ground, a drastic brush cut that is soon covered with tender new growth. To give the sheared clumps a boost, spread a layer of compost or old manure around them and soak the ground thoroughly. Spring or fall is the time to pull older clumps apart and replant the divisions to extend a patch.

Chives freeze well but dry poorly. We do neither, since this is the earliest herb to rise in April and one of the last to retire in November—an eight-month, fresh-from-the-garden season. But gardeners intent on picking fresh herbs over winter should

know that chives are one of the best candidates for the winter windowsill. As bulbs, they may be forced into early growth like any tulip or daffodil, as long as their need for a dormant spell is met. Sometime in early September, pot up several small divisions from a garden clump, trimming the roots in the process to fit the containers. Set the pots in a cold place protected from freezing and thawing—the corner of an unheated shed or garage or in an uncovered cold frame filled with straw, sawdust or leaves—until early in the new year. Then bring the pots indoors to the very sunniest window. Fresh greens will soon sprout.

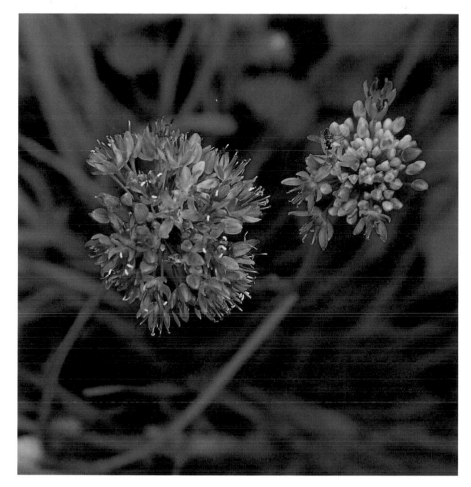

GARLIC CHIVES
Allium tuberosum

Considering that garlic chives have always been highly regarded in the East—"a jewel among vegetables"—it is surprising that this allium has only recently made an inroad into Western cuisine. In nurseries, *A. tuberosum* may be labeled Oriental garlic chives. In Chinese markets, bundles of leaves and bud-topped flower stalks are offered alongside Chinese parsley (coriander) and watercress for stir-fries and soups.

Although the plant is tasty from leaf to flower, the most prized part in China is the pale portion at the base of the leaves. Just as French growers exclude sunlight from asparagus to produce tender white stalks, Oriental market gardeners have come up with ingenious ways of "stretching" garlic chives into pallid mild leaves. In early summer, after the first growth of green leaves has been cut close to the ground, the clumps are top-dressed with compost and deeply watered. Then tall terra-cotta cylinders, lidded to block all light, are slipped over them. In a month, blanched leaves fill the cylinders. To try this at home, use a deep overturned clay pot or a section of clay flue tile with an improvised cap. Blanched or green, the savor of garlic chives comes through in any number of cooked dishes. In addition, minced fresh leaves are used in the same ways as chives, taking into account their mild garlic flavor.

Similar to chives in height and habit, garlic chives are as decorative as they are flavorful. In summer, loose umbels of fragrant white stars bloom above the narrow, flat leaves. In a perennial bed, garlic chives are well placed toward the front, where their flowering may overlap with the showy stonecrop (*Sedum spectabile*), known around here as

Garlic chives, also known as Oriental garlic chives, are praised as "a jewel among vegetables" in Asia.

live-forever or frogs' bellies. Both the allium flowers and the sedum's flat heads of reddish blooms encourage congregations of butterflies.

A hardy perennial, garlic chives grow quickly from either a starter plant or seeds. This plant is also an enthusiastic self-sower. To save the work of rooting out hundreds of seedlings from awkward places, we snip away the faded flowerheads before they shatter. Divisions from established clumps, made in spring or fall, soon settle in the garden, and this useful plant is content in ordinary garden soil, in sun or very light shade.

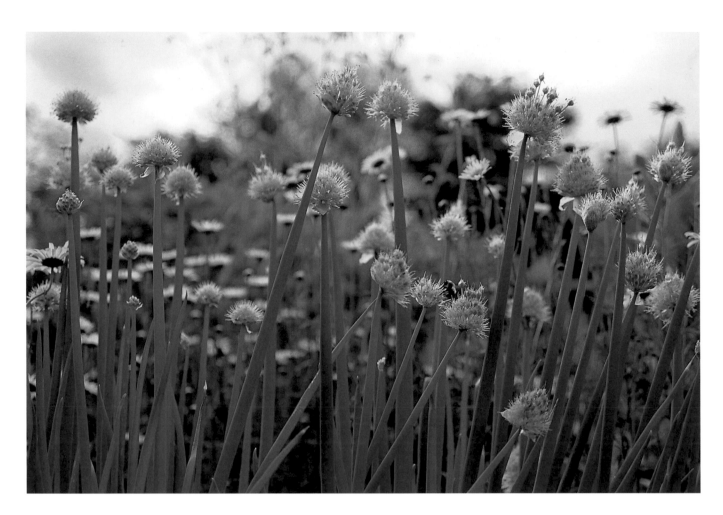

A hardy perennial, the Welsh onion nonetheless needs thoughtful care to ensure its success in the garden, where it is an excellent companion for Jerusalem artichokes, asparagus and rhubarb.

WELSH ONION
Allium fistulosum

A well-traveled species, this onion moved west from Siberia, was dubbed the *welsch* ("foreign") onion in Germany and eventually entered England as the misnamed Welsh onion. Like overgrown chives in appearance, *A. fistulosum* is easily grown from seeds sown in the same way. Underground, you find elongated white onions, like fat

scallions; and above, a bunch of hollow dark green leaves. All parts are used as seasoning in early spring.

Hardy and perennial, the Welsh onion is well placed in a part of the garden growing other perennial food plants—asparagus, rhubarb, Jerusalem artichokes, strawberries and the like. To keep this onion and eat it too, a little thought must be given to its propagation. Come September, break older clumps into individual bulbs and plant these about 4 inches apart in a row or bed. Use some of the fresh green onions the following spring and the next, always leaving a few clumps to multiply for eventual splitting and renewal. The Welsh onion is pretty enough in flower, and its gray-white heads, the size of tennis balls, dry

easily for winter bouquets if hung in an airy shaded place.

WILD LEEKS
Allium tricoccum

This North American native, described by Roger Tory Peterson in his guide to wild edibles as "our best wild onion," is one of the strongest onions, wild or tame. Also known as ramps, wild leeks have ramped in profusion through our local woods and, says Peterson, in forests throughout southern Canada and the northeastern United States. Before maples and beeches bud, before woodland wildflowers appear, deep green leek leaves emerge by the thousands from the rubble of

last fall, a lively sign in the brown and gray landscape.

I'll always associate their pungent scent with chilly April walks up the gravel lane and through a "tree tunnel," where the hardwoods link their upper branches overhead, a stretch I've walked literally thousands of times in the years we've lived on this back-country road. After futile attempts at pulling wild leeks from the ground, I learned to take a strong trowel to pry the tenacious bulbs from the root-woven soil.

To prepare this best of wild foods, wash soil from the leeks, peel off the outer layer of skin, trim away the roots, and wash again. Then simmer in water until tender, drain well, and toss with butter and salt for a simple side

Wild leeks, above and below, "this best of wild foods," are washed, peeled, trimmed and washed again before being simmered in water till tender. Eat them raw if you dare.

dish. Chopped wild leeks impart their flavor to mashed or scalloped potatoes or potato soup with fresh lovage. Pickled leek bulbs are for those who like their food to bite back. Wild leeks also make a delicious topping for pizza.

EGYPTIAN ONION
Allium cepa viviparum

"A vegetable triffid," one visitor called our Egyptian onions, and indeed, this gangling plant, also dubbed the walking- or top-onion, does seem ready to take giant steps across the garden. No other plant proliferates in quite the same way. From the base, a fat stalk arises, hoisting not a head of flowers but a cluster of small bulbs, some of which grow green shoots topped with a second story of bulblets. When the whole becomes too top-heavy to stand, down tumbles the stalk, top-onions and all. Soon, the fallen bulbs root and begin raising a new crop, and so on, ad allium infinitum. Left to their own devices, they pop up hither and yon. To maintain some order, we pluck the bulbs before they topple, break

The Egyptian onion, above and below, is also appropriately named the top-onion or walking-onion for its habit of producing, at the stem tops, clusters of bulbs that topple to the ground and root.

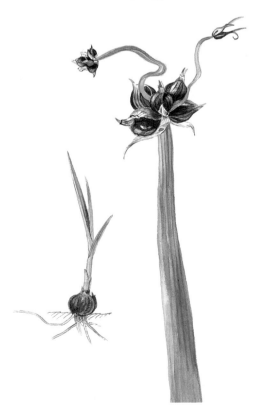

apart the clusters and tuck individual bulbs where we want them—in a nice neat row. Any that escape are troweled up and repositioned.

With little work on the gardener's part, this species provides spring's first fresh green onions. In midsummer, the peeled top bulbs make pearly pickles or an easy seasoning dropped whole into summer ratatouille, soup or fresh tomato sauce. Or anoint them with oil, and roll them around on the grill—but be careful they don't fall through. Start a plantation of perennial Egyptian onions in spring, midsummer, fall or anytime a handful of bulblets comes your way.

GARLIC
Allium sativum

For many years, under the false assumption that this Mediterranean native needed a long, hot season to mature, we grew no garlic, making do, instead, with store-bought bulbs, often shriveled or moldy. Then, one September day, a friend brought us a basket of the best garlic we had ever seen and surprised us with the news that it had been grown not in California but a few miles south. The next day, we returned from the local market garden with enough garlic to plant a 4-by-25-foot intensive bed—and have been reveling in the "reeking rose" ever since.

Garlic is as hardy and as easy to grow as any allium. After years of growing it, I'm still surprised at the generous return for so little work—plant one clove, harvest ten. The best crops grow from a fall planting in reasonably fertile, well-drained soil in full sun. Sometime in September, perhaps after beans have been blackened by frost, we turn a layer of very old cow manure or sifted compost and a dusting of bonemeal into the garlic bed. Whole heads of garlic—either our own harvested that summer or bought locally—are broken apart into individual cloves. Sorting through the cloves, we remove the very smallest and any that are discolored, moldy or missing their protective papery jackets. After raking the soil to a fine texture, we push the best cloves several inches deep into the loose earth. (In heavy ground, trowel out a little planting hole.) We set cloves at 6-inch intervals in rows 8 to 12 inches apart. Depending on the season, thin blades of garlic grass may emerge and grow in fall until

give the garlic bed a wide berth.

Like new potatoes and perfectly ripe tomatoes, fresh garlic is a special treat. Sometime in July, as the pigtail seed stalks emerge, I begin to pull the occasional garlic—the fatter the stem at ground level, the larger the head underneath. The crisp cloves may not be fully formed at this stage but are mild enough to slice raw over a fresh tomato salad or to mince into cucumber-yogurt sauces; pressed cloves, with olive oil and lemon juice, flavor cooked broccoli or beans or go on pizza, bruschetta and the like. Zucchini goes from bland to delectable when sautéed with fresh tomatoes, garlic, tarragon and lemon thyme or basil. The abundant use of fresh green herbs, especially lovage, parsley or celery, helps mute the "sulfurous stink" that is garlic's chief virtue in the kitchen but can be a liability in some company. In any case, fresh garlic has a much fainter aftermath.

Back in the garden, snapping off the curled seed stalks is usually recommended. I've done it both ways—broken them off, left them on—with no obvious difference to the eventual harvest. Nowadays, the stalks are sold fresh as a gourmet item, so why not snap them off for use? Peeled of their thin green skin, the stalks are full of garlic flavor, as are the small bulbs that eventually mature on top—so use the works. Do not, however, plant the top bulblets; cloves from the underground bulb taste better.

As foliage begins to yellow and die back—late July in our garden— it is time to harvest the crop. Left in the ground too long, especially during a spell of heavy rain, the bulbs continue to swell and often split their protective husks. We pull whole plants (putting aside any damaged heads for immediate use)

checked by severe cold, but usually not.

Garlic growers in regions of fickle winter weather—freeze and thaw— often mulch garlic beds with straw over winter, but since consistent snow cover is the winter rule in our garden, we skip this step. As soon as the snow recedes in spring, flat, arching garlic foliage begins to grow strongly. Several visitors have looked at the garlic beds in June and wondered why the "corn" was

Regular garlic, shown here in bud, is exceedingly easy to grow from the largest cloves saved from the previous season's crop.

so far advanced. Some attention to weeding and a deep drink periodically in a droughty season are all that garlic requires for good growth. Since this allium has pesticidal properties of its own, insects

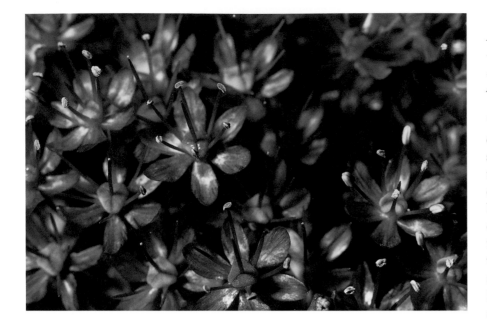

Giant allium in vibrant flower, above, and cloves of wild leek, garlic and elephant garlic, below.

and lay them out in a single layer in a very dry, shady place for a week or so. If they are to be braided—a skill I have yet to learn—the tops are left on. Otherwise, brush soil from the bulbs, and with pruning shears, trim roots close and cut shriveled tops to within an inch or so of the bulbs. Stored in open baskets in a cool, very dry place, garden-grown garlic should keep firm and fresh for months.

Today, as in times past, garlic excites either ardent admiration or definite repugnance. Few plants are as lauded in the old herbals, few as damned. "When Satan stepped out from Eden after the fall," says one ancient legend, "garlick sprang up from the spot where he placed his left foot, onion where his right foot touched."

And several centuries ago, English herbalist John Evelyn pronounced a complete censure of garlic: "We absolutely forbid it entrance into our Salleting, by reason of its intolerable rankness, and which made it so detested of old. To be sure, 'tis not fit for Ladies Palates, nor those who court them."

Times have changed. I suspect that more than a few romantic liaisons have begun over a shared dish of garlic-laced Caesar salad or garlic chicken. "In Spain," Evelyn did admit, "they eat Garlick boil'd which taming its fierceness turns it into nourishment, or rather medicine." It is in part for its medicinal properties (both preventive and curative) that garlic has long been and continues to be praised. Isn't it grand—something that is a pure pleasure to eat and good for you in the bargain.

ELEPHANT GARLIC
Allium scorodoprasum

"Produces huge bulbs, sometimes exceeding one pound each; flavor is sweeter and much milder than regular garlic," rhapsodizes one herb catalog of elephant garlic. Sorry, but I have not been impressed with either the flavor or the growth of this allium. Planted side by side with our crop of regular garlic, the supposed giant failed to mature larger bulbs, and to my taste, a disagreeable bitterness underlies the faint garlic flavor. The off-putting taste disappears with cooking, but then the bulbs are bland. We maintain a small stock of elephant garlic in a corner of the vegetable garden for the sake of the round, lilac-tinted flowerheads that appear in late summer and dry easily for winter bouquets, but I would never trade our patch of the real thing for this disappointing novelty.

SHALLOTS
Allium ascalonicum

So often are these small alliums linked with gourmet fare that ordinary gardeners may be excused for assuming that they must require as much effort to grow as pale Belgian endive or white asparagus. The fact that shallots seldom crop up in markets, and always at a premium price, keeps alive the illusion that this is a difficult bulb to grow. Not so. Nothing to it but to push single "sets"— longer and fatter than onion sets and covered with papery, pinky brown skin—into loose, fertile earth up to their necks, about 6 inches

apart. Early spring is the usual planting time, but shallots are hardy enough to be fall-planted like garlic and will sail through winter safely if snow-blanketed or mulched. High-rise gardeners should know that shallots can be successfully culti-vated in containers, six bulbs to a 12-inch pot. One shallot bulb yields an aggregate of 6 to 10 in a season. Harvest this care-free crop in late summer as the tops yellow and begin to dry, and lay the clusters in the sun for several days to cure. This process is especially important if one hopes to keep shallots free from mold for any length of time. Stored in net bags or open baskets in any dry, cool and airy place, shallots should keep until spring. The taste of shallots has been described as "an ideal blend of onion, garlic and scallions." In France, where they are widely used in cooking both haute and du jour, each region has its own prized shallot variant. On this side of the water, we make do nicely with a generic "French shallot"—but note that shallots are distinct from yellow-skinned multiplier onions sold by the bagful alongside plain old onion sets in spring.

Ornamental Onions

Ornamental onions—the host of alliums grown for their im-pressive flowers—are not herbs in the true sense. But they are somehow "in keeping" with the spirit of a herb garden. Their muted colors blend beautifully with the silver-grays of artemisias and sages; among old-fashioned roses, a traditional denizen of herb beds, the allium globes hover with fine effect. Flowering onions may also share some of the insect-deterring proper-ties of garlic and chives, helping to keep roses free of aphids or chasing some other small plant predators from the garden.

Allium christophii
(formerly A. albopilosum)
Even if it had no pesticidal prop-erties and did nothing but be its

The "space-age" *Allium christophii*'s outrageous good looks make it a welcome garden comrade.

lovely, outrageous self, we would still grow this plant. The literal translation of the old Latin sur-name is "white and shaggy." To my eye, this onion appears to be from another world, a sort of vegetable alien. Its six-pointed star-shaped flowers, looking as though they've been cut from some ghostly lilac-tinted metal, radiate from a com-mon center to form large, gleaming globes that seem ready to hurl sky-ward. Our space-age alliums grow with a colony of old-fashioned roses, swaying foxgloves and sprightly coralbells, the whole a blaze of pink, white, crimson and lavender for many weeks in July This picture was borrowed from Vita Sackville-West's famous garden at Sissinghurst Castle in Kent, Eng-land. A sunny corner of any garden can achieve a similar flowery juxta-position—one rose, a couple of fox-gloves and a handful of alliums.

Allium aflatunense
Don't let the botanical name put you off. Less otherworldly than

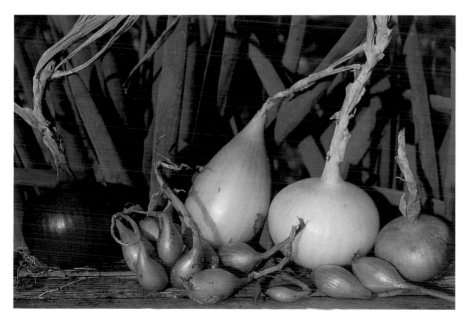

Shallots, nestled in front, enjoy a more sophisticated reputation than their relatives.

A. christophii but just as striking, this ornamental onion is one of late spring's best gifts, with grapefruit-sized spheres of tightly packed lavender stars swaying atop 3-foot stems. Of them all, this is my allium of choice for several reasons. It blooms in the lull between the departure of spring bulbs and the arrival of June's colorful crowds. Flowers last in good condition for up to three weeks, and even after the blooms fade, the heads remain round and decorative. And this allium increases generously from year to year. Gardeners who find its color a trifle weak might like the darker shade of 'Purple Sensation.' In our garden, both grow in front of pink honeysuckle shrubs in a close harmony of pink and mauve, with a neighboring patch of pearly Florentine iris, source of the herbal fixative orrisroot. This allium is at home anywhere in sun or light shade, and few gardens are too small for its slender growth. One caveat: If the seedheads are left to dry and shatter, countless little onions will spring up everywhere, adding an extra job of weeding to your workload—off with their heads before they seed.

Allium giganteum
Resembling 'Purple Sensation' but much taller and larger altogether, this July species is native to high Himalayan slopes. I would like to see the giant onion increase or at least maintain its original numbers in our garden. But for some reason, whether lack of hardiness (doubtful in a Himalayan) or some quirk of diet (what *do* giant onions eat?), the big fellow frequently stalks off after one season of bloom or waves a few pale tantalizing leaves as a reminder of past glory. As befits a behemoth, the bulbs are too expensive to be treated as annuals. All things considered,

the reliable and much cheaper *A. aflatunense* (the price of one *A. giganteum* will buy a dozen of the lesser) is a fit substitute for the inconstant giant. But our experience may not be typical, and an experiment would be worthwhile for the sake of the splendid lilac-colored balls of bloom towering at the back of a sunny herb bed or waving in light shade amongst ferns and wildflowers.

Recently, several named allium

The lilac-colored blooms of *Allium giganteum* 'Lucy Ball' make a bold if madcap statement in the garden.

cultivars—'Beau Regard' and 'Globemaster'—have appeared on the scene. Shorter than *A. giganteum*, both flaunt impressive rosy lavender flowerheads, round as small cantaloupes. We tuck the big bulbs, a foot apart, close to gray-leaved herbs,

The nectar of a garlic flower draws a female ruby-throated hummingbird to feed and pollinate.

such as *Artemisia* 'Lambrook Silver' or 'Powis Castle,' or behind 'Moonshine' yarrow so that the allium constellations hover dramatically above the veils of silver and their bare stems and no-account leaves are partially obscured. Expensive when first introduced, these alliums have come down in price as supplies have increased. How gratifying it is to watch one costly 'Globemaster' bulb turn into six or eight over the course of three summers.

Allium moly

From the tallest, we come to a virtual dwarf. Standing just 8 inches high, *A. moly* trades the usual rosy purple of the clan for bright yellow. This inexpensive, hardy bulb can be drifted along the edge of a sunny herb bed, perhaps fronting the glowing violet of *Salvia nemorosa* 'East Friesland,' best of the ornamental sages, or massed in dappled shade beneath shrubs. Both the bulbs and leaves of *A. moly* are strongly garlic-scented,

an odor that is undetectable unless the parts are crushed. Flowers appear in June, and although this pretty allium does not self-sow, the bulbs make a steady increase.

Dubbed golden garlic, *A. moly* has lived in gardens for centuries and has always been considered one of the best floral talismans. A black cat may cross your path, you may walk under ladders and do what you will on Friday the 13th, if only golden garlic grows in your garden. And, the teller of the tale goes on to say, many gardeners are unaware that the presence of this "assiduous vegetable" is responsible for their "astounding good fortune and prosperity." No credit, though, to the plant catalog that has assumed the right to rechristen golden garlic 'Sunny Twinkles.' Besides being confusing, this tampering with names strips away the pleasant association with gardens and gardeners of the past.

Allium sphaerocephalum

Globe-headed garlic blooms in July and carries many walnut-sized heads of deep-wine-colored flowers on thigh-high stems. An overlooked treasure, this showy plant—pretty with pink baby's breath, among yellow daylilies or anywhere in the sun —is easy to grow, good for cutting and drying and inexpensive enough to mass.

Allium karataviense

The best feature of this eye-catching native of central Asia may be its decorative broad foliage, blue-green edged with red. Softball-sized flowerheads of pale lilac,

nearly gray, appear on short stems. Our bulbs grow well and seed freely in almost pure gravel.

Allium caeruleum

The only blue-flowered onion I know, this slender 2-foot allium is not as strong-growing as its kin. Our dozen bulbs have not increased—in fact, may even have dwindled—over the years. Still, it is worth planting for its clear color, best appreciated when the bulbs are set only a few inches apart in a close group.

Easy to cultivate, ornamental alliums make few demands on a gardener's time or skills. All are planted in fall, like any tulip or daffodil. Set larger bulbs deeper than smaller ones; a covering of earth twice the height of the bulb is a simple rule of thumb. Like their edible counterparts, these alliums revel in a light, warm, well-drained soil enriched with old manure, compost and such. Once bulbs have grown crowded or when you want to increase a favorite kind, September is the month to lift and split clumps for redistribution.

Compared with dividing other perennials, handling alliums is a light task: Clumps come out of the ground readily and practically fall apart into individual bulbs as you lift them. With their unique flower shapes, gentle colors and range of heights, flowering onions add interest and distinction to any garden.

Alliums: a family resemblance.

Salad Days
Leafy herbs

A friend tells the story of how the weed inspector, on the lookout for noxious thistles and pigweed on the edge of farmland, visited her carefully tended suburban garden. "Everything's fine," he said, after looking around, "but you'll want to get rid of that mustard."

"Get rid of it?" she countered indignantly. "I planted it."

In an attempt to set down a herbal "who's who," one writer suggests that "quasi-vegetables, herbal weeds and medicinal whatnots are not herbs and never will be; clumsy food plants, curlicue salad messes and roots belong in the kitchen garden and not with the herbs." The following greens—arugula, cress, mustard and such—might well be considered "quasi-vegetables" and "curlicue salad messes"; but they can also be thought of as herbs, because all are far too spicy to be primary "saletings." Like other herbs, they are used as extras, adding unique, concentrated flavors to salads composed of milder ingredients.

MUSTARD GREENS AND MIZUNA
Brassica juncea

To most people, mustard is a tart yellow condiment for burgers and sandwiches, made from mustard seeds ground coarse or fine. But the same plant that yields seeds, and a few of its relatives, may be grown for spicy leaves that impart bite and piquancy to salads and stir-fries. All mustards are part of the *Brassica* genus, a group that includes broccoli, cabbage, cauliflower, kale and turnip. Leaf mustards appear in several shapes, textures, sizes and colors. For variety, look for: 'Green Wave,' with tall crinkled leaves; 'Florida Broadleaf,' plain and wide; 'Southern Curled,' with frilly bright green leaves; 'Green in Snow,' extra hardy for fall picking. 'Red Giant' and 'Osaka Purple' are veined and tinged with dark purple, a color contrast in green salads. "Florida"

and "Southern" remind us that in the Southern states, mustard (along with the related collards) has traditionally been appreciated as a "boiling green," slow-cooked with pork in some form. For cooking, leaves may be left to grow large and pungent; simmering mellows their hot taste. But for salads, mustard is best picked small. Mustard greens can be grown on their own or mixed with seeds of lettuce, endive, chervil and chicory to add spice to mesclun mixes—salad greens sown thickly in spring and cut with scissors when small and again (and again) as they regrow.

If you wait until the end of May to sow mustard, you'll miss its best season. Quick-growing and cold-resistant, it is always the first thing we seed in spring. The day after the snow goes—in late March or early

Salads have moved from predictable portions of chopped iceberg lettuce to delectable snipped greens of all descriptions.

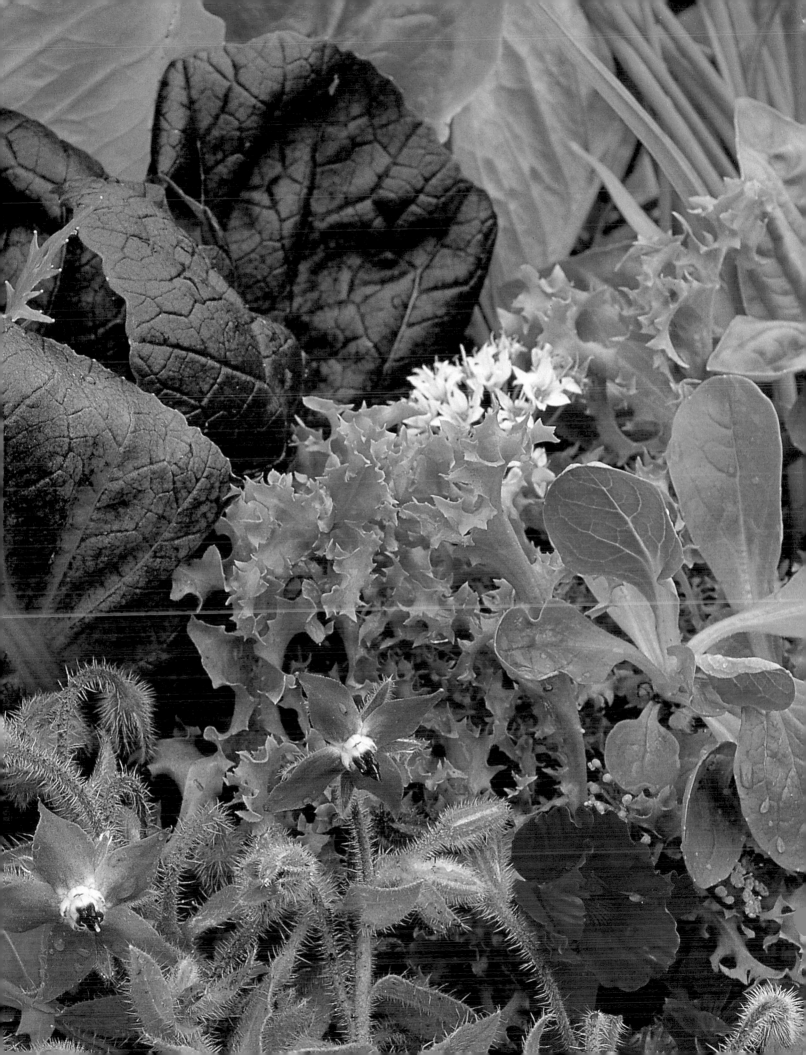

A salad for the picking: Gardeners can have fresh ingredients at hand all spring with successive harvests of mustard spinach, mizuna leaves, miner's lettuce and cress.

April—we haul out a cold frame and sow mustard seeds; by daffodil time, the frame brims with peppery greens. At the other end of summer, a mid-August sowing yields an October harvest. Early and late sowings are the best way to outwit flea beetles, hungry small bugs that perforate mustard (and other leaves) with small holes in warmer weather. Mustard is a good herb to broadcast, scattering seeds thickly (but not solidly) over a well-cultivated, enriched square of soil. Otherwise, plant a couple of seeds per inch in shallow furrows a hand span apart; and thin seedlings to several inches apart. Frequent waterings make for juicy milder leaves, although mild is a relative term when applied to mustards, since all have a burn to them. Mustard greens are at their best for salads when under 6 inches tall. To harvest, break off outer leaves or cut whole plants about an inch from the ground; cut plants will regrow rapidly. Pick leaves as long as they are tender and not overly hot, but when the plants begin to send up seed stalks, pull them to make room for something else. Mustard greens grow tough and hot in the heat of summer.

Odd how one culture or region passionately adopts a particular food plant, while in other places, the same plant is virtually unknown. Lacking a common English name, mizuna (*B. j.* var. *japonica*) is so commonplace in Japan that the Chinese call it Japanese greens. Milder than other mustards, mizuna also looks different, with its white stalks and finely cut green leaves. So feathery and pretty is this low herb, some gardeners plant it as a decorative edging. Among the many greens widely used in Oriental cooking, peppery mizuna leaves are an excellent addition to salads in early summer and again in fall. The plant is so cold-tolerant, it stands in the garden green and fresh long after lettuces are past.

ARUGULA, or ROQUETTE
Eruca sativa

Also called rocket or rugola, arugula is a sharp-tasting salad herb, absurdly easy to grow and hardy even into the Far North. For a long harvest, sow seeds of this cabbage cousin at various times: first thing in spring and a few weeks later for May/June picking and again in mid-August for eating in fall; a late-October sowing gives you small seedlings that may well survive the winter for salads in early spring. Seeded whenever, arugula leaves are ready to pick a month later.

Like mustard greens, arugula is a favorite forage for flea beetles, and leaves can become riddled with holes within a few days.

For the earliest crop of undamaged leaves, sow in a cold frame (as for mustard) weeks before you would normally consider planting in the open; or cover the bed with floating row cover, a sheer spun fabric that admits light and water but keeps out flying insects. To extend the picking, remove the outside leaves from each plant, allowing the centers to grow. Toss the leaves with other early salad fixings, or use roquette as a substitute for watercress. Remember, though, that this quick-growing herb rockets past pleasantly spicy to unbearably hot in the blink of an eye—taste a little

Arugula, underplanted with milder-tasting purslane, above, and illustrated at left, has a flavor that quickly "rockets" from mildly spicy to unbearably pungent in hot weather.

before you add handfuls to a salad.

By mid-June, arugula plants (along with spinach, mustard and other early greens) respond to the lengthening days by going to seed. If you don't mind some randomness in the garden, let a few plants flower, set seed and self-sow; half-wild arugula will spring up around the garden for years to come—a bit of work saved, a free harvest.

CRESS

The various cresses are cousins of mustard in the large botanical family Cruciferae, a name that refers to the four-petaled, cross-shaped, or cruciform, flowers of its members. Like mustards, with which they are often teamed in British salad making, cresses have a hot, peppery taste that sparks up milder salad greens. Cress is a cool-weather herb, best sown several times in early spring and again in mid- to late August. Hardy and quick-growing, it is ready for the salad bowl within a month, even before arugula. Curly cress is as frilly as parsley and just as pretty a garnish. Plain cress is less ruffled, while the leaves of broadleaf cress are wider and flat. Cress is best sown broadcast fashion, scattering the seeds over a square or strip of ground so that they land close together but are not dumped in clumps; cover lightly with fine soil. The harvest begins when the leaves are a couple of inches high; and scissors are best for snipping the greens close to the soil. Before long, new growth will appear, making four or five cuttings possible. When the leaves grow too tough and hot, turf out the plants to make room for something else. If you don't need the space, allow cress to flower and seed; collect seeds for next year, or grind them as a pepper substitute.

Known to early settlers as peppergrass, cress is packed with vitamins and minerals, as potent as any pill. In medieval monastery gardens, this low plant was prized as a medicinal herb. Modern science confirms that all the dark green vegetables, and especially brassicas and related

A fairly coarse plant that resembles arugula and tastes like watercress, upland cress can be grown throughout the season but does best in spring and fall.

plants, guard the body against disease and infection.

The foregoing cresses do well when sown in a flat of soil in a sunny window indoors. But upland cress (*Barbarea verna*) is for the outdoor garden only. Much like arugula in appearance and watercress in taste, it can be grown in the absence of running water—that is, in almost every garden. Sometimes called winter cress, it often survives the winter in temperate areas. In any case, it may well be the only salad green still standing in the garden on December 4, the feast day of St. Barbara, from whom this hot

herb takes its genus name. The name scurvy grass bespeaks the plant's high concentration of vitamin C.

Like all our spicy salad herbs so far, upland cress grows best in spring and again in fall; a whole salad can be made of the mild leaves that develop in cool weather. In summer, it turns almost unbearably hot—taste a leaf to determine how much (if any) to use. Scatter seeds in bands about a hand span apart, sowing every second week during April and May; sow again in August, and you'll be picking nutritious leaves until the snow flies— frost-hardy seedlings thrive in the cool October days. With luck, upland cress will overwinter and yield early greens the following spring before running to flower.

PURSLANE
Portulaca oleracea

The 19th-century radical (and early food snob) William Cobbet reckoned that purslane was a "mischievous weed" eaten by "Frenchmen and pigs when they can get nothing else." A contemporary writer, on the other hand, describes purslane as "a delight, a thick, juicy, leafy green as delectable and as eagerly awaited as 'Sugar Snap' peas." The plant's aquatic look may have given rise to the common name Indian cress, although Samuel de Champlain noted that the native people of Maine, where "purslane grows in large quantities among the Indian

One of the most popular of the cultivated purslanes, the heat loving 'Goldgelber' has thick, very pale yellow-green leaves about the size of quarters.

corn," took "no more account [of it] than weeds."

Weed or wonderful salad plant— take your pick. The weedy version can be found in many gardens, where wild purslane, a quick-growing annual, spreads its succulent reddish stems over open sunny ground; easy to pull up, it proves the old maxim, "One year's seeding means seven years' weeding." Cultivated purslane, by contrast, grows into short upright clumps of larger leaves; look for the cultivar 'Goldgelber' (from The Cook's Garden in

Vermont) for good-sized, yellow-green rounded leaves. Garden-grown purslane, as opposed to the sharp-tasting one that grows in your garden whether you want it or not, is mild, almost bland—"snow peas infused with lemon."

Native to India, purslane defies drought and thrives in a hot, sunny site, traits that set it apart from our cool-weather mustards and cresses. Several sowings are not necessary; seed once around the frost-free date for a summer-long harvest. Broadcast the small seeds, unmixed with other greens, in a sheltered bed of light well-drained loam, where the sun beams down all day, and cover lightly with fine soil. Seedlings appear within a week and are thinned after several weeks to stand 2 inches apart. Later, as plants branch and grow taller, begin to pick by shearing or pinching back stems and leaves. A final thinning to 4 inches gives bushy purslane all the room it needs for the rest of the season. Some gardeners use this pretty herb as a soil-holding groundcover to prevent washout along the edges of

Unlike its cultivated relative, wild purslane, above, is low-growing, with small, round, meaty green leaves. Facing page, the succulent moisture-craving watercress.

raised vegetable beds. Slugs are the only pest that may bother purslane, and then only in damp weather and in cool, heavy soils—not the best place for it to be. Delicate purslane stores badly, so pick it for immediate use, adding the mildly citrusy leaves to mixed salads or stir-fries.

WATERCRESS
Nasturtium officinale

Watercress is among my favorite salad herbs. Water-crisp leaves are sharp and peppery and, if grown in fresh-flowing water, always succulent and clean-tasting, never hot or bitter. We have tried to grow watercress in our dry garden several times, going to some trouble to prepare a special spot of rich soil near

the pump or under a faucet, only to harvest a few pale shoots and then watch the plants disappear during the heat of summer.

Now we look for a free harvest from the wild. Like asparagus, watercress lasts for four to six weeks in late spring. One of the best wild foods, it grows thickly along the margins of shallow streams in many places. I've picked it from the mouth of a large metal culvert that keeps a spring-swollen swamp from flooding the road; and in another place, watercress hangs in heavy green mats from the sheer face of a high limestone cliff—a piece of the Niagara Escarpment—just where a spring seeps and trickles from the rock crevices. Since watercress absorbs whatever is in the water, foragers should find out what is going on upstream. Avoid gathering watercress from areas where beavers are plentiful, since the water may be contaminated with giardia, the so-called beaver-fever bug.

Chinese cooks stir-fry watercress or simmer it in soup, but there must be some technique to it—any I've cooked has become stringy and unpalatable. Watercress sandwiches, de rigueur in England, are very refreshing in their crisp simplicity. In late May, nothing could be finer than a salad of young spinach, early leaf lettuce, crisp radishes, green onions and lots of peppery watercress tossed with a simple oil-and-vinegar dressing well flecked with chervil. What could be better for you? Rich in minerals, tonic watercress is also a famous antiscorbutic —a potent source of vitamin C.

Tea Leaves
Herbs to blend and brew

Larkwhistle Garden grows a score or more of tea herbs. Many a morning, from May to October, we take the teapot into the garden and loosely fill it with an impromptu blend of fresh herbs—mostly leaves, but sometimes seeds or flowers. One day, it may be a citrus-sweet mixture of lemon balm, lemon verbena and anise-hyssop leaves, with sprigs of peppermint and green seeds of sweet cicely; the next, a tonic, slightly bitter brew of sage leaves combined with a few flowers of common yarrow. A favorite blend includes lemon balm, spearmint and orange mint as the dominant flavors, with a leaf of sage for depth and a few leaves of sweet cicely for sweetness. Into the pot go calendula flowers, the fragrant petals of old-fashioned roses, leaves of scented geraniums or spikes of lavender. In the evening, we may have a sleepy tea of catnip leaves and chamomile flowers, with a little mint to temper the medicinal edge. And sometimes I brew a bouillon-like tea of parsley, lovage and savory leaves, with dill seeds and chive blossoms; a few drops of tamari lend saltiness and more flavor.

Blends vary with the seasons. Summer teas may include lemon or cinnamon basil with leaves of tender tropical sages—pineapple and fruit—and a snippet of scented geranium. Seldom is one pot of herb tea just like another. But besides their endless variety, herb teas have a lot going for them. They are homegrown and hence free of pesticides and other chemicals routinely used in the raising, processing and packing of commercial herbs. They cost nothing beyond the price of seeds or starter plants; and best of all, the tea plants themselves are among the easiest in the garden to grow.

MINTS
Mentha spp

Growing with such abandon that they need occasional restraining, mints are pushy plants that move in on neighbors by surface runners. Even so, most gardeners make room for mint because no other herbs hold such cool refreshment in their leaves. Peppermint brews a classic herb tea, the one everybody

Facing page, mints are excellent tea plants, but varieties such as curly mint, spearmint and peppermint, left, may need containing.

knows. But judging by the surprised reaction of garden visitors to a whiff of fresh peppermint, few grow the true plant, *M. piperita*. Smelling like the traditional red-and-white-striped candy cane, peppermint is also sold as candy mint. It is sometimes labeled black peppermint in reference to its purple-brown stems and top leaves suffused with violet. Still, it is wise to taste this herb before buying; a nibble or an inhalation of peppermint fills the mouth with mentholated coolness as it opens sinuses and clears the head.

Peppermint is a hybrid plant. As one herb catalog explains: "Seeds sold as peppermint are never true to name; quality strains can be grown only from cuttings or divisions." Like all mints, peppermint will cover a wide swath of ground where conditions are right. Given that one of its parents is water mint (*M. aquatica*), a vigorous plant that grows beside streams throughout Europe, peppermint thrives in rich, moist loam. A little shade is fine in hot gardens, but given enough water, this best of tea herbs flourishes in full sun.

All herbalists agree that the active constituents of peppermint act on the digestive system. The tea or peppermint oil, which contains about 50 percent menthol, is often recommended to allay stomach cramps, nausea, abdominal pains and the like. "Peppermint," said Jethro Kloss in his 1939 book of herbal medicine, *Back to Eden*, "will stimulate like a glass of whiskey." Unless you change his "like" to "in" and make yourself a mint julep, this is an overstatement. Still, several people have told me they cannot take their mint tea strong and straight ("Goes right through me"). Overdone, peppermint tea can be a potent drink, but brewed right, it

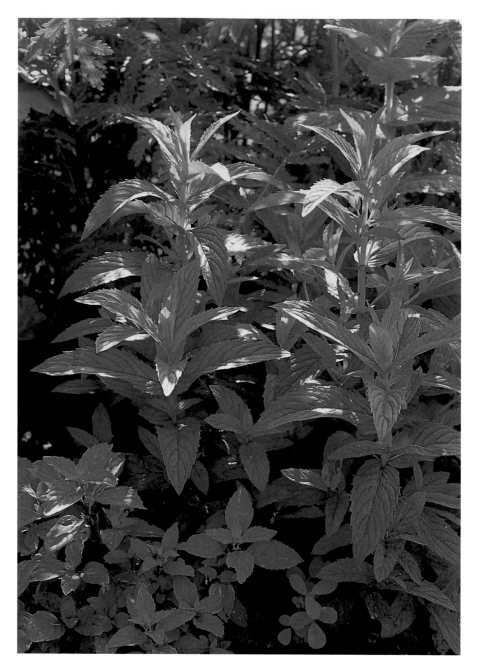

Growing side by side in the garden, ginger mint and apple mint, like all mints, are care-free, bug-free and rapid runners. Once established, they're yours for life.

is delightfully refreshing. Six to eight fresh peppermint leaves or a pinch of dried is enough to brew a pleasant tea for two.

Peppermint's other parent, spearmint, is far more common in gardens. It can be distinguished from peppermint by its leaves. Uniformly green and pebbled, spearmint leaves are toothed along the margins and longer and more pointed—spiked, as the Latin *M. spicata* tells us—than peppermint leaves, which are rounded and smooth-edged. Southerners call spearmint julep mint; and the names lamb mint and pea mint indicate that this is

the one for general culinary use in mint sauce and jelly or minced and sprinkled over boiled potatoes, steamed carrots or fresh peas. A little spearmint clipped into yogurt-based salad dressings or added to the handfuls of parsley in tabbouleh is a cooling touch.

As a herb tea, spearmint is milder than peppermint and blends well with other herbs, such as anise-hyssop, chamomile, lemon balm or sweet cicely, where peppermint would overpower. Curly mint (*M. spicata* 'Crispa') is a pretty variation of spearmint, with leaves twisted, waved and crimped at the edges. Gardeners with limited space might prefer to grow curly mint for the sake of its decorative foliage. In our garden, curly mint never succumbs to the spotty fungus disease that sometimes bothers other species.

Different from the rest is orange mint (*M. citrata*), with a fragrance

Sometimes called American apple mint, the shade-loving ginger mint also has a hint of tangerine.

of eau de cologne. Also called bergamot mint, its scent is like that of bee balm, or monarda, a mint relative. Orange mint is too perfumed (for my taste) to make good tea on its own, but a few sprigs add a distinctive bouquet to a blend that may include lemon balm and anise-hyssop. Broadly heart-shaped leaves and a unique "nose" identify orange mint.

For sheer beauty of leaf, no mint can match the variegated form of apple mint (*M. suaveolens* 'Variegata'), also called pineapple mint. Woolly pale green leaves smelling of apples and spice are decoratively blotched and bordered with cream and white. Not as invasive as some mints, pineapple mint is an easy 3-foot herb for massing in a lightly shaded corner where height and highlights are needed. I have seen it growing prominently at the front of English perennial beds as an effective foliage accent—just keep an eye on its roving roots. Although they impart some flavor to herb teas, both apple and pineapple mint lack the characteristic cool mintiness of the others.

Equally decorative is golden ginger mint (*M. arvensis* 'Variegata'), sometimes called American apple mint. (Given the many and similar common names, it is easy to see how useful the Latin can be.) Smaller, serrated, dark green leaves are shot through with yellow and cream. Instead of ginger, my nose picks up a scent of tangerine. In our garden, ginger mint grows at the side of a concrete watering pool, where it seems to like the shade and dampness.

Considering how fast they run, mints are the easiest plants to propagate. Any shoot eased from the ground is likely to have a few roots attached; planted firmly in a new

Apple mint and its variegated form add visual diversity to the garden, although neither plant contributes mint's signature "cool mintiness" to tea.

place, it soon takes hold and starts to travel. Gardeners go to great lengths to confine mints: sinking sheets of metal—license plates and the like—around a patch, hauling old tires into the garden or planting in containers of all sorts. Our choice for containing mints is wooden half-barrels. Made to age whiskey or wine, they are roomy and nonporous; filled with rich soil and compost, they hold the moisture that mints crave. One half-barrel comfortably grows up to three varieties of mint for a season—but with fast-spreading mints, there's always some work involved.

We want a lot of peppermint for drying but do not want to tie up garden space with its roving roots. Every spring, we plant up a half-barrel with peppermint alone. Over

replant them in the half-barrel; the remaining roots are passed along to other gardeners or tossed someplace where there is no danger of their rooting and running. In milder areas, mint could be left in a barrel over winter but will still need lifting and splitting in spring. One half-barrel of peppermint yields enough dried leaves to make mint tea for the next eight months.

With mints, you can have your tea and bathe in it too: The long branches of any fresh mint swished vigorously back and forth in a tub of hot water, then left to swirl under the faucet, make a refreshing, fragrant bath; or simply empty a teapotful of strong minty brew into the tub. The practice is an old one. John Parkinson, apothecary to King James I and author of two 17th-century herbal classics, wrote, "Mints are sometimes used in the bath with balm and other herbs to comfort and strengthen the nerves and sinews." Since mint is a reputed anodyne—an agent that soothes pain—and is also recommended to relieve itchy skin conditions, a mint bath may be as therapeutic as it is pleasant.

CATNIP
Nepeta cataria

A well-known stimulant to cats, the freewheeling catnip *Nepeta cataria* grows enthusiastically in the garden and can be brewed into a relaxing tea.

the summer, its tightly woven surface runners spread to the barrel's edges—and sometimes over the top, as if sensing earth below and freedom to roam. Come October, after the leafy stalks have been cut and dried, we pry the whole tangled mass of roots out of the barrel with a spading fork and carry it to an out-of-the way corner of the vegetable garden. There, the circle of roots is dropped intact into a shallow "basin" large enough to hold it and is covered with about 3 inches of soil. In spring, as the mint begins to sprout again, we slice away four or five lively small segments and

Although we have never planted catnip, it has always been in the garden. Cats writhe and revel in patches of *N. cataria*, a coarse, sprawling herb that springs up around barns, in vacant lots and in neglected corners of the garden. We leave a plant or two to fight it out with the raspberries and harvest the leaves to brew, fresh or dried, into a soothing herb tea. Just *how* soothing, I learned one summer after-

noon. After drinking a cup or two of a fairly strong brew, I felt myself growing increasingly drowsy, until I could barely keep my eyes open and had to curl up for a catnap. A herbalist friend tells me that herbs (like catnip) which are stimulating to animals have the opposite effect on humans and suggests that harmless catnip tea be given to hyperactive children before bed in place of nerve-jangling chocolate drinks.

CHAMOMILE

Chamaemelum nobile;
Matricaria recutita

A sprinkling of seed scratched lightly into any piece of sunny ground in spring will provide chamomile in perpetuity. What you sow, you reap: either the creeping perennial Roman chamomile (*C. nobile*, or *Anthemis nobilis*), a colonizing species that grows so thickly, it has been used as a groundcover for paths or as a lawn substitute—"so that being trod upon, the scent is set free to regale and invigorate the passerby"; or the annual German chamomile (*M. recutita*, or *M. chamomilla*), sometimes judged better for tea.

We grow annual chamomile—or rather, it has grown itself for years—with no attention except thinning (to 3 inches apart) the dense crop of fine-leaved seedlings that springs up every season; that and weeding out their increasing kind from the paths (maybe we should leave them) and from the crowns of low perennials edging a bed opposite. It may be wise to grow chamomile (both the self-seeding German and the creeping Roman) in the vegetable garden, perhaps at the end of an intensive bed or in a corner,

For a pleasant mellow brew, mix chamomile, shown below, with spearmint or lemon balm leaves.

where seedlings can remain undisturbed. Grown near other small herbs or perennials, the seedlings soon become a nuisance, lodging where they will.

There is but one difficulty associated with chamomile: Harvesting the flowers is like picking wild strawberries—it takes forever to gather a handful. This is leisurely work for a sunny Sunday morning, when one is content to sit in the chamomile patch, under the shade of a wide-brimmed hat, and just pick. A friend suggests that a scrupulously clean comb with widely spaced teeth can be gently run through a patch of chamomile to snap off the tiny blooms. We first harvest chamomile flowers when the patch looks to be in full flower, taking small button buds, the wide-open flowers and everything in between. Soon, this generous herb is full of blooms again; three or four succes-

sive pickings are possible if patience persists. To dry chamomile flowers for tea, spread them in a single layer on a screen in an airy, shaded place protected from rain or dew, stirring and turning every few days until the flowers appear desiccated. Then store for a while in a punctured paper bag to ensure that drying is complete, lest the bulky flowers mold in closed jars.

In preparing chamomile tea, it is easy to oversteep the flowers past pleasant and fruity to bitter; equal parts chamomile and spearmint or lemon balm leaves make a more mellow brew, and a scant teaspoon of dried chamomile makes a cup of tea. Once dubbed "the plant physician," chamomile produces one of the most venerable herbal brews, long popular in the home medicine chest to soothe and strengthen stomachs and to calm restless or feverish children. In her book *A Modern Herbal*, published in

1931, Maud Grieve said of the plant, "It has a wonderfully soothing, sedative and absolutely harmless effect." This is another herb tea to pour into bathwater, and a little can be reserved for rinsing the hair to bring out highlights.

Chamomile has a reputed influence not only upon "frail humanity in distress," as one herbalist put it, but also upon other plants; grown near "weak or ailing plants, [chamomile] exerts a strengthening influence." Cooled tea sprayed over a flat of seedlings or dried chamomile flowers scattered among them is said to reduce the risk of damping-off, a fungus that can lay low a batch of small plants in short order.

BERGAMOT

Monarda spp

While chamomile makes the best of lean, dry ground full of sand and stones, bergamot demands moist, fertile soil. A herb of many names —bee balm, monarda, Oswego tea—*M. didyma* is a favorite of ours on several counts. The stalks, flowers and leaves (and roots, says one writer, although I have not investigated the claim) smell deliciously of oranges and spice. In a tea blend, the leaves impart a special bouquet, similar to the flowery essence that pervades Earl Grey tea. Bergamot is a North American native. In 1744, so the story goes, Virginia farmer and amateur botanist John Bartram collected seeds from stands of red bergamot found growing near

One of the most decorative of the tea herbs, bergamot is often grown strictly as an ornamental for its gorgeous colors.

Oswego, New York; both the town and the tea received their names from the Oswego aboriginals who lived in the region and used several species of *Monarda* to flavor their food. Bartram sent seeds to English horticulturist Peter Collinson, who recorded that "plants flowered the next year, and by 1760, there were plenty in Covent Garden Market."

More than two centuries later, there are plenty in our garden too, and I wouldn't want it otherwise. Crowns of tubular flowers, sometimes one atop the other, bloom in shades of violet, purple, pink and red; for curious gardeners, seeds of the 'Panorama' strain flower in a range of colors the first season. Better, though, are the named varieties: 'Croftway Pink' is well named, while the hot-pink 'Marshal's Delight,' a mildew-resistant Canadian introduction, shows up well in a perennial bed amidst lilies, lavatera, Shasta daisies and veronicas. After two decades, I'm still partial to 'Cambridge Scarlet,' its glowing red crowns always alive with hummingbirds performing their aerobatics. 'Gardenview Scarlet' is said to be less prone to mildew. Bergamot colors for weeks in July and early August. I often find a corner of the garden that would be brighter for a planting of bergamot, perhaps beside a cloud of baby's-breath or in front of the towering blue spires of delphiniums or aconite. With tall lilies and warm-toned daylilies, red bergamot makes a fiery picture, while the deep purples of 'Prairie Night' and 'Violet Queen' are lovely with yellow gaillardia or yarrows.

If its few needs are met, bergamot is more than willing to lend its color to a garden picture in either sun or light shade. Give it organically enriched ground that does not dry out, or it will lose its lower leaves and

become stunted. Give it elbowroom and good air circulation, lest it grow lanky and mildewed. Divide it annually (or at least every second year), first thing in spring, or it will spread, mintlike, into a choked mat of weak shoots. Reducing bergamot's scope is one of the least interesting spring tasks, but easy enough. The plant's roots are near the soil surface. Speared with a spading fork and pried out of the ground, a clump offers little resistance. The spent center must be ruthlessly tossed out (and not into the compost, or it will reroot), while lively-looking wedges from the outer edges can be cut away for replanting. When set firmly and a little deeper than before, in the best ground you can manage, the divisions will raise up a stand of aromatic foliage and flowers—and bergamot will be a jewel in July's crown.

The delicate lavender flowers of wild bergamot (*M. fistulosa*) decorate roadsides, thickets and clearings throughout parts of eastern Canada and New England. At one time, indigenous peoples steeped the leaves to make a medicinal tea for mild fevers, headaches, colds and sore throats; other herbalists speak of bergamot as both a general tonic and a specific treatment for stomach ailments. The genus is named for Spanish medical botanist Nicholas de Monardes, author of a book titled *Joyfull Newes out of the Newe Founde Worlde*. Whether the news was "joyfull" or not depended on which side of the inequation—aboriginal or explorer —you were on; native peoples had found this herb long before Monardes arrived on the scene.

Although not as well known as mint or chamomile, anise-hyssop is a delicious tea plant that provides weeks of summer color.

ANISE-HYSSOP
Agastache anethiodora

Although little known and seldom grown, anise-hyssop is good company for bee balm in both the garden and the teapot. This 3-foot North American herb wants a place in the middle of a bed of tea herbs or perennials. Bumblebees and butterflies flock to its showy wands of lilac flowers. Heart-shaped leaves redolent of both anise and mint give rise to another common name, licorice-mint. By any name, the fresh leaves brew a fine herb tea. If hung upside down in an airy, shaded place, the flower spikes dry as easily as yarrow for a winter bouquet; shriveled leaves may be stripped from the stems and stored for winter teas.

Anise-hyssop does not spread by runners, as do the closely related mints, but spring-sown seeds grow in one season into full-sized plants. Left to seed, anise-hyssop usually scatters a colony of young plants at its feet.

In hot, starved soil, this hungry herb grows stunted and weedy-looking, but given moisture and goodness—and room to spread its branches—anise-hyssop is uncommonly decorative and provides weeks of late-summer color and months of fresh licorice-mint leaves for tea.

COSTMARY
Chrysanthemum balsamita

Years ago, in a long-abandoned farmstead across the road and through the woods from our garden, we found a stand of costmary that had held its ground against encroaching field flowers and grasses for half a century. Our elderly neighbors know the herb as "sweet Mary," but none could recall just what their parents or grandparents had used it for—"probably tea," was the usual response.

A close relative of feathery, dark green tansy (*Tanacetum vulgare*), costmary grows smooth, elongated, oval leaves, toothed along the edges and lightly silvered with a coating of fine hairs. Its tall, flowering stems support clusters of small, yellow button flowers, the central disk of a composite (or daisy) flower minus the ray petals. Given costmary's persistence in old gardens, it is no surprise that the herb takes to sun or light shade, dry or moist ground, and quickly forms an enduring clump.

To my nose, the scent of costmary is a mixture of mint and wormwood, an aroma once described as "vaguely reminiscent of 'morning bitters,' whiskey with bitter herbs."

Bitterness is all that comes through if costmary is nibbled, yet the herb was once included in every "Sabbath posy," a nosegay of aromatic leaves and flowers carried by church-goers to amuse the nose and titillate the taste buds during drawn-out sermons. At meeting's end, the long leaves were tucked between the pages of the Good Book, a custom reflected in the name Bible leaf.

Today, this stalwart old herb, "once very common in all gardens," according to a 16th-century writer —and amusingly listed as "new this season" in a recent herb catalog— is appreciated (again) by herb-tea fanciers for the balsamic bite it gives to a blend of milder herbs. The bitterness of a nibbled leaf is considerably mellowed by several minutes' steeping. Temper costmary's edge with the licorice sweetness of anise-hyssop or sweet cicely or with the citrus taste of lemon

Costmary, a stalwart old herb once common in every garden, has made a welcome comeback.

As stern-tasting as its name suggests, horehound has a long history of medicinal uses. Its early beauty gives way to weediness.

balm or verbena. Ordinary black tea can be spiced with a bit of costmary, but like the early New World settlers, I sometimes enjoy a cup of costmary tea straight.

HOREHOUND
Marrubium vulgare

If costmary is pleasant on its own as a tea, horehound (or whore-dog, as an irreverent friend calls it) is not. Whether brewed or chewed, this bitter herb tastes like the good medicine it is reputed to be. The Latin is thought to be derived from the Hebrew *marrob*, or bitter juice, a reminder that horehound was one of the five bitter herbs on the Jewish Passover table commemorating the exodus from Egypt.

Horehound has a long history of medicinal use, its bitter agents acting to ameliorate respiratory problems—coughs, asthma, bronchial congestion and the like. Even today, horehound syrup and candies help soothe a scratchy throat and allay a cough. An infusion of horehound is also meant to remedy a weak stomach or lack of appetite. To aid a summer cold or mild asthma, try horehound tea: Pour two cups boiling water over five or six fresh horehound leaves, and steep for 10 minutes; sweeten with a little honey to help the medicine go down, and drink three or four cool or lukewarm cups a day.

In our garden, woolly tufts of horehound appear here and there like catnip. Grown originally from seed, horehound can be counted on to reseed and naturalize. Pretty in its springtime silver-green growth, horehound soon turns rank and weedy-looking. Still, this 2-foot herb might be chosen to decorate dry, hard-to-plant places where other plants are reluctant to grow.

ROSES
Rosa spp

Although rose petals are an exotic addition to the teapot, it is the fruit of the rose—the rosehip, or hep—that is most often brewed. And it is the species *R. rugosa* and its cultivars that produce the most abundant crop of plump hips. Unlike modern hybrid tea roses—lanky prima donnas which demand that we keep them warm in winter, fight off pests that might annoy them and generally pander and fuss—rugosa roses flourish in any soil, remain unmolested by insects and are hardy without protection in harsh northlands and on the Prairies. Rugosas yield fragrant flowers from mid-June through July, then twinkle out the occasional blossom until September, when they regain a rosy fall glow. By then, the orange-red hips are conspicuous ornaments among the last roses; and a few weeks later, the bushes begin to put on a brilliant yellow fall coat.

Why doesn't every garden grow at least one rugosa rose? Perhaps the tag "shrub rose" frightens some gardeners who envisage a space grabber. But this prickly beauty needs less room than a suckering lilac or a straggling (and none-too-hardy) forsythia. Some gardeners may feel that any rose more exuberant than a spindly hybrid tea has gone wild —and indeed, rugosas do grow into thickets in parts of New England and along the Eastern Seaboard. Or we may think that a rose is only a rose if its petals spiral formally into a tight, high-centered blossom, beside which blowsy rugosas seem not quite elegant. Let's call rugosa roses informal and appreciate the plant's many good qualities.

The lovely blossom of the old-fashioned dog rose (*Rosa canina*).

The dusky plum foliage of the red-leaved rose is resistant to disease and unattractive to bugs.

The color of the wild rugosa rose is magenta, its form simple and open: five petals around a tuft of yellow stamens. Canadian hybridizers have been keen on improving this Japanese native, as well as the numerous wild roses that grow across the country. During the 1920s, in Ottawa, horticulturist Isabel Preston turned her considerable skill from lilacs and lilies to roses and left as a legacy a willowy amber-cream cultivar named 'Agnes.' Lovely above a floor of flowering catmint (*Nepeta* x *faassenii*), with lavender alliums hovering nearby, 'Agnes' follows her flowers with small hips. Recently, gene jugglers in both Morden, Manitoba, and Ottawa have introduced a number of hardy beauties, with single or full-petaled double blooms of white, magenta-red or pink.

Along a 75-foot stretch of split-rail fence, we have planted a selection of rugosa hybrids. The two fall days given to digging deep, wide holes, removing subsoil, piling in a well-stirred mixture of old manure, topsoil, peat moss and bonemeal and, finally, setting in the stripling rosebushes have yielded perennial returns in flowers, fragrance and fruit. The dense hedge also buffers westerly winds that would otherwise chill the vegetable garden. Tall and vigorous, 'Hansa' is well known for its loose wine-colored flowers and large rosehips. 'Jens Munk' opens pure pink semidouble blooms followed by lots of marble-sized crimson hips. The double white 'Blanc Double du Coubert' has been with us for almost three decades. But it is the single-flowered rugosas, closer to their wild roots, that mature the best and biggest fruit. Medium pink 'Scabrosa' and paler 'Frau Dagmar Hartopp' are good choices, and the single white rugosa displays a lovely, simple elegance.

Some visitors are intrigued by the sight of a bush laden with orange rosehips: "Pretty, but what are they? Cherry tomatoes? They look like little pumpkins." Others grow nostalgic: "We used to pick those during the war in England, for vitamin C, when you couldn't get oranges."

What do you do with them—tea?"
What I mostly do with rosehips is
eat them directly from
the bush. Picked
when they are
plump and red but not
softly overripe,
rosehips taste a
little like plums
(to which
they are dis-
tantly related).
There is a trick,
though, to
eating rose-
hips: Nibble
gingerly around
the sides but not
too deep, or you
will get a mouth-
ful of hairy
seeds; then there

is a nice bite from the top and the
tail of the berry.

To dry rosehips, cut them in half,
scoop out the seeds and fibers with a
tiny spoon and dry the halves com-
pletely on a screen in an airy, shaded
place indoors. Dried rosehips are as
hard as coffee beans; to make tea,
pulverize a handful in a blender
or grinder, and simmer gently for 5
minutes before steeping for 10 min-
utes with other herbs, dry or fresh,
for more flavor. Fresh rosehips can
be processed into jam, jelly,
syrup or chutney, but be sure to
remove or strain out all
the little hairs, or the
final product will
be unpalatable.
The hips of other
roses brew up a pleas-
ant tea as well. The

**By early fall, the red-leaved rose
is covered with hundreds of hips,
above, which can be dried and used
for tea. Left, lemon balm in flower.**

red-leaved rose (*R. rubrifolia*) is a
tall, willowy shrub, hardy into
Zone 4 and perhaps beyond. Its
dusky plum foliage seems to be
immune to black spot, mildew and
yellowing, and insects appear to
have no appetite for this rose. By
September, hundreds of small oval
fruit, as decorative as the leaves,
are turning red. These can be
screen-dried whole and used as
they are for tea.

The ideal tea herb, lemon balm has a mild citrus flavor that blends well with all other tea herbs.

LEMON BALM
Melissa officinalis

"Comforts the heart and driveth away melancholy and sadness," wrote English herbalist John Gerard of balm in the 16th century. Almost every potful of fresh herbs we pick for tea includes a helping of lemon balm leaves. Few herbs are as sweetly cordial—the scent is citrus but not sharp. Here is the ideal tea herb: The mild flavor blends well with all others and offends no taste buds. A completely hardy perennial, lemon balm grows willingly in any good ground, in sun or shade. True, lemon balm is a mover, but less so than mints; three clumps have been in place in our dryish garden for seven years with no tampering or attention. Its spread— faster in rich, moist earth—is easily

checked with a sharp shovel. Cutting back maturing seed stalks ensures that no seedlings spring up.

One plant of lemon balm will meet most needs, but beekeepers might want more. *Melissa* is the Greek word for bee; *M. officinalis* ("medicinal bee") is the botanical name for lemon balm. Balm and honeybees belong together. Not only do the worker bees seek out balm nectar, but leaves rubbed over a hive seem to calm the colony. In preparation for working with bees, some beekeepers rub their hands with balm and brush their clothing with balm branches—better safe than sorry. This little ritual slows down both bees and keeper and is supposed to make bees take more kindly to the intrusion. Greek beekeepers once stuffed their skeps— those picturesque hives made of coiled straw—with branches of balm in hopes of attracting a passing swarm. Balm is just as appealing to humans. In all herbal literature, the plant is described as soothing and useful for "nervous

problems, hysteria, melancholy and insomnia." Equal parts of lemon balm, chamomile and catnip make an effective nightcap tea; balm, mint and anise-hyssop create a delicious breakfast brew. Fresh balm leaves also add a mild citrus tang to green salads and light summer dishes. My preference is fresh balm for tea as well, although we always dry a few branches for a winter blend. In any case, frost-hardy balm can be harvested fresh for half the year here, longer on the "balmy" West Coast.

LEMON BERGAMOT
Monarda citriodora

Staying with leafy lemons but moving from hardy perennials to annuals and tender tropicals that need to be wintered indoors, we come to lemon bergamot, an attractive

An annual relative of the hardy bee balm, lemon bergamot is among the prettiest tea plants.

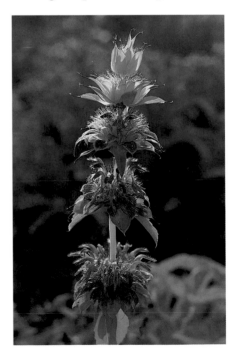

Seeds are a simple and economical way to bring lemon bergamot into the garden. Choose a sunny, well-drained site, and scatter seeds directly in the garden around the last spring-frost date. Thin seedlings to stand a hand span apart, and they should take care of themselves after that.

LEMON GRASS
Cymbopogon citratus

The name says it all: This herb looks like a clump of wide-leaved, bluish green grass and smells mildly of lemons. Widely grown in tropical and subtropical regions, where it is often planted on slopes to reduce erosion, lemon grass is a choice, easy container herb in the North, sitting outdoors in the sun all summer and coming inside for the cold and frosty months. Lemon grass is best started as a potted tuft from a local nursery or mail-order source, but supermarkets often sell bundles for cooking, which (I hear) can be potted, rooted and grown. A larger clump is easily divided for increase. Insects never bother the fibrous foliage, but cats may nibble it.

Lemon grass—a few blades per cup—brews a superior, mildly citrusy tea: Simmer the leaves gently for a few minutes before steeping for 5 minutes. Cooled tea is an excellent base for herbal lemonade. In Thai and Vietnamese cooking, the swollen leaf base flavors many dishes before being removed and discarded like bay leaf. Commercially, oil expressed from lemon grass is used in the manufacture of perfumes. But my favorite use comes from olden-day Ceylon: There, lemon grass was woven into

annual relative of hardy bee balm. Similar in appearance to the northern wild bergamot (*M. fistulosa*), lemon bergamot grows naturally in the hot, dry climate of the American Southwest, where it has long been used by the Hopi to flavor wild game. Strongly lemon-scented, its new leaves, fresh or dried, make an excellent tea with reputed digestive properties. Among the prettiest of flowering tea plants,

Lemon grass grows naturally in tropical and subtropical climates. Here in the North, it is an elegant and easy container plant.

lemon bergamot tops its 3-foot stems with crowns of mauve blooms that are very appealing to butterflies and bees; cut for indoor decoration, the flowers hold up well in a herbal bouquet.

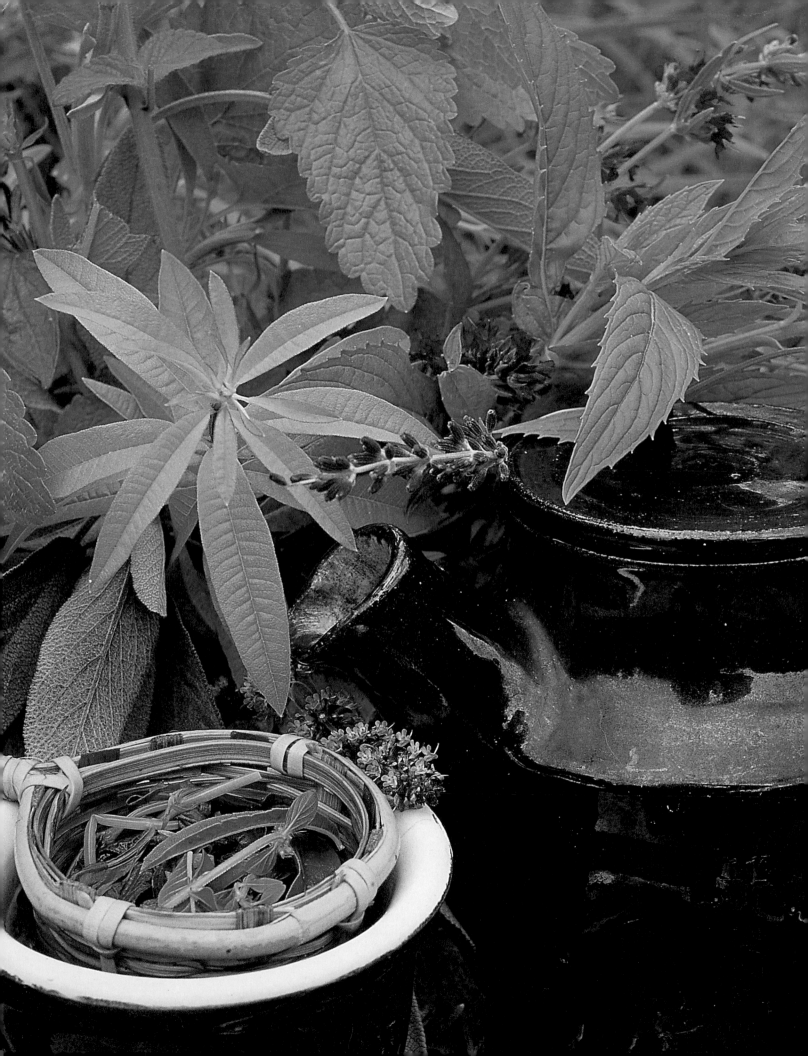

sun blinds made from other grasses and bamboo (itself a grass); on sultry days, water was sprinkled on the blinds, and as it evaporated, a refreshing scent of lemon filled the air—good idea.

LEMON VERBENA
Lippia citriodora

"What does this smell like?" I asked a 5-year-old visitor, tucking a crumpled leaf under his nose.

"Suckers," he said without hesitation and, after another sniff, "yellow suckers." A number of herbs—basil, geranium, lemon balm and thyme —mimic the sharp citrus scent of lemons, but none as closely as lemon verbena. In its native Chile and Peru, it grows large and lush, forming a perennial shrub comparable to forsythia—and in the greenhouse of a local herb lady, I've seen it as big. But a breath of frost shrivels this tender tropical. At Larkwhistle, we're content with a potted lemon verbena sitting in the sun beside the back door for the summer, within easy reach for teas or cold drinks. Used in perfumes and liqueur, lemon verbena makes a popular tea in southern Europe, where it is reputed to relieve indigestion and to raise lethargic or depressed spirits. Even a whiff is cheering.

Drying, Storing and Brewing

The foregoing fresh herbs alone or in combination fill a teapot from day to day during the growing season. For winter brews, all are easy to dry. Simply gather and tie bundles of three or four branches

Lemon verbena, facing page (with sage, lemon balm, mint, hyssop and lavender), above and below, is the strongest lemon of all.

(many more, and drying is uneven due to bulk), and hang them upside down anywhere out of direct sun where air circulates freely. Attic rafters or a garden shed will be fine if there is ventilation. In fall, we hang bunches from a dowel suspended over the woodstove, where the rising heat crisps them in a few days. Leaves may also be plucked from the stems and laid out to dry in a single layer on a piece of clean screen—a spare window screen propped up on a few books —set on the floor in front of an open patio door, where dry late-summer breezes

blow through. When the leaves are crackling dry, gather them up or strip them from the stalks onto a sheet of paper, pick out bits of twigs, and funnel the herbs into jars or any containers that can be closed tightly. Store clear glass jars out of light; opaque containers, anywhere. If you concoct a summer herb-tea combination you like, why not dry those herbs for the winter? Teas composed of garden-grown herbs are as varied as the imagination; a little experimental brewing and sipping are sure to result in a unique blend or two. If I could grow only five tea herbs for drying, they would be anise-hyssop, bergamot, chamomile, lemon balm and peppermint.

A word about brewing hot herb teas: "Doesn't taste like anything" and "Too strong" are frequent reactions. The good-tasting middle ground between insipid and medicinal varies from herb to herb and taste to taste and can be found only by trial and error. When determining the amount to brew and the duration of steeping, be guided by the scent and flavor of the herbs themselves. Mild leaves of anise-hyssop, lemon balm and spearmint, for example, are used alone or as the predominant flavors in a blend, while stronger or more bitter flavors—a leaf or two of sage or a bit of rosemary—add body and complexity. Most herb teas are steeped a little longer than black tea, about 5 minutes in total—but taste and see. It is possible to fill a teapot almost completely with fresh herbs and still brew a delicious tea that is not overpowering. But use proportionately fewer dried herbs; one teaspoon per cup is about right.

Garden Silverware
Plants with gray foliage

"What can we plant," visitors often ask, "that will come up every year, bloom all summer and look after itself?" The answer, in a word, is nothing. Like the birds, plenty of plants come back every year, but all need some attention, and none flower nonstop. A garden, in any case, is more than just flowers; foliage plays an all-important role. Plants chosen for good and lasting leaves, especially when set in prominent places or near the front of beds, keep a garden fresh despite inevitable declines in color.

Among the most effective foliage plants are herbs with gray, blue or silver leaves; even those with insignificant flowers add the equivalent of color to the ensemble. Woven among brighter hues, gray leaves serve to harmonize discordant elements and create a peaceful atmosphere. Silver plants make their presence felt all summer, but during September and October, they truly come into their own. As perennial flowers fade in turn, the soft-toned herbs—rue, lamb's

ears, yarrows, artemisias and such—gleam quietly on, reflecting the autumn sun and keeping their corners fresh and full.

A leaf's gray color—glaucous is the botanical term—is due to the presence of countless hairs covering its surface. If the hairs are tiny and dense, the leaf appears deceptively smooth, but a magnifying glass will show otherwise. If the hairs are more substantial, the leaf texture is furry, downy or velvety—pubescent, say botanists. In nature, most gray-leaved plants grow in dry, sun-baked places. Surface hairs are an evolutionary adaptation that helps plants survive intense heat and drought. A woolly covering checks the loss of moisture from the leaf; at the same time, the hairs trap rain and dew and hold the life-giving water on the leaf's surface. While deep green absorbs heat, silver-gray or metallic blue provides a cooler reflective surface in the face of the sun's relentless glare.

Converted from an open field, our

garden lies in full sun. During a summer of scant rainfall, its sandy soil dries almost to dust. Not surprisingly, our search for adaptable plants led to gray-leaved herbs, camel-like plants that can go a long way in the sun and sand with relatively little water. Most are medicinals of ancient repute. Some may find their way into home-brewed remedies or teas, but even if they don't, all are lovely, easygoing plants that provide subtle contrasts to flowers and greenery.

ARTEMISIAS
Artemisia spp

A sunny garden bed might be planted entirely with different species of artemisia and still be full of variety. While showy flowers are

Lamb's ears form a silvery border for the dramatic purples and yellows of geraniums and lilies.

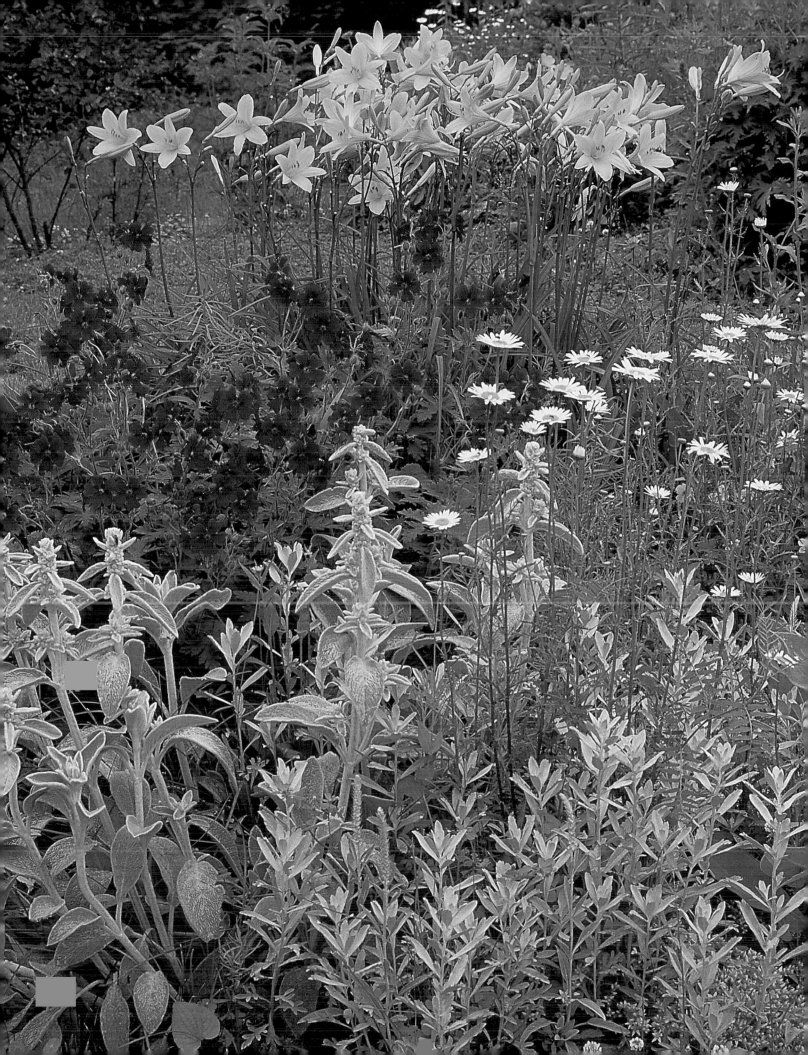

Whether for height, edging or groundcover, there are artemisias for every part of your garden.

not this family's forte—a wand of dowdy yellow-green buttons is the typical inflorescence—artemisias compensate with fine filigree foliage, silver or frosted gray-green, often delicately incised. When a full moon illuminates a summer night, ghostly artemisias reflect the lunar glow, somehow fitting for a genus deriving its name from Artemis, the Greek goddess of the moon. Dwarf artemisias are for rock gardens or edging; spreading sorts beautify dry, sunny places; and several tall species belong in the back row.

Once, the common wormwood (*A. absinthium*) gave both name and

bitterness to absinthe, a 136-proof brew deleterious to both body and mind. In Edgar Degas' painting *L'Absinthe*, a glum, benumbed figure, head propped on hands, sits in a Parisian café, a glass of milky liquid on the table before him.

For all absinthe's well-deserved bad press—half an ounce of the plant's volatile oil has caused convulsions and unconsciousness in humans—wormwood was once lauded as a medicinal herb. Indeed, it "ranks first," according to one herbal, "for conditions of enfeebled digestion, debility and melancholy." The common name wormwood indicates that the herb was used to rid both man and beast of internal parasites. Russian peasants considered wormwood the bitterest plant in the world; their folk medicine theorized

that wormwood's taste resulted from the herb's "absorption of bitter human suffering, and its properties drive sickness from the body and restore the soul to peace and calmness." Yet all herbalists temper their praise with a caution that wormwood must be used moderately and only in the doses recommended— or left to history.

Applied externally, wormwood is safer. Country folk once used a poultice of wormwood leaves to treat sprains and swellings in horses. Later, an ointment called Absorbine® was refined from absinthol, the oil of wormwood, and still later, the less potent Absorbine Jr® appeared, which continues to ease the sore muscles of thin-skinned humans. Pliny suggested a more pedestrian use, saying that leaves

placed in the shoes would keep a walker from growing weary.

In our garden, *A. absinthium* 'Lambrook Silver' has replaced the original species—its growth is less exuberant, its foliage whiter than the species. But even this restrained sport fills a 3-foot space, its girth equal to its height. Wormwood is half shrubby; that is, it does not die right back to the ground over the winter. It is best to wait until spring to prune the woody branches. Shape and shorten them when they begin to sprout, cutting away winter-killed parts in the process. A second midsummer pruning keeps this artemisia from sprawling into a tangle of weak stems; and since its flower stalks are ragged and ugly, I cut them away during the summer trim-up. One or two plants make a shimmering patch, very pretty with pink, blue or yellow bearded irises. A dozen daffodil bulbs around the 'Lambrook Silver' give spring color, and their fading foliage is soon obliterated by the artemisia's spreading branches.

When well grown, 2-foot artemisia 'Powis Castle' creates a sumptuous spread of silver, a great bushy mass of feathery foliage. The absence of flowers means no summer pruning. Winter can be hard on this sun lover, but wait awhile in spring and see whether new growth doesn't begin to bristle at the base. Trimmed, the plants will likely recover and grow quickly when days warm up. I often pop in a few plants of drought-proof 'Powis Castle' where some other perennial has died over winter—in short order, the spot is freshly refurbished.

The dwarf *A. schmidtiana* may be the best-known member of the genus. If the Latin does not roll off your tongue, look for this piece of silverware under the name 'Silver Mound.' Feathery, gray-white symmetrical hummocks, 8 inches tall and twice as wide, make an ideal border for a bed of flowers and herbs or create a neat, persistent accent in a rock garden. I have seen 'Silver Mound' used as a ground-cover on a hot, dry slope and planted along the top edge of a sunny retaining wall. Tolerant of poor, dry ground, this herb needs full sun and elbowroom to show at its best; crowded or shaded, it grows lanky and misshapen. A clump can be carefully split in spring, or new plants can be grown from cuttings.

One of the first things you learn in the garden is that it is possible to have too much of a good thing, even silver. One spring, I planted an innocent-looking shoot of the grandly named artemisia 'Silver King,' a cultivar of the silver sage (*A. ludoviciana*), in a bed of culinary herbs. By summer's end, all the meek thymes and savories were swamped. Both 'Silver King' and Roman wormwood (*A. pontica*) extend underground runners on all sides and soon monopolize any area within reach. Despite its aggressive roots, Roman wormwood is delicate and lacy above ground, its aromatic foliage shimmering in the sun as if veiled with frost. When allowed full possession of a dry, sunny bank or other difficult corner, both are lovely knee-high ground-covers. 'Valerie Finnis,' a more compact variety, is said by some to be "the best silver-gray foliage plant available," with a less invasive habit. In fact, the only fault these artemisias have is rampaging roots; if they stayed put, these drought-defying herbs would be perfect for so many places in the sun.

A multitude of common names tells us that a plant has been welcomed in gardens for a long time. Known variously as southernwood, smelling weed, lad's-love and maiden's ruin, *A. abrotanum* has been a fragrant favorite over the centuries. Hoary, sage-gray, thread-fine leaves suggest yet another name: old-man.

Smelling of spice and bitters, shrubby southernwood grows high and wide (5 feet by 3 feet); pruning in early spring and again (if need be) in midsummer keeps it within bounds. Like *A. absinthium*, dried southernwood stems are a useful base for herbal wreaths. Its branches can also be dried and its leaves rubbed fine

Though deceptively smooth-looking, the leaves of artemisias are covered with tiny, dense hairs.

to fill moth-chasing sachets for drawers and wardrobes—the French name is *garde-robe*. Southernwood once formed a part of every nosegay, and sprigs of the herb with a stem of moss rosebuds made a classic bittersweet lovers' bouquet—a tradition worth reviving?

CATMINTS

Nepeta spp

Those who garden solely for flashy color might wonder why anyone would give space to catmints, modest low herbs related to catnip that can elicit the same crazy-cat reactions. All wear pebbled gray leaves below thin wands of lavender-blue blooms—nothing dazzling there. But it's their very neutrality which makes catmints so useful in the front line of sunny beds and their self-sufficient nature that asks a gardener for only one intervention a year—cutting back the dead tops in early spring. Fastidious gardeners might do a second trimming once the first flush of flowers is over.

For years, we have grown Persian catmint (*N.* x *faassenii*), and every spring, we welcome back the gray-green aromatic mounds studded with lavender spikes that color in time to heighten the glow of tulips and carry on as the irises and peonies flower and fade. More robust, 'Dropmore Blue' is a Canadian cultivar still going strong since its introduction in 1932. At the edge of a hot, dry bed, it is well placed next to 'Moonshine' yarrow. Both catmints show their true color when massed or used as a low perennial hedge. To cover the ground between old-fashioned rosebushes, we have planted three clumps of 'Six Hills Giant' catmint, a silver-and-blue

While a single Siberian catmint might not draw much attention, a massed planting of the purple flowers cannot help impressing.

octopus of a plant that sprawls to fill the space among the roses, providing a pleasing foil for their pink, white and crimson and suppressing weeds in the bargain.

Instead of sprawling, Siberian cat-mint (*N. sibirica*) 'Blue Beauty' grows up tall and straight; and few perennials bloom as long. A single plant might go unnoticed, but planted in a hedgelike row in our kitchen garden, this lavender-studded herb draws a lot of comments and questions—and requests for roots. In fact, roots run a bit (but nothing compared with some artemisias) and are easily split in spring just as shoots are showing through the

ground. The variety is sometimes called 'Souvenir d'André Chaudron.'

While not spectacular, ornamental catmints are hardy, drought-resistant herbs, quietly decorative all season long. Honeybees, bumblebees and butterflies flock to the nectar-rich flowers. For early color, crocus corms can be tucked around their crowns.

LAMB'S EARS
Stachys lanata; S. olympica;
S. byzantina

The whitest foliage in the garden belongs to velvety lamb's ears; and only Turkish mullein is as densely furred. The name woundwort alludes to an earlier practice of using the leaves as bandages, a purpose for which they seem nicely suited, given their cottony surface. Although the wands of small, rose-purple flowers —a favorite forage of honeybees— grow fairly high in June, we have

Tall spires of woolly lamb's ears tower over the low-growing artemisia 'Silver Mound.'

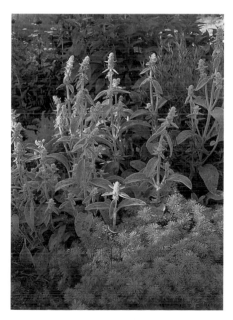

stretches of stachys along the front of a perennial border for the sake of its silver foliage, fresh from April to November and in harmony with anything growing behind. Pushing 20 years old, the patches need only occasional renovation—tucking shoots from the perimeters into bald spots in the middle and trimming back in summer as the flower stalks grow seedy and disheveled. 'Silver Carpet' stachys is a low, nonflowering variety.

A mint relative, lamb's ears spreads in a slow but steady fashion; every few years, we pull back and cut away shallow-rooted shoots that have crept out of bounds. Hardy stachys is immune to scorching sun and drought and, like all gray-leaved herbs, needs full sun and perfect drainage.

MILK THISTLE
Silybum marianum

The species name *marianum* comes from a legend which claims that milk falling from the breasts of the Virgin Mary caused the herb's prominent white markings. Legends aside, most gardeners shy away from or actively dig out anything called or resembling a thistle; we're not pleased to be pricked by our plants. But times may be changing. Thistlelike sea hollies are gaining favor in flowerbeds; and I know a few local gardens where giant silver thistles, like mace-wielding knights in armor, stand tall and vaguely menacing. Some thistles are undeniably beautiful, and the milk thistle is one of them, its mound of broad, scalloped, crinkly leaves etched with silver-white veins and armed with yellow thorns. For foliage effects, few plants are as strik-

With silver-white veins running through its scalloped leaves, the milk thistle seems almost more fauna than flora.

ing. The milk thistle is a biennial: Year one gives you leaves; year two, if plants winter successfully, brings 5-foot stems topped with mauve blooms surrounded by spiky halos of sharp prickles—decorative but dangerous-looking. As one writer notes, "This handsome plant is not unworthy of a place in our gardens and shrubberies and was formerly frequently cultivated."

For all its fierce demeanor, the milk thistle has a proven reputation as an effective medicinal herb and a nutritious vegetable. Young spring stalks and leaves, said Charles Bryant in his *Flora Dietetica*, are "one of the best boiling salads…and [surpass] the finest cabbage." Roots can also be dug and eaten like burdock or salsify and the flower buds treated like artichokes. Goldfinches seek out the seeds in fall.

But it is as a potent liver tonic

that the milk thistle has been most esteemed. Writing in 1694, a Mr. Wesmacott said of milk thistle: "It is a friend to the Liver and the Blood; but as the World decays, so doth the Use of good old things and others more delicate and less virtuous brought in." I wonder whether every age thinks theirs is a time of decay. In any case, modern research has confirmed the earlier knowledge that milk thistle can be very helpful in the treatment of liver ailments, ranging from low function and chronic hepatitis to cirrhosis. Studies have shown that the compound silymarin, the active principle in milk thistle, helps block the entry of viruses and other toxins through the membranes of liver cells. Milk-thistle tablets are available, and anyone with a patch of this interesting herb might snip away the prickles and simmer up a plate of young leaves as a spring tonic. Milk thistle is easily grown from seed started indoors in April or outdoors in May.

MULLEIN
Verbascum spp

Certain plants are unaccountably absent from North American gardens. Mullein, for instance, seldom makes an appearance, even though several species are silvery and garden-worthy. No doubt the mania for tidy dwarf plants has led to mullein's exclusion, since most are imposing giants. But as their growth is all upward, where the sky is the limit, they can be grown in gardens too small for sprawling delphiniums or top-heavy peonies. Almost anyone who has traveled a country road in eastern North America has seen the conspicuous gray-flannel rosettes of common mullein (*V.*

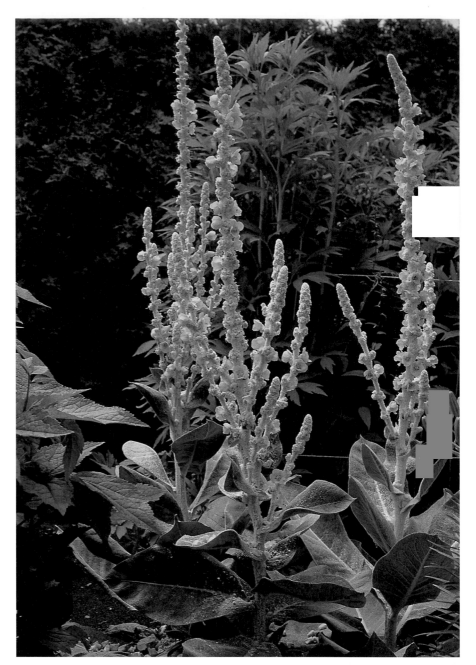

Both 'Silver Spire' mullein, above, and wild mullein, facing page, are respectable garden residents.

thapsus) and its downy spires set sparsely with five-lobed yellow blossoms. This mullein's mission seems to be to rescue waste places and recently bulldozed roadsides from ugliness. I remember a nearby vacant lot, transformed every June into a glorious wildflower garden as mullein masts swayed over a sea of blue viper's bugloss and rippling white-cap daisies. I was almost tempted to repeat the picture back home. Indeed, I know one gardener, as wild and woolly as the mullein itself, who encourages the gray rosettes (by overlooking them in his rounds of weeding) in odd corners of the herb garden.

As well he might, since mullein

has been a respected healing herb for centuries. Specifically, a tea made from leaves, flowers or both (one teaspoon to one cup boiling water) is said to alleviate hoarseness and bronchial catarrh. A brew created from the flowers alone is reputed to allay pain and induce sleep. When immersed in water and cider vinegar, the flannel leaves can be applied to areas of inflamed skin, and when dried and smoked like tobacco, the leaves soothe a cough.

A kind of vegetable exclamation mark in the garden, mulleins have a plethora of common names: Aaron's rod, Jupiter's staff, shepherd's staff and beggar's stalk; telling of the leaf's texture, Our Lady's flannel, feltwort and velvet plant; and the common name mullein was "woollen" in times past. The German *konigskerze* is king's candle, and other names repeat the association with light: candlewick plant, hag's taper and torches. Not only does the plant resemble a lighted torch when in flower, but in medieval castles, mullein stalks were dipped in tallow and set ablaze for illumination.

Like a candelabra when in full bloom, Greek mullein (*V. olympicum*) is a branching relative of the single-stalked native species. Here is a herb to shine at the very back of a bed or to be naturalized in a wild garden or the corners of a vegetable patch. The first season from seed, wide gray-leaved rosettes develop. The following July and August, the spot is alight with yellow flowers crowding the tall branched stalks. Left to seed, Greek mullein finds its own way around the garden. One season, three specimens towered above a bed of green beans in our vegetable garden where we had left the rosettes during fall cleanup. Besides appreciating the gratuitous color, I like this kind of haphazard companion planting, because it allows the garden, usually so orderly, to mirror the randomness of nature. Many herbs, among them calendula, chamomile, clary, coriander and dill, sow their hardy seeds and reappear annually in the vegetable garden, providing a bonus harvest and, we hope, keeping insect pests at a comfortable distance.

Few plants in our garden draw as much comment or as many requests for seeds as the Turkish mullein (*V. bombyciferum*), a species so thickly coated with "wool," both leaf and stalk, as to be entirely silver-white. In the bone-dry soil of a raised iris bed, Turkish mullein grew beautifully into 6-foot spires studded with soft yellow flowers. Thinking to encourage the herb to greater heights, we planted a few seedlings in a new bed prepared with manure, peat moss and clay loam. Not a good move: In the dense, damp earth, the rosettes dwindled and died from too much rich food. Clearly, it is sun, sand and drought for Turkish mullein, a denizen of the deserts.

Most mulleins are biennials, and most are tall and yellow. The showy *V. chaixii* 'Album' is an exception in several ways: It is solidly perennial and, at 4 feet, shorter than most, and its flowers are white with conspicuous purple stamens—altogether a worthy plant and one that always attracts attention. All mulleins are free and easy about sharing pollen—not that they have any choice, with bees working their flowers incessantly—and the short, white perennial appears to have crossed with a tall, yellow biennial. How else to explain the spontaneous appearance of a tall, yellow mullein that keeps coming back every year and even submits to careful division? However it came to be, this surprise plant now lives in the back row of a perennial bed against a gray split-rail fence, where it makes a delicate color pairing with the pinky apricot pompons of double hollyhocks.

New mulleins occasionally appear in catalogs and on nursery benches, and all are worth trying. A first step (if you go that route) is to secure seed; after that, mulleins are so easy to grow that as one old-time garden writer said, "Anyone who can achieve zinnias and marigolds may have mulleins." For all mullein's eventual bulk, its seed is as fine as pepper but sprouts thick and fast. Start seed in early spring, 6 to 8 seeds to a 4-inch pot, thinning eventually to a single sturdy seedling. When the plant fills the pot, set it in the garden where it is to flower. I like to see mulleins in a narrow border, perhaps on the sunny side of shrubs or at the edges of a gravel walk or drive-

way (always in the sun), where their silver first-year rosettes show to best advantage. Let them go to seed—the spent flower stalks are architectural, and the seeds are a favorite winter forage for chickadees—and mulleins will linger in the garden perennially.

Only wormwood tastes more bitter than rue, a plant that should not be consumed in any form.

RUE
Ruta graveolens

Next to wormwood, rue is the bitterest of plants. Sixteenth-century herbalist Thomas Tusser recommended the two for strewing in sickrooms: "What saver be better, if physick be true, for places infected than wormwood and rue." Shakespeare's "herb o' grace," or, more colloquially, "herbygrass," was so named because brushes made from rue branches were once used to sprinkle holy water. To my nose, rue has the weirdest smell of any herb, unearthly somehow. An aura of mystery hangs about the cool blue-green rue bushes; the acrid scent seems to conjure past associations with witches, spells and incantations. Rue has always been counted as a prime antidote to poisons and plagues, as well as the less material but no less malevolent evil eye. We grow rue for its metallic, lobed foliage, a foil for pink bee balm or purple coneflowers; rue's unusual greenish yellow flowers make little show. Like the taller artemisias, half-shrubby rue needs moderate clipping in spring to keep it shapely. This 2-foot herb cannot be successfully divided; grow it from seed or from nursery plants in any decent loam in sun. And although rue was once used in herbal medicines, it is a potent plant that should not be brewed, stewed or otherwise consumed.

RUSSIAN SAGE
Perovskia atriplicifolia

Recently named Perennial Plant of the Year, the elegant Russian sage— tall, shimmering silver and blue —has come into its own. Looking like a cross between artemisia and lavender, this plant bears finely cut, gray-green leaves below branched inflorescences of light lavender-blue, an ideal neutral companion to other garden flowers, ornamental grasses and herbs. Neither edible nor medicinal, Russian sage—it's not a sage either—might be called a

smelling herb; to my nose, the scent is fresh and resinous, like a Christmas tree.

Sun and fertile loam suit this 3-foot drought-resistant beauty, which shows best in groups of three or more. Winter can spell trouble north of Zone 5, but a mound of soil covering the base of the plant can make the difference. Leave Russian sage standing in fall, and cut it back to about 8 inches above ground when (and if) it begins to sprout in spring.

SANTOLINA
Santolina chamaecyparissus

You may have seen santolina, also known as lavender cotton, in public plantings, where it commonly edges formal beds or contrasts with green in interwoven knot gardens. The low aromatic bushes of fuzzy silver-white foliage thrive (like most gray

Santolina, above and below, should be cut back during the summer months to prepare it for winter.

herbs) in well-drained or sandy soil in full sun. Left to flower, santolina sends up stems of mustard-yellow buttons in summer, showing its kinship with the daisy family (Compositae). In a herb bed, frosted-looking santolina contrasts nicely with dark green savories, 'Golden' oregano, purple sage and variegated mints and thyme; decorative at the feet of bronze fennel, it also gleams in association with other gray-leaved herbs. Branches of santolina dry well and can be woven into wreaths with branches of dried rosemary, oregano and winter savory, then dotted with garlic bulbs, dried chilies, rosehips and bay leaves. Dried branches or pulverized leaves are a traditional moth repellent when placed among sweaters and linens.

Like lavender and sage, santolina benefits from a summer shearing. Take the scissors to it, trimming the bush back by about a third. This results in tighter, more compact growth that will winter better. Be prepared, in any case, to trim up the herb in spring; and don't be surprised if a harsh, wet winter kills santolina outright. Set out in spring, small replacement plants soon fill in the gaps.

YARROW
Achillea spp

The genus *Achillea* is high on my list of decorative, low-maintenance herbs. Provided its need for sunshine is met, yarrow is among the easiest plants to cultivate in any reasonably good ground. When herbalists speak of yarrow, they are referring to *A. millefolium*, the common milfoil that weaves its feathery gray-green among meadow grasses and wildflowers throughout North America. Its small white flowers are packed together in a flat head, or cyme, a form typical of yarrows. At first glance, you might think these umbrellalike heads show kinship to Queen Anne's lace, dill or lovage and presume that yarrows belong to the Umbelliferae family. But look closer: Each cyme consists of many small daisies clustered tightly together; yarrows are part of the Compositae family.

When wild yarrow (see Chapter 15) blooms by the roadside, I sometimes think it is pretty enough for the garden. But the common field yarrow is too invasive for any but half-wild places. In the past few years, a raft of more restrained cultivars, flowering in a range of lovely colors, has appeared in catalogs and nurseries: 'Great Expectations' displays wide heads of buff-yellow; 'Paprika' is glowing scarlet with a yellow center, always eye-catching at the front of a summer bed; 'Salmon Beauty' is well named; and there are other yarrows of lilac, cerise and pink. If any threaten to roam out-

of-bounds, it is a simple matter to slice away excess and weaker shoots with a sharp spade in spring and top-dress what is left with compost. Or, better yet, lift the clump, enrich the soil, and replace a division about the size of a lunch plate. So treated, yarrows will be as good as new—for a season or two.

Several yarrows bring both silver and gold to the garden. The big bear of the genus is A. *filipendulina*, better known for its cultivars 'Coronation Gold,' 'Parker's Gold' and 'Gold Plate.' This 4-foot herb is decorative tip to toe, from the time the aromatic gray leaves emerge in spring until the last of its mustard-yellow flowers have mellowed to autumnal brown.

More elegant and better for small gardens is 'Moonshine' yarrow, with its finely cut silver foliage and heads of lemon-yellow. Planted with ornamental catmints or salvia 'East Friesland,' it forms part of a classic duo of yellow and blue. I first saw this herb growing in shining clumps at the Royal Botanical Gardens in Hamilton, Ontario. For months afterward, I searched nurseries and catalogs without success. When I finally spotted a flat of small, wilting plants on a nursery bench, I bought the lot—only to find, when setting them in the garden, that they were badly handled recent divisions with scarcely a root anchoring them in their pots of soggy sphagnum. Careful not to injure incipient rootlets, I trimmed away a few lower leaves from each plant, dipped the ends in rooting hormone powder and planted the bits of silver in the sandy soil of a shaded cold frame—in essence, treating them as cuttings. Within a week, all were perky and growing. After several weeks, to my surprise, some began a tentative flowering and were still producing

their lemony parasols four months later. If given the winter protection of evergreen boughs and burlap, 'Moonshine' yarrow would do well in wooden half-barrels on a sunny patio or balcony; its spilling silver and gold would be effective all season long.

For the smallest gardens or a rockery, woolly yarrow (A. *tomentosa* 'Aurea') is in scale. Native to mountain ranges in Europe and through Russia to Siberia, this diminutive creeper has densely furred, finely cut silver foliage. Bright yellow flowerheads top 6-inch stems in early summer; 'King Edward' is the same plant in creamy yellow. Woolly yarrow tolerates—even thrives in—dry, gravelly ground and is not adversely affected by drought, but it needs full sun for health.

Most gardeners eventually try their hand at plant division, often to increase some treasure that is

'Cerise Queen,' above, is a cultivated yarrow that flowers in pink or white. Facing page, lemon-yellow heads of 'Moonshine' yarrow grow alongside corn poppies.

too expensive to buy in quantity. Tackling a hefty hosta or a mass of tightly woven Michaelmas daisy roots can be a back-wrenching task. How pleasant, in contrast, to split a mat of woolly yarrow, composed of many distinct small plants, each with its own roots, the whole woven together by shallow underground stems. Individual crowns are easily detached with clippers and a trowel without disturbing the clump, or the entire mat can be lifted and divided. After a season or two, a single starter plant can be conjured into a dozen to edge a herb bed or to carpet a patch of sunny ground.

In Living Color
Beyond the green herbal horizon

The herb garden of most imaginations is filled with modest plants, plain green or gray, that scarcely draw attention until a touch or a gentle breeze sets free their fragrance. For the most part, herbs are defined by aromatic leaves, not colorful flowers. But it has not always been so. If you were to turn to the old herbals and gather a list of plants deemed useful 400 years ago, you'd end up with a very eclectic—and very large—garden: perennial borders, wildflower meadows, woodland, vegetable beds and all. Green and gray foliage would be abundant, as would every floral color. Everything from the loftiest pine to the lowliest violet, including such commonplace flowers as peonies, irises, primroses and carnations, was used in some way for flavoring, fragrance, ritual and medicine, for brewing or strewing, for cosmetics, baths and dyes. There is ample precedent for admitting many bright flowers into the ranks of herbs, for making a garden as lovely as it is practical.

A variety of flowering herbs—alliums, anise-hyssop, bergamot, lavender, primroses, roses, violas, yarrows—are discussed in other chapters. But there are a few ornamentals that history places squarely in the herb garden.

FOXGLOVE
Digitalis purpurea

The foxglove is a time-honored resident of gardens, herbal or otherwise. Almost lost in the trend toward instant floral gratification and bedding annuals, this showy biennial is once again appreciated for its elegantly tapered spires hung with freckled white, pink or rosy purple bells. The botanical name is derived from the Latin *digitabulum*, or thimble, in obvious reference to the flower's shape. Common names link the foxglove with fairies, the wee folk—folk's glove, fairy's glove, fairy thimbles—while the plant's poisonous nature is evident in such

monikers as witches' gloves, bloody fingers and dead men's bells.

Until the 19th century, foxglove was used medicinally as a purgative, something that "goes right through you." Today, the plant remains important as the source of digitalis, a chemical that acts directly upon the muscles of the heart, slowing the pulse, raising blood pressure and increasing blood circulation. Digitalis is so potent, it must be used only when prescribed by a doctor—this is no plant to fool around with as a home remedy.

In the garden, tall aspiring foxgloves are an ideal vertical contrast to rounded bushes of old-fashioned roses blooming at the same time—nothing prettier than white foxgloves and pink roses. Add the spreading silver of *Artemisia* 'Lambrook Silver' or 'Powis Castle' to

A close cousin of the musk mallow, the old-fashioned hollyhock brings both height and history to the herb garden.

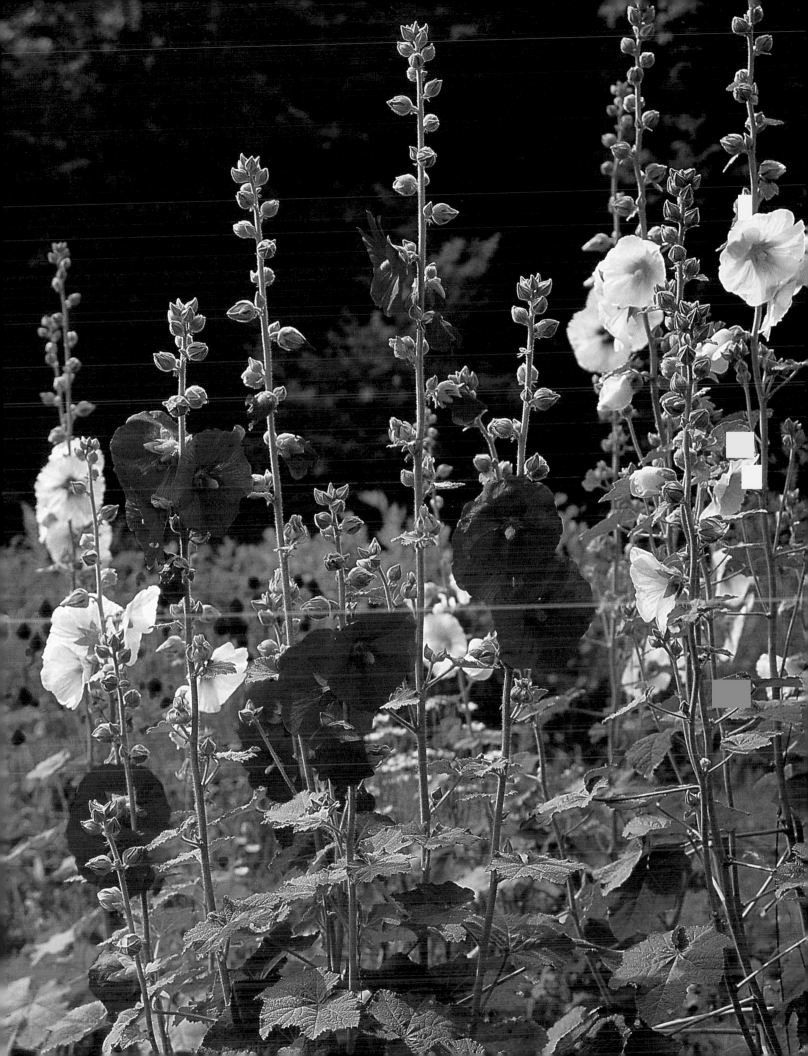

one side, and edge with pink or red coralbells and ornamental catmint. A few hovering metallic globes of *Allium christophii* create a picture to satisfy any gardener's soul. But don't count on foxgloves to come up in the same place every summer. As biennials, they grow leafy rosettes during year one and flower the next—end of plant. Allowed to seed, they usually reappear somewhere in the vicinity. Years ago, we grew a few foxgloves from seed, and they have been with us ever since. Sometimes they lodge between the old hand-hewn barn beams that raise a flowerbed or sprout from the sides of the stone steps. Seldom do we have the heart to remove a foxglove unless it is actually blocking traffic.

For a concentrated show in one place, it is best to buy or raise fresh plants and set them where you want them. To have a mass of foxgloves with the roses in July, I often salvage some of the plentiful seedlings left from last year's flowering and move them into the vegetable garden in spring, setting them a foot apart. After growing there over the summer, they are transferred as leafy rosettes to their flowering position in early September, time enough for them to become well anchored before winter. Moving a year-old foxglove rosette is not done lightly: Lift the plant carefully, with a root ball of undisturbed soil, and set it in an oversized hole; tamp earth firmly around the roots, and flood with water to settle the ground. Consistent snow cover is all the winter protection foxgloves need, but a springy mulch of evergreen boughs is useful in cold areas where snow comes and goes. Given their woodland origins, foxgloves grow to greater heights—I have seen them

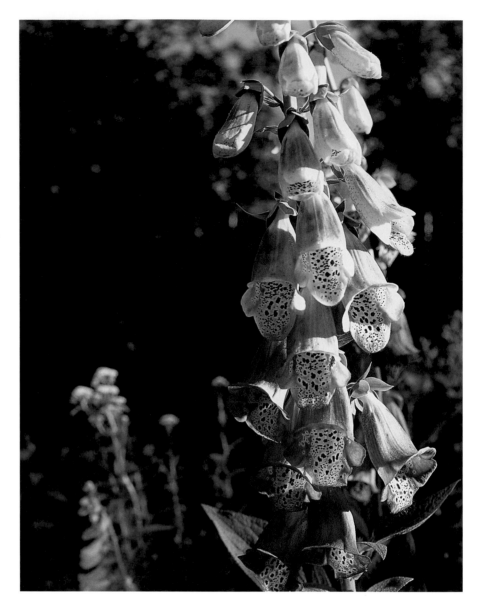

The foxglove has a venerable medicinal reputation, but its properties are so potent that it is used only as an ornamental in gardens today.

8 feet tall—in moist, humus-rich earth. Well-grown plants of the common *D. purpurea* are all one could ask for in foxglove beauty, but the cultivar 'Excelsior' (often available at nurseries in spring) has larger bells that flare out all around the stalk rather than hanging down on one side. Only fans of oddities, however, should grow the variety *D. monstrosa*, which opens a saucer-shaped flower at the tip of the stalk, spoiling the plant's graceful taper. As one old-time writer said, "As well top a cathedral spire with a cart wheel and ask for praise."

Gardeners have always been willing to put up with the here-one-summer-gone-the-next nature of *D. purpurea* because it is so pretty. But the genus holds some hardy perennials as well. Medicinally potent, the woolly foxglove (*D. lanata*) is the species now grown commercially for pharmaceutical companies; with small

"finger-gloves" of muted rose and white, this one looks at home among ferns in a shaded or woodland setting. The yellow foxglove (*D. ambigua*, syn. *D. grandiflora*) has reappeared for many years (and seeded in a small way) near the front of one of our perennial beds; not too tall at 3 feet, it rings its wands of light yellow brown-veined bells in June. The hardy perennial *D.* x *mertonensis* bears lightly furred, strawberry-pink blooms on tall, willowy stalks, while *D. ferruginea* opens flowers of brownish yellow flecked with spots of rust.

At 5 feet tall, valerian is best placed at the back of a border, but it may not stay there.

VALERIAN
Valeriana officinalis

The species *officinalis* indicates that a plant was once officially "of the apothecaries," or sold as a medicinal herb; the common name allheal illustrates how highly regarded valerian, or garden heliotrope, once was. Until the advent of synthetic tranquilizers, roots of valerian were made into an effective sedative, calming nerves and promoting sleep without narcotic side effects. Today, valerian tablets are again available as a natural soporific, or sleep inducer.

The lacy umbels of valerian give a light, airy effect to the garden, especially when grown behind heavy-headed peonies. And they flood the air with fragrance. My nose must be bent, though, because I find the odor barely tolerable on the air and heavy and musty (litter box, actually) close up. But everyone else seems to like it, and it is obviously an evocative scent.

"What's that smell?" one visitor muttered as she wandered through the garden. "I know that smell." Like a bloodhound, she followed the invisible trail to a stand of valerian. "That's it," she said. "It grew in my grandmother's garden. Takes me right back."

Hardy valerian grows in any soil and spreads by both roots and seeds. Left to its own devices, it will soon colonize the space around it and beyond—I see it in the field outside the garden these days. The shallow spaghetti-like runners are easily pulled back if they threaten to grow out-of-bounds, and cutting off faded flowerheads eliminates seeding. Start valerian initially from seed or from a bit of root from a friend's garden. A tall herb (5 feet), valerian is nicely suited to the back row, where it will take care of itself in sun or partial shade.

MONKSHOOD
Aconitum spp

First the warning: Monkshood, or aconite, is one of the most poison-

ous plants in the garden, one that should *never* be tasted or used in any way. Nevertheless, it has a long herbal history, used in minute doses as a sedative or a painkiller. In quite another context, it was valued specifically for its lethal properties: Both ancient Celt and Chinese warriors used to smear their arrowheads and spear tips with aconite, and the mythical sorceress Medea included aconite in her panoply of poisons. "Without question," wrote John Gerard, "there is no worse or more speedie venom in the world."

Even so, our flowerbeds are full of aconites; the tall spikes of slate-blue, white or deep violet flowers provide pleasing and dependable summer color. Gerard recognized their ornamental value, describing them as "so beautifull that a man would thinke they were of some excellent vertue." To my mind, the most decorative monkshood is two-toned *A.* x *bicolor*, native to mountain slopes from the Himalayas to eastern Europe. Grown behind red bergamot and warm-toned daylilies, with a cloud of baby's-breath nearby, the 6-foot spikes of blue-and-white hooded flowers contribute gloriously to July scenes. They are also fine company for orange tiger lilies or yellow yarrow.

The two-toned aconite is not often seen. We found a few exhausted clumps standing guard over an old grave site in the woods behind a nearby farmhouse. An elderly neighbor recalled that "before my time," the family living in the house had suffered a tragedy: One day during target practice, the father had accidentally shot and killed his son. Wanting to keep the boy close, the family had buried him under the maples and planted the grave site with aconite. Monkshood is also known as wolfsbane, and the

Beautiful but deadly, monkshood makes a dramatic statement at the back of the garden.

family may have hoped that this poisonous herb would keep away wolves and other wild creatures.

Coming in June, the shorter slate-blue *A. henryi* competes with tawny daylilies for root room beside the steps of many older farmhouses in our area; in a flowerbed, it is well placed in the middle row next to the old-fashioned lemon-lily (*Hemerocallis citrina*). All through

July and into August, the monkshood known as 'Spark's Variety' hangs out deep violet flowers on its network of branching stems; arriving at our garden as a single shoot, this tall, dark perennial has been split and split again for planting behind rosy phlox and pink bergamot. Coloring coldly blue into October, tall *A. autumnale* is one of the last perennials to bloom; it is lovely with white Japanese anemones.

Aconites grow slowly from seed but are one of the simplest big perennials to divide. Even long-established clumps are easily pried

from the ground with a spading fork and fall readily into separate divisions that can be further eased apart by hand. Each stem ends in a rooted tuber that soon takes hold in a new place. Well enriched, moisture-holding ground is a must for these robust, thirsty plants, in sun or partial shade. If starved or dry, aconites lose their lower leaves and grow stunted and yellowish. A mulch of compost, manure, grass clippings or old straw helps but is no substitute for fertile soil at the start. In leaf and habit, monkshood resembles the related delphinium and might be a good alternative where delphiniums prove short-lived. Tough and enduring, aconites unfurl their fans of dark green foliage without fail very early in spring, a welcome sign of things to come.

HYSSOP
Hyssopus officinalis

Here is a darkly decorative medicinal herb with narrow, deep green foliage that tastes sharp and bitter and smells of crushed pine needles with a hint of turpentine. A member of the Labiatae family, the vast group that includes mints, balm, thymes and savories, hyssop is well placed in a sunny, well-drained flowerbed in front of tall yarrows or the lanky stems of lilies—any-where, in fact, where its mid-summer crop of small, ink-blue flowers on 2-foot spikes would be appreciated. Seeds sprout with encouraging speed; spring cuttings

soon form roots, but this low shrub cannot be divided with any hope of success.

Hyssop is used by some people, though not by me, as a culinary herb to flavor fatty meats. This may be a holdover from distant days in Europe, when meat and game com-posed almost the whole diet and bitter herbs were needed to aid digestion. I can think of no other reason you would welcome the taste. But the herb has its uses. A tea of hyssop and sage is a recom-mended gargle for sore throats. I once used crushed hyssop leaves, reputedly antiseptic, to make a poul-tice that included thyme, comfrey, cayenne pepper, garlic, olive oil

and the juice of aloe vera for some nasty scrapes incurred by a young neighbor when he fell from his motorbike onto the gravel road. "Smells like stew," he said, but it did the trick.

HOLLYHOCK
Alcea rosea

Once, tall "holy hocks" grew against the walls of every monastery herb garden in Europe, where the flowers were used in medicinal preparations. Scorned as weeds by some today, hollyhocks linger in city lanes or spire up against rail fences and house walls in country gardens because "they've grown here since my grand-parents had the place." Visitors often ask for a few hollyhock seeds, be-cause this erstwhile favorite has been ousted from seed racks by flashier newcomers. Seeds, preferably sown outdoors where they are to flower, are the best route to hollyhocks in the garden. Young hollyhocks move fairly well, but occasionally, the earth falls away from the thonglike roots, and the plants are set back. Seeding where you want them saves the work of transplanting.

Where established hollyhocks are left to seed, they stay in a gar-den indefinitely and flower in a surprising range of colors: white through all shades of rose (to be expected from a plant with *rosea* as a surname), crimson, peach, pale yellow and plum, some with zones of darker color. For years, I preferred the fat doubles but now

As a cooking herb, hyssop has been lost to history, but brewed with sage, it remains a soothing gargle for a sore throat.

Hollyhocks flower in a range of rich colors, including vibrant red, above, pink, peach and maroon.

admire the simple singles more, perhaps because of one visitor's comment that the doubles look "like those toilet-paper decorations on wedding cars"—enough to put you off any flower. Still, well-grown double red or apricot hollyhocks— 'Peaches 'n' Dreams' is a choice variety—are undeniably lovely.

Hollyhocks would probably be in the forefront of perennial popularity if they did not succumb so easily to a fungal disease called rust, nasty orange spots that can render a clump totally leafless, if still bravely flying its colors. One possible remedy is garden sulfur sprayed on as spots appear. Another solution is to plant hollyhocks at the very back of a bed, where their stems will be hidden by the tall growth of other plants

Mallows, especially the musk mallow, facing page, are known for their soothing properties.

in front; ornamental grasses such as miscanthus form an admirable screen. To tidy ratty hollyhocks, we simply strip away the worst leaves; hollyhocks look better with no foliage than with stalks full of twisted, rusty leaves. Since young plants are usually healthier, we remove badly infected older clumps and leave new seedlings to carry on. Hollyhocks respond to the rich earth of the perennial border. So treated, they often soar 10 feet high and flower for many summer weeks.

MUSK MALLOW
Malva moschata

The mallow family (Malvaceae) encompasses plants as diverse as the exotic southern hibiscus and the lowly garden weed known as cheeses (*M. neglecta*). Hollyhocks are members of the clan, along with musk mal-

lows, one of English garden artist Gertrude Jekyll's favorite flowers. I first saw musk mallows gleaming shyly in the shadow of tangled briar roses and half-wild apple trees that had grown up, like a Sleeping Beauty garden, around a windowless, decrepit farmhouse, long abandoned to time and weather. In our locale, musk mallows spring up on margins of woodland and along the gravel roadsides. From the wild, they have leaped the fence into our flowerbeds and potato patch. The circle has come around: British settlers originally brought over seeds of musk mallows to plant in their New World gardens, and the enterprising flower soon set about colonizing fields and roadsides throughout Canada and the northern United States.

The musk mallow bears satiny funnel flowers—a shape typical of the family—tinted soft mauve (*mauve* is French for mallow) or white. Plants give quick results, and seeds are a slower but sure way to bring this no-care 2-foot perennial into the garden. Start seeds indoors, or simply sow them where you want them in spring; they may bloom the first season or take a year to size up. The self-supporting plants flower for weeks in midsummer, a pretty counterpoint to sea holly, phlox, coneflowers and such. Musk mallows are elegant enough to decorate a formal flowerbed and tough enough to hold their own in half-wild places; light shade or sun, dry soil or damp are all the same to this plant. Let musk mallow seed if you dare, and root out the excess.

Mallows of all kinds —and, in particular, marsh mallow (*Althaea officinalis*)—

are known for their emollient action, soothing and softening inflamed skin and persistent sores. "In inflammatory conditions of the external parts," wrote Alma R. Hutchens in her *Indian Herbalogy of North America*, "the bruised herb forms an excellent application, making as it does a natural emollient cataplasm. Our Indians used leaves, soft stems and flowers steeped and made into a poultice for running sores, boils and swellings." Full of mucilage, mallows have been used through the ages to soothe irritation and inflammation internally as well—marsh mallow root tea is indicated for coughs, scratchy throats and stomach ulcers, and in the past, teething babies were given a stick of marsh mallow to suck on.

SAFFRON CROCUS
Crocus sativus

The fiery red stigma snipped from the heart of the small lilac-colored saffron crocus is one of the costliest of spices. And no wonder: 4,500 flowers are plundered to yield one ounce of dried saffron, a flavoring for rice dishes, confectionery, medicines, perfumes and liquors. This ancient herb crops up in the writings of Homer and King Solomon, among others. The scent of saffron was described as "an odor of perfect ambrosia"; theater benches and banquet halls were scented with saffron water, and the cushions of the high and mighty were stuffed with the crocus petals. Persian kings wore saffron-yellow shoes, and the gods on Mount Olympus were robed in saffron hue, much like contemporary Buddhist monks in the Far East.

Persia, Greece, the steamy Orient:

Associated through the ages with both courage and joy, borage brings a welcome dash of color to the garden and to summer salads.

We should have known that this famous flower would not take kindly to a Northern garden. Unlike spring crocuses, the saffron crocus produces its fragrant blooms in fall, once the bulbs have had a good summer baking in the soil. Fall is an uncertain season in the North, often cut short by the chilly blade of winter; and a summer baking is not a sure thing either. Planted five years ago, our *C. sativus* bulbs have so far steadfastly refused to flower. In any case, I wouldn't have the patience (or the heart) to pinch the stigmas if they did appear. Our experience with the saffron crocus is echoed by Louise Beebe Wilder in her informative 1936 book *Adventures With Hardy Bulbs*: "It is sadly disappointing in the garden...indifferent to your best efforts in its behalf, flowering sparsely and seldom. ...Save for its antique interest...it seems to me the saffron crocus is not worth growing."

throughout the summer. I'm not too keen on eating flowers; a bunch of petals strewn over a salad doesn't appeal to me, and I don't know why. But borage is one I like, along with nasturtiums, Johnny-jump-ups and chives blossoms. The rough, hairy borage leaves are supposed to taste of cucumber, but my taste buds detect a hint of fish oil, which disappears when the leaves are minced into a salad. Steamed young borage leaves, on the other hand, are a decent spinach substitute. Illustrator Turid Forsyth says that she uses borage leaves "almost more than any other herb, especially to mix with other herbs into sour cream or yogurt as a dressing for potatoes or vegetables—and lots in a salad."

A hardy annual, borage is easily grown from seeds sown in full sun in shallow furrows about two weeks before the last spring-frost date. If started earlier indoors (not really necessary), borage should be seeded in small pots and thinned to a single plant to eliminate transplant shock. Borage is a pretty thing when young but grows into a lanky sprawler, about 2 feet tall, as summer progresses. Still, I can't imagine the garden without it and always welcome its enthusiastic self-seeding.

Like its cousin borage, anchusa makes a stunning display in the June garden and is also a delightful edible floral garnish.

BORAGE
Borago officinalis

I do not pretend to understand the subtle links between herbs and human emotions, but for as long as people have written about plants, borage has been associated with both courage and joy. Pliny called the plant *euphrosinum*, because it was supposed to make people happy. John Gerard wrote in the 16th century. "Those of our time do use the flowers in salads to exhilarate and make the mind glad.... The leaves and flowers put into wine...drive away all sadness, dulness and melancholy." Maybe the wine did most of the driving.

Whatever their effect when ingested, nodding, bright blue starflowers of borage, beloved by bees, are cheery enough in the garden

ANCHUSA
Anchusa italica, syn. *A. azurea*

I always think of anchusa (pronounced an-COO-suh) as the herb that stopped a bus. One June morning years ago, 20 to 30 people came tumbling out of a bus and swarmed into our garden, all wanting to know the name of "that incredibly blue plant." Touring back roads in search of birds and wild orchids, the group of naturalists had spotted

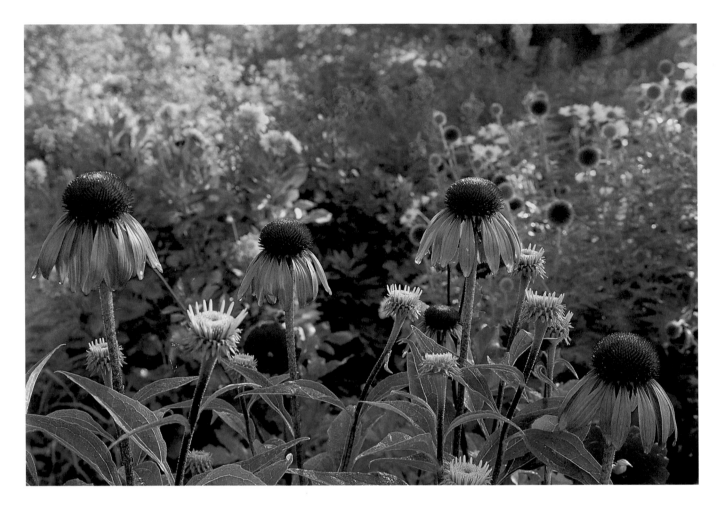

Not only is the purple coneflower decorative in the garden, but it's renowned for its healing properties.

flowering anchusa from a distance. Related to comfrey and borage in the Boraginaceae family, this showy herb tops its bristly leaves with great panicles of flowers, like overgrown forget-me-nots, of intense bus-stopping blue. June is its festal month.

Like those of borage, anchusa flowers are edible floral garnishes. The roots yield what has been described as an "incredible" red dye. But practicalities aside, anchusa earns garden space for its brilliant blue, since "no plant," noted one old-time writer, "not excepting the delphiniums, decks itself in a more truly azure color." Listed as a biennial in some

catalogs, anchusa behaves more like a short-lived perennial here, which may account for its rarity in gardens. Plants usually reappear for three years before their crowns succumb to rot over winter. But as older clumps die away, new seedlings appear to carry on the color.

Seed is the best way to start anchusa in the first place, since the taprooted herb wilts badly if moved. Start with 4-inch pots—a few seeds per pot—then thin to one seedling. Alternatively, dig up seedlings from the garden, and tuck them into their flowering positions when they are still quite small. Anchusa, also known as Italian bugloss and alkanet, has but one fault: The top-heavy 3-to-5-foot-tall stems are prone to topple, smothering nearby plants and generally creating

confusion in a border. Two or three stakes pushed firmly into the earth around each clump and wound around with strong cord help to corset this showy but untidy herb.

PURPLE CONEFLOWER
Echinacea purpurea

Over the past decade, echinacea has come into its own as a reputable herbal remedy in widespread use. Visitors who know echinacea only in tablet or tincture form are often surprised to see this tall, sturdy perennial—one of the most decorative members of the daisy family—in flower. Showy reddish purple petals surround a bristly orange

A sun-loving member of the daisy family, the golden marguerite is covered with bright yellow flowers through early and midsummer.

central cone, a frequent landing site for butterflies drawn to sip its nectar.

Native Americans were well acquainted with echinacea's medicinal properties, using the plant to help heal insect stings and snakebites; pieces of root were also chewed to ease toothaches. Current research has shown that when used in a timely way, echinacea bolsters the immune system working to defend the body against cold and flu viruses.

Like most daisies, coneflowers are easily grown from seed and may well flower the first season if started early indoors. Set in the garden about 16 inches apart, coneflowers respond to rich, moist soil in sun. 'Magus' and 'Bright Star' are improvements on the original species, and 'White Swan' gleams in contrast. In garden beds, purple coneflowers consort with white phlox and blue sea hollies, with a backdrop of monkshood.

GOLDEN MARGUERITE
Anthemis tinctoria

Also known as yellow chamomile, the golden marguerite is another member of the daisy family. All through June and July, sprawling knee-high mounds of finely cut aromatic leaves are topped with hundreds of bright yellow daisies. The name dyer's chamomile reminds us that the blossoms yield a golden orange fabric dye. The cultivar 'E. C. Buxton' flowers a pale yellow, which fits into any scheme. Grown in front of delphiniums, either helps hide that plant's lanky, leafless lower stems. Anthemis is also good company for dusky purple salvia 'East Friesland' and lavender-blue catmints. In our garden, individual anthemis plants usually prove short-lived, but new seedlings always appear and move well when young.

FEVERFEW
Chrysanthemum parthenium

Closely related to anthemis, feverfew produces small white daisies above highly aromatic, cut-leaf foliage. In 1772, herbalist James Hill wrote of feverfew: "In the worst headache, there is no more efficacious remedy." Research has confirmed that this modest ornamental herb, used medicinally since Roman times as a sedative and an all-purpose tonic, is a great boon to people who suffer from migraine headaches. The *British Medical Journal* reported on laboratory tests conducted at the City of London Migraine Clinic with both feverfew capsules and a placebo. Migraine patients on the placebo had recurring headaches, while those taking feverfew reported an improvement in most cases, and for a number of

Feverfew, a determined spreader in the garden, is also a proven headache remedy.

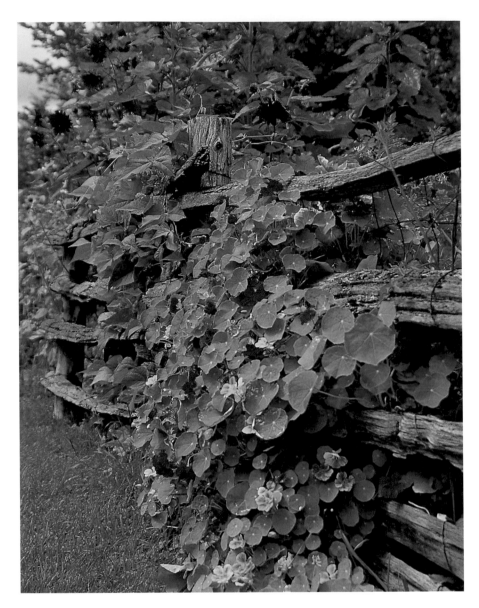

creates a knee-high, weed-suppressing groundcover in any soil in sun or light shade. Even so, we want a plant or two among other perennials, where feverfew's small daisies lend a lightness like baby's-breath. 'White Star' is a fine single sort, while 'White Bonnet' is fully double and quite showy. Feverfew grows easily from seed sown in spring, and nursery plants are widely available. A friend reports that this herb is an exceptionally long-flowering houseplant, grown in a large pot or hanging basket in a bright window, sun room or greenhouse.

NASTURTIUM
Tropaeolum majus

The name nasturtium means nose twister. For a long and colorful display from this tender annual, a native of Peru, all you need do is push the pea-sized nasturtium seeds into any patch of poor, sun-drenched ground around your spring frost-free date and wait; six weeks later, a crop of yellow, orange, scarlet or cream flowers will begin to decorate the mounds of round leaves. In rich soil and rainy weather, nasturtiums grow lush and leafy at the expense of blossoms. I recall one summer, hot and dry in the extreme, when all the garden was feeling the heat and showing signs of stress and fatigue; in their corner of sandy soil, the nasturtiums flowered blithely on. In cooler areas, start nasturtiums in small pots in early May and set them out when the weather turns warm.

At one time, nasturtiums were valued for treating infections; perhaps their high quota of vitamin C did the trick. Today, they are appreciated as a tasty salad herb, with

Boasting peppery seeds, leaves and flowers that are all edible, nasturtiums, previous page and above, have been bred into cultivars of a wide range of colors.

them, migraines disappeared entirely after a period of use. Some mouth soreness and temporary stomach upset were experienced, minor side effects compared with other drugs and less traumatic than the headaches themselves.

If I feel a headache coming on, I often nibble a fresh feverfew leaf—its bitter taste is not unlike that of aspirin. Chewing several leaves a day is, in fact, recommended for migraine sufferers, but be aware that feverfew leaves are very potent and may cause a kind of mouth ulcer in people with sensitive skin. Taking them sandwiched between bread slices is said to help, and buffered tablets of a regulated dose are available.

In the garden, feverfew is a determined spreader, flinging seed around and coming up where it will—I've seen several casually tended gardens completely overrun with it. Left to seed, feverfew soon

some of the sharpness of watercress. Snip the peppery leaves into green salads, or use them like lettuce in a sandwich. The big, bright flowers are an edible garnish, and unripe seeds can be pickled and used as a substitute for capers.

CALENDULA
Calendula officinalis

Calendulas are among the handful of hardy annual flowers—the others being California, corn and opium poppies, love-in-a-mist, alyssum and borage—that routinely self-sow in our kitchen garden to create patches of color amidst the tomatoes, beans, lettuce and such. Also called pot marigolds, calendulas grow into tidy bunches of simple leaves topped with equally simple daisy flowers in warm tones of yellow, orange,

rusty red and apricot. There's something sturdy and unassuming about a calendula, a cottagey flower with no airs or pretensions. The name comes from the Latin *calendae*, for the first day of the month, the root of the word calendar. The name may derive from the fact that in a moderate climate, this tireless flower blooms the year through or from calendula's reputation as an aid for menstrual problems, the "monthlies."

Soothing calendula creams and ointments are commonly available. The plant has a time-honored reputation as a healing herb, an emollient for skin ailments ranging from cuts and scrapes to burns, eczema, warts, corns and boils. More appetizingly, fresh calendula petals have a mild spicy taste and contain a gentle food-coloring substance. Through the ages, calendula has been grown in kitchen gardens for use in broths and salads and to impart a yellow color to butter and cheese. As an inexpensive saffron substitute, calendula petals turn plain rice pale yellow; soaked in warm milk, the petals also impart

The calendula, above and below, is a common garden flower with a practical use: Its petals, like those of many other herbs, can be added to colorful summer salads.

a warm eggy shade to baked goods.

If they are not already coming up on their own in your garden, calendulas are easily grown. Scatter seeds in spring in any open sunny spot, over soil that has been loosened but not necessarily enriched. Cover lightly, and look for seedlings in a few days. Give each plant a 10-inch circle to fill, and you'll enjoy the flowers for months. For a return visit the following summer, let calendulas seed or shake their dry seeds here and there in fall.

Shades of Green
Choice selections for dark corners

Some years ago, while on a bicycle tour of English gardens, my partner and I visited one of those grand country places for which England is noted. In addition to the picture-perfect herbaceous borders, an alpine terrace, a peony walk and a herb garden flourishing far from the house, there was a shaded area filled with perennials chosen for their foliage. Admittedly, this estate employed four full-time gardeners, but the shaded garden, said the owner, "requires very little work indeed to keep in trim." The plants themselves were tough and self-sufficient; many of them crept over the ground to form a weed-suppressing cover. The overall effect was a densely woven foliage carpet—leaves of many colors, textures, shapes and sizes—as picturesque, in a different way, as flowerbeds out in the sun. Focused as it is on foliage, a shade garden trades color and dazzle for subtlety and cool serenity.

Most sun-loving perennials—daylilies, peonies and the like—do best when given their own space

to fill. But shade plants, as a rule, do not need such segregation. Let them mingle and, in some cases, fight it out. Given a good start in the form of organically enriched, weed-free earth and some encouragement thereafter—occasional top-dressings and scrupulous weeding—they soon widen to form interlacing swaths of foliage. For spring color,

hardy bulbs such as snowdrop, scilla and narcissus can be tucked right through the carpeting plants in fall.

Shaded yards, front and back, are almost the norm in city neighborhoods, where old trees weave skyward through a warp of wires. Here is a place for shade-loving herbs, mingled with ferns and native woodlanders. Even a single tree or the shady side of shrubs invites such treatment. At Larkwhistle, most of the beds catch the sun from dawn until dusk, but the afternoon side of old lilac bushes presented us with a place to grow shade-loving plants. As we read, collected and planted, we were surprised to learn how many of the plants had once been used as herbs.

While sun-loving herbs such as lamb's ears and poppies tolerate dry, even poor soil, violets, facing page, are at their best in rich, moist ground. Left, sweet wood-ruff is a restrained creeper.

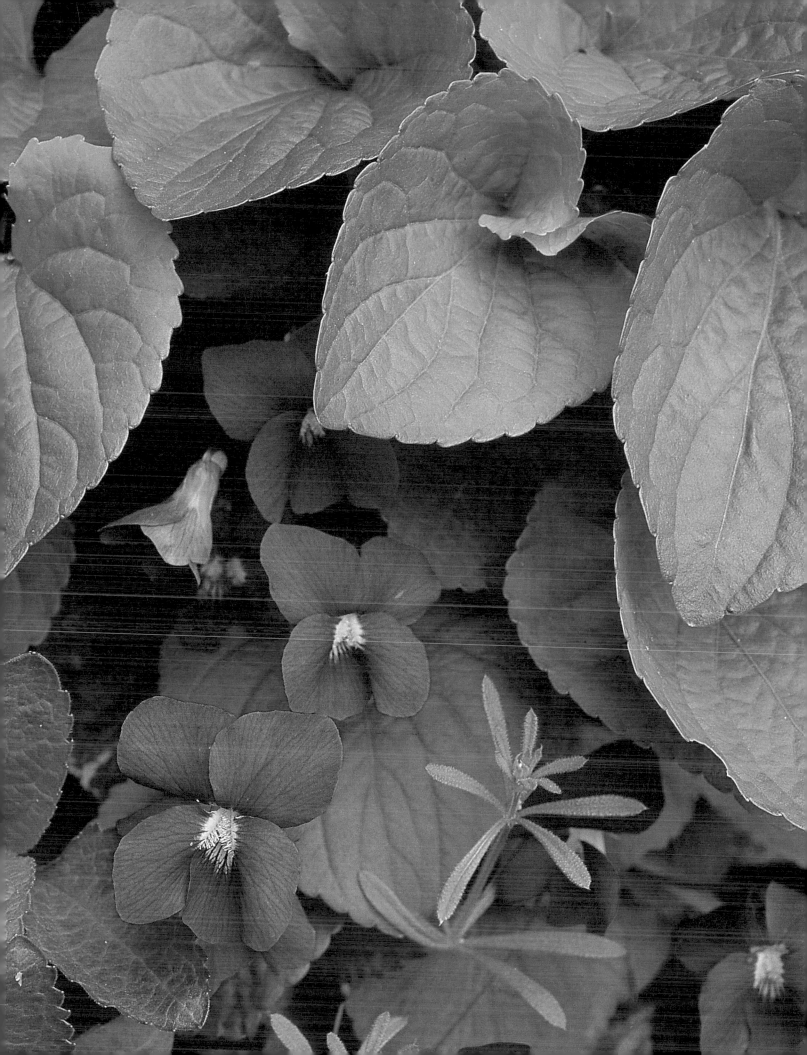

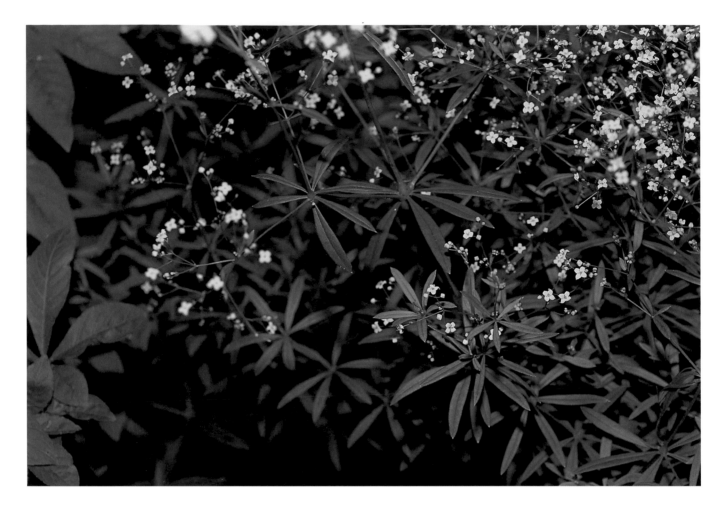

One of the prettiest dwarf herbs, sweet woodruff, above, asks for little. Facing page, violet, sweet woodruff and bugleweed hint at the range of greens the shady herb garden can offer.

SWEET WOODRUFF

Asperula odorata, syn. *Galium odoratum*

Although a single specimen makes little impact, sweet woodruff en masse forms a carpet of glossy green whorled leaves and an earth-borne Milky Way of tiny white blooms in June. Delicate in appearance but tenacious and hardy, this denizen of British and European woods craves shade, a modicum of

moisture and, some say, acidic soil. With us, it does well in soil that is definitely sweet or limy. This is a no-care plant: Winter sweeps away its old leaves—no need to cut back —and rainfall takes care of watering.

Germany's famous May wine, Waldmeister-Bowle, is traditionally served on May Day and throughout woodruff season, until the plant begins to flower. "There is something of a ceremony involved in making May wine, like brewing tea in Japan," says Turid, recalling her childhood in Germany. "People go into the woods to gather fresh sprigs of woodruff. White wine and woodruff go into an earthenware jug or crock that is then buried in the ground for half a day to chill to earth temperature. The woodruff is strained out and the wine served,

sometimes mixed with champagne, from a crystal punch bowl into crystal cups."

Woodruff gatherers also bring home bunches to hang in wardrobes and linen closets, where the herb dries, permeating clothes and bedding with a summer sweetness. I remember my first whiff of woodruff in the greenhouse of a commercial herb grower. It was a gray February day, but the scent of a few dry woodruff leaves transported me to a summer meadow. The fragrance, often compared to that of freshly cut hay, reminds me of spring earth and honey. Only faintly aromatic when fresh, the leaves develop their full bouquet when dry and remain fragrant for years.

In the past, sweet woodruff was one of the "strewing herbs," a room

freshener scattered over the floor to scent the air; bunches of dried leaves hung from church rafters did the same. It was also a common element in snuffs and perfumes. Today, snuff is gone and we'd balk at a herb-strewn floor, but dried woodruff remains an excellent potpourri ingredient, both for its own fragrance and for its ability to hold the scents of other herbs. As a mild medicinal, woodruff is a gentle tranquilizer, reputed to calm and soothe the nerves; a cup of woodruff tea before bedtime is supposed to relieve tension and help you relax, much like valerian.

A restrained creeper, not aggressive like mint, woodruff sends small searching runners in all directions. To cover a given area once all perennial weeds have been removed, set out at least five plants, 8 inches apart, and keep the intervening spaces weeded until cover is complete. Woodruff is slow and difficult from seed—germination can take a year—and plants in quantity are expensive. A gardening friend

may part with starter clumps, and if patience allows, several plants left to spread for a season will provide propagating stock. Either take small plugs—pieces of crown with roots attached—using a sharp knife and a trowel, or lift a whole plant and break it into rooted bits to plant elsewhere. Give new plants a recuperative dose of fine-textured organic matter—damp peat, composted manure, leaf mold or compost—stirred deeply into the planting hole.

LADY'S BEDSTRAW
Galium verum

Somewhat like the related woodruff in appearance but a little taller, Lady's bedstraw produces a froth of greenish yellow flowers. This herb does not run but expands gradually outward, filling whatever space you give it. In our garden, it competes with the dense surface roots of cedar trees but would do better without that struggle. For those who like balance and formality, clumps of bedstraw can be set at intervals along a shady border; it will also sprawl decoratively over the top of a retaining wall. Spaced on 12-inch centers, bedstraw soon creates a lacy cover for spring snowdrops, fritillarias, scillas and dwarf daffodils, filling out after the bulbs have bloomed and gone underground. Although bedstraw is more tolerant of sun and dryness than is woodruff, it still appreciates good ground. Maintenance is slight—clearing away the strawy debris left by winter and, if necessary, reducing the size of

Once used to stuff mattresses, lady's bedstraw tolerates dryness and sun but likes good soil.

the clumps with a trowel or small spade. A midsummer shearing keeps this lax herb from swamping nearby plants.

The genus name *Galium* comes from the Greek word for milk. Also called "cheese renning," bedstraw was once widely used as a rennet substitute, because its leaves and flowers cause milk to separate into curds and impart a yellow tinge to the finished cheese. Bedstraw leaves also yield a fine yellow fabric dye, while the roots effect a red coloring. The habit of stuffing mattresses, "even of ladies of rank," with the dried herb earned this plant its common name. The practice may have been an imitation of the Nativity, since bedstraw was thought to be one of the herbs that lined the manger in Bethlehem.

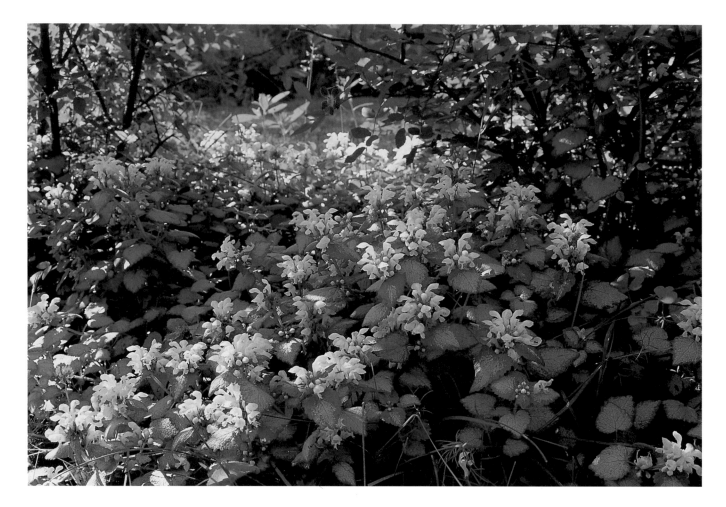

'White Nancy' is a dead nettle whose snowy flowers and striped leaves lend grace to a shady corner.

BUGLEWEED
Ajuga reptans

A good neighbor for bedstraw, the common bugleweed flourishes in any company but may be a threat to less ambitious plants. Here is a herb that will thickly cover any expanse of ground with persistent tongue-shaped leaves of various hues. The glossy foliage of one variety shines with the verdigris of old copper, another has bluish green leaves, while others are mottled red, white, green and cream. Several sorts planted randomly together

weave a colorful tapestry, and all hoist decorative short spikes of blue blossoms in early summer. Square stems and lipped flowers show kinship with mints, balm and other labiates. Ajuga spreads quickly and far, so it is wise to keep it away from smaller plants and out of a rock garden if you hope to grow anything else. But bugleweed is no plant to fear. Some perennials are shunned as invasive, but sometimes invasive is just what we want. This handsome herb willingly covers ground otherwise difficult to plant —the dryish shade under trees, for example—and is easily checked if it strays out of bounds.

Ajuga has a long history as a vulnerary, a plant used to heal wounds. "This herb belongs to Dame Venus," Nicholas Culpeper

declared in the 17th century. "If the virtues make you fall in love with it (as they will if you be wise), keep a syrup of it to take inwardly and an ointment and plaister of it to use outwardly." The herb, which he called bugle, sickle-wort or herb-carpenter, "is wonderful in curing all manner of ulcers and sores… gangrenes and fistulas also, if the leaves [are] bruised and applied or their juice be used to wash and bathe the place."

DEAD NETTLE
Lamium maculatum

A fine aesthetic complement to the preceding three and pushy enough to hold its own is lamium (*L. maculatum*). This labiate might be chosen more frequently were it called something other than dead nettle. How about its old name, purple archangel, or even false salvia? Like common field yarrow, lamium has hemostatic properties: The bruised leaves are said to stanch the flow of blood.

With plain green leaves and dull magenta flowers, ordinary lamium is a bit dowdy, but it has given rise to some truly beautiful ground-covers. The heart-shaped leaves of *L. m.* 'Album' are freshly striped with white below candles of white flowers; in 'White Nancy,' the light stripe extends almost to the leaf edge. 'Beacon Silver' lights up a shady garden with silver-white leaves outlined with a hairline margin of green, and its flowers are pink. I admire 'Pink Pewter' for its silvery foliage and rosy blooms; when blue forget-me-nots seed among it, the result is as fresh and pretty as spring gets.

Rooting as it runs, lamium grows a foot tall and forms a weed-smothering groundcover; but it is easily reined in if it covets more than its share of space. There is no trick to growing this mint relative, save finding plants of the better sorts and setting them two hand spans apart in reasonably good ground in the shade. Tall daffodils will bloom through for spring color.

Sweet cicely's anise-flavored foliage makes a delightful tea when blended with mint and lemon balm.

SWEET CICELY
Myrrhis odorata

The botanical name says that this herb "smells of myrrh." At Larkwhistle, one no-care corner is perennially cool green and white. An exuberant mass of white lamium and a few plants of bedstraw form the edging. At the back are some native cedar trees; in front, clumps of sweet cicely fan their fernlike foliage and hoist umbels of white flowers, like giant Queen Anne's lace, on strong 4-foot stems. It was Gertrude Jekyll, an influential English garden artist of the 19th century, who first drew our attention (in her book *Wood and Garden*) to sweet cicely, a roadside weed in Britain. "*Myrrhis odorata*," she wrote, "for its beauty, deserves to be in every garden; it is charming, with its finely cut, pale green leaves and really handsome flowers." Take her suggestion, and interplant daffodils with sweet cicely; the early

fronds create a green setting for the daffodils and then grow up to hide the fading bulb leaves.

Sweet cicely—"sweet, pleasant and spicie hot, delightfull unto many," according to John Parkinson in his 1629 herbal—is a favorite nibbling herb for garden visitors, and neighboring children keep coming back for "more licorice." The whole plant —leaves, stems and especially the unripe green seeds—is intensely flavored of anise. "Sweet" is no misnomer: This herb contains up to 40 percent sugar. A friend stews chopped stalks with rhubarb or other fruits and reduces sweeteners accordingly. I like to mix fresh leaves with mint and lemon balm for a favorite herb-tea blend or to mince a leaf with other herbs to scatter over salads. Pieces of tender stems and very young green seeds—nibble a few to make sure they are not fibrous—can be baked into cookies, quick breads and rhubarb or strawberry pies.

A single sweet cicely is plenty for cooking, but several plants spaced 2 feet apart make more of a statement in the landscape. Be aware, though, that one plant will fill a space as wide as your outstretched arms. Packaged seed can be expensive and may not be lively; like other members of the Umbelliferae family, sweet cicely germinates best when fresh. If you know someone who grows this herb, ask for a palmful of ripe black seeds in July or August, and sow them right away (certainly by fall) where you want the plants; started plants are a shortcut. In our garden, small self-sown cicely springs up by the score around mature plants and sprouts from the compost heap. To avoid forever rooting them out, we've learned to cut seed stalks to the ground before seed ripens and falls; this trimming also keeps the plants tidy and encourages fresh growth.

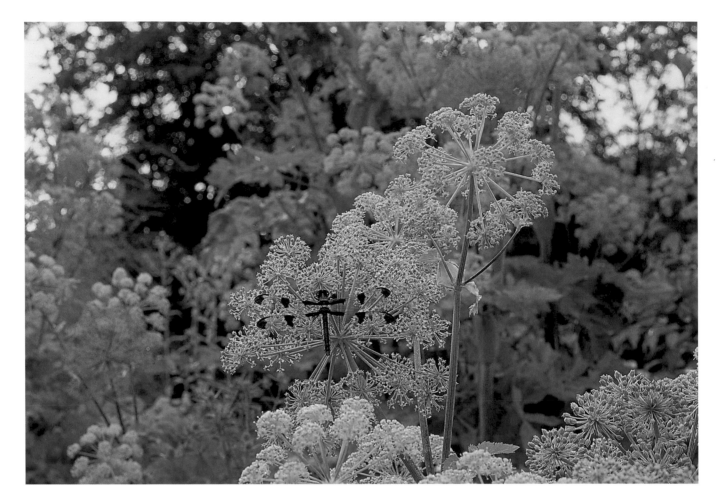

Especially decorative when in flower, angelica will grow only from fresh seeds and can reach heights of up to 6 feet.

ANGELICA
Angelica archangelica

I am a little in awe of any plant named *Angelica archangelica*. In his 17th-century herbal, John Parkinson put this herb at the forefront of his panoply of medicinals because it was angelically able to ward off evil spirits, spells, witchcraft and enchantments. On a more material level, angelica is recommended for digestive ailments, which explains its presence in vermouth and liqueurs, in particular that strange

green firewater Chartreuse. The whole plant has a scent that cannot be mistaken for any other herb. Essence of angelica goes into some perfumes. Roots "dried rapidly and placed in airtight receptacles retain their virtues for years," said Mrs. Grieve, and they can be brewed into a pleasant tea. I like a bit of fresh angelica in a spring tea blend, while others use it in stewed rhubarb, fruits and jams, cooking the slightly sweet whole stalks with the fruit and removing them when the compote has cooled.

Native to Syria and naturalized in high places in northern Europe, angelica has proved hardy beyond the Arctic Circle. Finns, Norwegians and Laplanders eat young angelica stalks as vegetables, a dish I intend to try some spring day. At the back of a

shady bed, angelica is a decorative herb, especially when it boasts big cartwheels of yellow-green flowers on 6-foot stalks. Like the related sweet cicely, this tall biennial grows only from fresh seeds. Rather than cutting down the impressive flower stalk, which is supposed to trick the plant into being perennial, we let angelica ripen and scatter its seeds. So treated, it has adorned our garden for many years.

GOUTWEED
Aegopodium podagraria

Warning: If someone gives you goutweed, give it back. Do not plant it in the garden; do not toss it on the compost heap. Slips of this

ruthless vegetable strangler are casually passed along as "a pretty green-and-white groundcover that grows itself"—to say the least. Pretty it may be and, said Nicholas Culpeper, "it heals the gout and sciatica," but unfortunately, I have seen too many small gardens completely swamped by this greedy herb, including one carefully terraced rock garden that had cost someone several weeks of work and now grows only goutweed. Digging out goutweed would give anyone sciatica. In *A Modern Herbal* (1931), Mrs. Grieve wrote: "It has a creeping rootstock that spreads rapidly, soon smothering all less rampant vegetation." Once entrenched, especially among rocks, it is next to impossible to eradicate. Recognize the foot-high plant by its pointed, variegated, slightly toothed leaves, six or eight leaves to a stem; or ask a few questions when presented with an anonymous "pretty green-and-white thing."

LADY'S MANTLE
Alchemilla mollis, syn. *A. vulgaris*

Few gardens grow lady's mantle, perhaps because hot-colored novelties have blinded us to subtler beauty. Ever attentive to the character and charm of plants, Gertrude Jekyll devoted an entire page in one of her books to a description of a leaf of lady's mantle. And it is mainly for its handsome leaves—broad,

Goutweed, above, is such an aggressive plant that it is best grown only in a contained situation—or not at all. Below, lady's mantle.

pleated blue-green, scalloped along the edges, fresh from spring to fall—that lady's mantle is now grown. Medieval alchemists, from whose science alchemilla derives its Latin name, valued this herb for treating wounds, for herbal baths and for "promoting quiet sleep" when the leaves were placed under the pillow at night. Especially prized for medicinal use was the dew that gathers on alchemilla leaves. To get a vivid picture of how the human relation-

ship to herbs has changed over the centuries, imagine going out in the morning and collecting water droplets hanging like a necklace of crystal beads from the points of a lady's mantle leaf.

Like bedstraw, knee-high lady's mantle sits as a neat specimen at intervals along the edge of a border and works as a tallish groundcover, but not in the dry shade directly under trees. For best effect, allow each plant an 18-inch-diameter space to fill without competition. In our coolish Northern garden, lady's mantle grows in shade but does as well out in the sun, where its fine foliage and fluffy chartreuse flowers form a permanent edging for a bed of rugosa roses, Siberian irises, rosy meadow rue and the like. In hot southerly gardens, some shade keeps the leaf edges from scorching. Lady's mantle is best started from nursery plants, since seed is slow and uncertain—for us, two plants were all that grew from a packet. Once established, lady's mantle splits with great ease first thing in spring and seeds itself with abandon where conditions are right.

With its handsome blue-green leaves, lady's mantle, above, will grow in sun in cooler climates but needs shade where it is hotter. Facing page, Solomon's seal, a relative of lily of the valley, is self-sufficient and stately.

SOLOMON'S SEAL
Polygonatum multiflorum

Our cool corner of evergreens and sweet cicely also includes Solomon's seal. Green and white are the colors of this tall, handsome herb, capable of coming up through other groundcovers in a shady bed. I have seen it used to good effect, giving an impression of order and symmetry, in a foundation planting as an alternative to dwarf pines and junipers. Oval ribbed leaves, each tilted forward at a precise angle, are set at regular intervals along gracefully arching stems. Toward the top of the stems, wax-white scented bells hang from each leaf axil. Nor does this tidy plant disappear in midsummer; its foliage stays fresh until fall, then colors a warm yel-

low in keeping with the season.

Solomon's seal is a close relative of lily of the valley (another favorite for shade) and spreads in much the same way, only slower. Thick, white underground rhizomes travel a short way and then emerge as new shoots. A patch in our garden that was hemmed in by lilacs and peonies did not increase much over the years, but when moved to a new corner, well enriched with humus, this hungry woodlander took off. Propagating the plant is an easy matter. Sometime during October or April, divide the rootstock with a sharp knife, allowing each piece of root an "eye," which looks like the tip of an asparagus stalk. Besides planting Solomon's seal and cutting back its stalks at season's end, I cannot recall ever doing anything else to or for this self-sufficient herb.

COMFREY
Symphytum officinale

A bold, leafy plant that dominates wherever it is planted, comfrey also holds a place of prominence in old herbals. Its venerable medicinal reputation arises from the presence of allantoin in its roots, a mucilaginous substance that can "promote cell proliferation," notes Purdue University's Dr. Varro E. Tyler in *The Honest Herbal*. Popular old names such as knitbone, bruisewort, boneset and healing herb indicate that comfrey once figured in poultices for sprains, swellings, burns and bruises. Taken internally, a decoction of comfrey root was said to soothe ulcers and respiratory ailments.

Recently, however, the safety of ingesting comfrey, especially in large doses over a long duration,

By summer's end, when comfrey stops flowering and starts to look bedraggled, cut back the stalks and leaves and add to the compost.

in summer, it unfurls coils of buds and hangs out a succession of small pink-white or (better, if you can find it) bright blue bells.

When this cousin of anchusa, borage, the wild viper's bugloss and the lowly forget-me-not ceases flowering and begins to look seedy and bedraggled, the time has come to cut the stalks and leaves and toss them into the compost, where they add a rich store of minerals mined by deep roots. Comfrey leaves, in fact, contain such high concentrations of soluble plant foods that the foliage can be brewed into a potash-rich green manure "tea" for watering tomatoes, root crops and cucumber or squash vines. Mix one part leaves in three parts water, and let the slurry steep for a week—be prepared for the mess to stink to high heaven—then dilute to weak-tea color before using. Once cut, comfrey sprouts a fresh crop of foliage.

A caveat: Give some thought to the placement of comfrey at the start. Not only is it a bulky plant to move, but every root severed in the process of digging will sprout into a full-sized plant. In other words, it is almost impossible to get rid of comfrey once it becomes established. Like horseradish and Johnny-jump-ups, comfrey can become one of a gardener's self-inflicted weeds.

has come into question. The plant contains alkaloids that have proved carcinogenic in laboratory rats. Says one expert, "Internal use is discouraged at present while research is being done into possible harmful effects." I am not a herbalist, but I would not hesitate to slap a comfrey poultice on any external wound; nor am I concerned about chopping a leaf or two of comfrey into a spring salad. But whether you consider comfrey edible, medicinal or simply ornamental, the plant might find a place in the garden in front of shrubs or toward the back of a bed where there is room for its 4-foot bulk. For weeks

VIOLETS
Viola spp

Violets cover a lot of territory, both botanically and in woods and gardens. Two members of the genus— tireless Johnny-jump-ups, or heartsease, and sweet violets—crop up in many herbals as medicinal plants. We're strict with both; a little leeway,

and they are all over the place. Johnny-jump-ups (*V. tricolor*) are small, pert pansies that take to partial shade or sun, charming wee flowers that peer up at you as if daring you to pull them up. Once, we let them all stay, but colonies of seedlings jumped up everywhere—tight in the crowns of perennials, under rosebushes, through the asparagus. Now we leave a few at the base of rocks that edge flowerbeds, and even these hop the curb and take off. And as much as we complain, we wouldn't be without these colorful violas. Given their own space, purple-and-gold Johnny-jump-ups are an easy groundcover, as bright as any annual and longer-flowering than most. Among the first flowers to open their eyes in spring, they are usually colorful in a small way at Thanksgiving. No wonder they are such unrestrained seeders. Although I am not a great flower-eater, I often pop a Johnny into my mouth while gardening—just to let the little pests know who's boss.

Sweet violets (*V. odorata*), the most famous of the herbal violets, are harder to come by. Several times, we have sent for plants or brought home a tuft of green from a nursery, only to have a crop of nice purple flowers but none

of the famous scent described by Francis Bacon in 1625 as "the sweetest smell in the air." Once you have the true sort, though, watch them closely. Self-sown sweet violets can quickly become a pain in the perennials. Evicted from our flowerbeds, they now have all the lawn space they can carpet. In April, they stain the green purple and flood the air with scent, and for the rest of the summer, they are run over with the mower and no harm done. Perennial relatives of pansies, sweet violets expand from year to year by small creeping rhizomes and plentiful seeds; ordinary ground in sun or shade suits them fine. Fragrance is what sweet violets are all about. One author states that "white wine vinegar derives not only a brilliant tint but a sweet

Johnny-jump-ups, above, are long-flowering and unrestrained seeders. The true sweet violet, below, is even more invasive.

scent from having violet flowers steeped in it." All violets are edible and add a festive touch to spring salads. Young violet leaves and flowers produce a tea rich in minerals and vitamin C; mint or lemon balm adds flavor. "I have an old steamer chair in the toolshed," said Louise Beebe Wilder in *The Fragrant Path* (1932), "and when a mild March spell starts the violets to blossoming, I drag it forth and lie by the hour in the sunshine inhaling the delicious fragrance." If I were to drag a steamer chair into the garden in March, chances are I'd be inhaling snowflakes—but the thought is there, and spring always comes.

Uncommon Scents

Herbs for fragrance

"Sweet perfumes work immediately upon the spirits, for their refreshing sweet and healthfull ayres are special preservatives to health, and therefore much to be prised."

—Ralph Austen

A Treatise of Fruit Trees (1653)

Scents affect us. What is it in an invisible fragrance that races to the brain and triggers an instant flood of vivid memories? What makes even the dourest person respond with an involuntary smile—and most kids with a giggle—to a noseful of fresh peppermint? Why do some of us recoil from a whiff of rue, while others take a second sniff ("Strange, but I think I like that")?

Closely linked to the sense of taste, our sense of smell tells us (among other things) whether or not something is fit to eat, an important information-gathering function that could potentially save

our lives. Rue's acrid odor, for instance, is enough to keep you from making a salad of this potent herb, which is toxic in any but the smallest doses. Animals, of course, rely even more on their sniffing snouts as they forage for food. But according to one William Bullein, writing in 1562, the ability to derive pleasure from fragrances is a human prerogative: "Humankind only doth smell and take delight in the odors of flowers and sweet things."

Aromatherapy is a new name for an old practice: using scent to effect some health benefit. It can't hurt, in any case, to have one's forehead and temples massaged with lavender oil. Before anyone knew anything about the chemistry of scents or the physiology of smelling, those wise in the ways of gardens recognized that fragrances are active and do something remedial. "Physicians," wrote Michel Eyquem Montaigne in the 16th century, "might in mine opinion draw more use and good from odors than they doe." In the first century, botanist

Pliny the Elder stated in his *Naturalis Historia*, "As for…mint, the very smell alone recovers and refreshes our spirits." The scent of wild thyme was believed to "raise the spirits and strengthen the vital energies"; that of basil, according to 16th-century herbalist John Gerard, "taketh away melancholy and maketh a man merry and glad." And, said Louise Beebe Wilder in *The Fragrant Path* (1932), "To me, the smell of Clove Pinks is instantly invigorating, while…the true Old Rose scent is invariably calming." Nowhere is the nose happier than in a garden, and if the garden is filled with herbs, so much the better. What could be more therapeutic than a stroll around the garden just after a mild June rain has encouraged roses, pinks and lavender to spill more of their perfume?

Harvest blossoms at midday in dry weather just before full bloom and enjoy the fragrance of peonies and lavender in February.

OLD ROSES

Rosa spp

Roses once loomed large in every herbal. At one time, their fragrant petals were such an essential ingredient in plant-based medicines, syrups, scented oils, rose water, rose vinegar, lozenges and vitamin-rich conserves that botanist John Lindley suggested in 1866, "The rose could form the sole basis for the entire pharmacopoeia." Nor was it always thought necessary to brew, stew or otherwise use roses directly; simply to inhale their fragrance deeply was considered curative.

Who can argue? The true old-rose scent, always a favorite floral fragrance, is sweet but never cloying, full-bodied but not heavy like that of some lilies or certain night-blooming tropicals. "Pure and transparent" is the apt description given by one old-time garden writer; it is "an odor in which we may…burrow deeply without finding anything coarse or bitter, in which we may touch bottom without losing our sense of exquisite pleasure." I remember a visit to Mottisfont Abbey, not far from Winchester, England, where a collection of historical roses has been gathered within the stone-walled garden of a 12th-century monastery. Warm June sun had just broken through the perpetual mist of the past week, and the atmosphere, still laden with moisture, diffused the

The heady fragrance of 'Rosa Mundi,' above, makes this old rose a favorite. *Rosa hybrida*, facing page, is a floribunda, ideal to mix with other plants.

light into a soft brilliance. The roses —a full half-acre of them —seemed to stir in response to the gentle heat and humidity and exhaled a wave of sweetness that was the very essence of rose.

Modern roses are to old roses what today's fashion models, all bone structure and paint, are to Rubens' female figures, plump, pink and glowing from a bath scented, no doubt, with rose water. Stop and smell one of the latest coral-colored creations, and chances are, you will detect only a ghost of sweet scent or none at all. But the gardener who wants to grow a rose or two from the past, all of which are full of fragrance, must replace the idea of long-stemmed, perfectly spiraled flowers with roses that are rounder, flatter and more loosely made and are colored crimson, white or, of course, rose-pink.

Reaching back to the dawn of history, the complex genealogy of the rose reads like Leviticus. But to include a few old roses in a sunny bed, perhaps with an edging of lavender, look for cultivars of the hardier species. *R. alba*, the white rose of the House of York, has been in gardens since the 1600s. The cultivar 'Suaveolens' is still grown commercially in Europe as a source of rose oil, while 'Celestial,' 'Königin von Dänemark' and 'Maiden's Blush' are better garden roses. Garden-worthy, too, are varieties of *R. centifolia*, the hundred-leaved, or cabbage, rose. Centifolias are so often depicted in the floral art of the Dutch masters and in the work of rose illustrator Pierre Joseph Redouté that one is called 'Rose des Peintres' and another 'Prolifera de

Redouté.' From *R. gallica*, the French rose, is derived the apothecary rose (*R. gallica* 'Officinalis') of many uses, once in medicine, now in perfumery. 'Rosa Mundi,' one of my favorites among old roses, is a gallica with parti-colored petals streaked red, white and rose and a heady fragrance; known before 1580, this beauty is the namesake of "fair Rosamund," one of the unhappy mistresses of Henry II. The buds of hardy moss roses, old-fashioned favorites for bouquets and nosegays, bristle with a formation that resembles green moss. More up-to-date, David Austin's English roses retain the fulsome shape and sweet scent of historical roses while adding a greater color range and a longer bloom time.

Historical roses are vigorous bushes that grow roughly 4 feet tall. In our garden, most have remained free of black spot and mildew over the years, a trait that can only endear them to gardeners who choose not to use chemicals. If small green worms threaten the buds, a single spray of *Bacillus thuringiensis*, a bacterium specifically aimed at caterpillars, works like a charm. For three weeks to a month, starting in late June (here in Zone 5) after peonies are past, the old roses bil

Sweet-scented lavender, growing here with yarrow and rudbeckia, has a long history of use in perfumes, sachets and potpourris.

low with bloom. Most flower once very generously, but some give a small encore in fall. Like their modern descendants, old roses revel in heavy, nourishing ground. Clay is to their liking, as long as it is not brick-dense or soggy; but both clay and sandy soils are best enriched with compost or manure. An annual mulch of the same maintains fertility.

Old roses grow naturally into a lax tangle of upright or arching canes; it is a mistake to think they must be tamed to resemble sparse-stemmed hybrid teas. Spring prun-

ing is necessary but consists only of shortening willowy canes and removing weak, twiggy growth, especially around the base of the bush. Deadwood is cut away, along with a few of the very oldest canes, which will be thicker and darker than the rest. The goal is to keep the bush open and shapely—cut above out-facing buds whenever possible—and promote strong new growth. Most historical roses are winter-hardy, but as a precaution, we carefully bend the pliable branches close to the ground and weight them down with a large flat rock or a cement block. Snow cover usually does the rest.

"One should make a decision," said Ippolito Pizzetti in his comprehensive *Flowers: A Guide for Your Garden*, "to have nothing whatever

to do with roses that do not have a roselike fragrance." When the old roses are in full flower above their edging of lavender, I inhale deeply and understand why they have always and everywhere been loved.

LAVENDER
Lavandula spp

Lavender is among the best garden company for old roses. Everyone likes this plant—"best of nose-herbs, cleanest and most invigorating of scents"—but some gardeners assume that lavender cannot be grown in a harsh climate. True, it may not attain the great size and purple profusion in the North that it does in England or in its Mediter-

ranean homeland. But I know one Ontario garden, as cold and clay-bound as any, where 'Munstead' lavender, child of Gertrude Jekyll's Munstead Wood garden, edges a bed of roses and lilies and sends up countless scented spikes; the 40 to 50 plants were all raised from a single packet of seeds. And in a local small-town nursery, an enormous lavender bush—"my mother plant," says the tireless woman in charge of propagation—provides hundreds of cuttings every year; dipped in rooting hormone powder and planted firmly in sand and damp peat, they soon grow to salable size.

All this gives clues to growing lavender in the North. Start from seeds or locally grown acclimatized plants, and choose hardier dwarf cultivars such as 'Munstead' or 'Hidcote.' Compact plants winter better than tall, rangy specimens, so trim lavender back by one-quarter when flowers have faded—or just as spikes are coloring, if you want them for drying. We do a spring pruning too, taking out dead branches, once it is clear which are alive and which have succumbed to winter. But it is important not to cut the whole plant down to the lower woody framework; lavender is a small shrub, and if pruned back too far, it may not regrow. Sun and good drainage are other essentials for this modest gray-leaved herb.

Old herbals speak enthusiastically of lavender's use in all sorts of remedial syrups, sweet waters, potions and pills. It was "especially good," said 17th-century gardener and writer John Parkinson, "for all griefes and paines of the head and brain." A lavender-scented oil, soothing for general massage or kneading sore muscles and joints, is easy to make. Cut a quantity of lavender spikes as

the first flowers are opening, and dry them on a slightly elevated screen in an airy, shaded place. Once the spikes are thoroughly dry, strip off flowers and buds—a fragrant task. Fill a clear-glass container with dried lavender, top with light olive oil (or more costly almond oil), cap the container, and leave it in a sunny place for a few weeks, shaking occasionally. Finally, strain the oil into another container through a funnel lined with a square of cotton, pressing and squeezing the flowers to extract more scent. Lavender vinegar, used as an astringent wash or a simple homemade perfume, is concocted in exactly the same way; white vinegar takes on a soft lavender tint.

Rubbed into the temples, lavender oil is said

to alleviate nervous headaches and depression, and a few drops will delicately scent a bath. Or you can try my giddy version of aromatherapy: Get down on your knees, bury your nose in blooming lavender, and move your head from side to side, inhaling deeply. I like to mark the pages of reference books with spikes of dried lavender and be pleasantly surprised one winter day by its sweet summer scent; a neighbor braids spikes of lavender with ribbon. Lavender sachets, using buds dried as above, are for linen closets or drawers; and last summer, I filled a small square of cloth with lavender and tucked it between pillowcase and pillow …sweet dreams.

FLORENTINE IRIS
Iris florentina

About a month before roses and lavender appear, the Florentine iris, one of the faithful "flags" of older gardens, scents a corner of our garden. This iris species is so old, it rarely turns up in catalogs—and then as an expensive novelty. We found a clump lingering by the lilacs in a chaos of quack grass, costmary and daylilies that marked the site of a long-abandoned farm garden. Recognize this sun-loving fleur-de-lis by fragrant flowers that are neither gray nor lavender but a kind of blurred opalescent color— "dove-tone," says one old book. It blooms in late May and June in this Ontario garden, just in time to

Now almost unknown, the Florentine iris was a valuable trade commodity a century ago. The root may be used as a herbal fixative

Pinks, though not as showy as their somewhat tender cousin, the carnation, smell just as sweet.

make a picture with pink and crimson tulips and a clump of bleeding hearts in the rosy glow of a crab apple tree.

Florentine irises have a fruity scent, but their dried roots smell like violets; pulverized, they be-

come orrisroot powder, a herbal fixative that enhances and holds the fragrance of other ingredients in potpourris and perfumes. In this age of chemically concocted scents, it is surprising to learn that as recently as the mid-1800s, the cultivation and processing of orrisroot was a major industry in Italy. Thousands of tons of the fragrant powder went to perfume distilleries in Florence (namesake of the flower

that is the city's emblem) and throughout Europe. One record shows that 10,000 tons of orrisroot were exported to the United States alone in 1876.

CARNATIONS; PINKS
Dianthus spp

As the Florentine iris fades, the first of the gillyflowers, beloved in the Middle Ages, appears. Clove-gillyflower is the old name of the florist's spice-scented carnation (*D. caryophyllus*) that, like the old roses, once flavored a variety of syrups, vinegars, candies and conserves for both medicinal and table use. "As they are in beauty and sweetness, so are they in virtue and wholesomeness," said the author of *The Country Housewife's Garden*. The old name, sops-in-wine, indicates another role: Imagine the bouquet of wine that begins with a "bushel of carnation petals clipped and beat with leaves of lemon balm."

Carnations are the showiest member of the dianthus genus; but in the North, they may or may not survive the winter. Far more certain are the perennials known simply as pinks, lower-growing dianthus with smaller flowers as sweet as any carnation. The sandy lime-filled ground at Larkwhistle grows pinks to perfection. In keeping with a resolve to fill the garden with plants suited to site, there are pinks aplenty tumbling over border edges and filling the June air with a sweet fragrance detectable from yards away.

Native to Britain, cheddar pinks (*D. caesius*) cover their grassy gray leaves with flat round flowers in shades of (what else?) pink. Sand pinks (*D. arenarius*) grow a short,

dense turf of green alight in June with fringed white flowers like scented snowflakes; among the first flowers we planted over two decades ago, this white pink (listed in some catalogs as 'White Princess') is still in place and flourishing. *D.* x *allwoodii* has single or double blooms of pink, white or crimson, some zoned with darker color, like the dianthus in Renaissance paintings. A single packet of seed grew enough plants to edge a 60-foot border, and no two were alike. Nurseries often carry named varieties of *D.* x *allwoodii* pinks and the smaller alpine versions. When it comes to pinks, my approach is to try any new variety I find—they don't want much space or attention in exchange for generous gifts of flowers and fragrance.

The small, dull black seeds of perennial dianthus sprout as swiftly as do lettuce seeds. Sown in a flat or a wide flowerpot in May, then shifted into individual pots as the plants come along, the green or gray tufts are set out in the garden, 12 inches apart, when they appear large enough to fend for themselves. Next summer, you'll have flowers. Especially fine colors can be further increased by taking cuttings—nonflowering tufts from the outside of the mat—in midsummer.

Dianthus love sun and absolutely need quick drainage; cold is less of a menace than is wet winter soil. These mountaineers are in their element clinging to the south face of a dry built stone wall, in a pocket of

The carnation finds a welcome home in potpourris and buttonholes.

the rock garden or along the edge of a sunny bed, where they like to hug a warm stone. They also make a sweet groundcover for a difficult-to-mow dry bank; just be sure that all perennial weeds have been thoroughly dug out— no garden job is as tedious and disheartening as extracting choking bindweed or prickly thistles from mats of dianthus. Maintaining these amiable plants in the garden entails shearing back flower stalks and about one-third of the foliage once the bloom is off; large, sharp scissors make a tidier job of it than dull, awkward garden shears. Recently sheared plants may look a little "strawy" and forlorn at first, but they soon bristle with new growth; and the tight, compact mounds winter well. Any bits that do suffer winterkill can be trimmed away in spring.

SCENTED GERANIUMS
Pelargonium spp

Scented geraniums are baffling plants with the extraordinary ability to mimic the scent of the fruit, flowers, leaves and seeds of unrelated species. But who can say why or how? Other herbs do this on a small scale: Thyme, balm, verbena and even one species of catmint capture the scent of lemons in their leaves; there is a rose-scented ber-

gamot and a thyme that smells like caraway. But the herbal masters of mimicry are, hands down, the scented geraniums (*Pelargonium* spp), South African relatives of the bright, summer bedding geraniums. Their foliage may be redolent of almonds, anise, apples, camphor, cinnamon, coconut, lavender, lemons, lime, mint, musk, nutmeg, pine, roses, strawberry and violets. What an amazing bunch of plants!

Scented geraniums are not hardy, although they are easy to grow. Among the best container herbs for sunny high-rise gardens or ground-level patios in summer, they must sit indoors in a sunny window for about seven months of the year— unless you treat them as annuals. We buy three or four varieties every spring: One year, a fuzzy-leaved peppermint geranium or a chocolate-scented sort will be included and always rose and lemon. Planted in large clay pots, they sit in the sun by the side door releasing their fragrance—a rub and a pinch as you pass by. Since they achieve a considerable bulk by summer's end and we have limited space indoors, we let the frost do its deadly deed and then add the wilted remains to the big fall compost heap. I can hear our tenderhearted herb-loving neighbor: "That nice big plant, leaving it out to get frozen—you're so cruel."

If you want to keep them over, scented geraniums require pruning and relocating twice a year. A small nursery plant should be set directly into a 12-inch-diameter container of soil that is both moisture-retentive and well drained. Come June or whenever frost is over, it can live anywhere outdoors in the sun where, like all container herbs, it will need frequent watering. Alternatively, sink pot and all into a garden bed or an oversized window

box where rain showers will probably suffice; a wooden half-barrel will hold three and soon spills over with fragrant foliage. Feeding is not essential unless the plants seem to be struggling; nourishing soil at the start should be sufficient.

Because scented geraniums wither at the mere hint of frost, they must be brought in to a bright window, a sun room or a greenhouse from mid-September until early June, rather longer than just "over winter," as one catalog states. If they have shot up during the summer, moderate pruning is in order before they are brought in. Indoors, water thoroughly but only when the soil is fairly dry. Do not feed a scented geranium in winter until lengthening February days spur the plant into active growth again. Late spring is the time to prune or pinch away at least half of the winter-spindly growth to prepare for another summer outdoors.

When a plant grows too large for the space it has been allotted, you can root a few cuttings in late summer and compost the original. (Or give it away: After seeing a scrawny specimen of "finger-bowl" geranium in a fancy food-shop window priced at a shocking $17, I started to feel I was being cavalier letting our big fellows freeze.) The best scented geraniums seem to grow for decades in the large, bright windows of old-fashioned barbershops.

Oils expressed from the leaves of scented geraniums flavor chewing gum, candy and ice cream. The home gardener is more apt to use a leaf or two when making jams and jellies, in herb teas, hot or cold, and in fresh-fruit desserts and baked goods. Dried leaves are also perfect for potpourris, alone or with any other fragrant flowers, seeds or leaves, a few drops of essential oil and a

herbal fixative such as orrisroot.

In her book *Home and Garden*, Gertrude Jekyll described the making of a potpourri (literally, "rotten pot"), which included primarily rose petals and sweet-geranium leaves, with lesser amounts of lavender, "sweet verbena," bay leaves and rosemary, all mixed with strips of dried orange peel stuck with cloves, orrisroot powder and "various sweet gums and spices."

Its scent redolent of citrus, the lemon geranium gains girth throughout the season.

Jekyll made the mixture in such quantity that she graduated from mixing it in a large pan to preparing it in "a hip bath in later years, in a roomy wooden tub; but now the bulk is so considerable, it can only be dealt with on a clear floor

The pulverized roots of *Iris florentina* are known as orris-root powder, one of the most common potpourri fixatives.

space." The "moist" method described by Jekyll involved layering semidry rose petals and herb leaves with salt in separate stoneware crocks, their lids weighted down. The ingredients were left to cure until fall, when "the pressed stuff… is so tightly compacted that it has to be loosened by vigorous stabs and forkings with an iron prong," after which the ripened ingredients were tossed together with the powders and gums in a heap that "grows like one of the big anthills in the wood until, at last, all the jars are empty and everyone's hands are either sticky with salt or powdery with sweet spices. Now the head Potpourri maker takes a shovel and turns the heap over… until all is duly mixed." Some fun, but who has bushels of rose and geranium leaves, not to mention the floor space and the extra hands? While Jekyll admits that dry potpourri is "neither so sweet nor so enduring," it is nevertheless "much the easier and quicker to make."

Potpourri is one way to use plants that otherwise seem unlikely garden candidates. If they were not fragrant, scented geraniums would

have disappeared from windowsills and flowerbeds long ago—they are not very pretty. And who would grow lavender if it were not so sweet? I suspect that the old roses, too, have lived in gardens for centuries on the charm of their fragrance. And rightly so—there is more in a garden than meets the eye. The last word goes to John Gerard, from his *Grete Herball* of 1597: "If odours may work satisfaction, they are so soveraigne in plants and so comfortable that no confection of apothecaries can equal their excellent Vertue."

POTPOURRI

Gather ye roses—scented only—while they are half to almost fully open; pull the petals away, and lay them in a single layer on an elevated window screen. Harvest laven-

der when, as Jekyll said, "a good portion of the lower flowers in the spike are out," and screen-dry in the same fashion before stripping off the flowers and buds. Dry the leaves of anise-hyssop, bergamot, eau de cologne mint, lemon basil, lemon verbena, rosemary, scented geraniums and other herbs either on a screen or by hanging loose bundles in an airy, shaded place. If all the potpourri ingredients are collected for drying one July morning after the dew has evaporated, everything will be ready for blending a week or so later.

In the meantime, purchase some fixative, a powder of vegetable origin that absorbs and retains the volatile scented oils of other herbs. This can be found in health-food stores and herbal shops. The most common fixatives are the dried and powdered roots of *Iris florentina* —orrisroot powder—and of sweet flag (*Acorus calamus*), or calamus, alone or in combination. For added fragrance, mix the fixative with an equal amount of ground spices, which may include freshly grated nutmeg, ground whole cloves or cinnamon sticks or ground anise or fennel seeds. And moisten the fixative/spice mixture with two drops of an essential herbal oil that suits the ingredients.

To assemble the potpourri, toss dried leaves and petals together in a large bowl, add two tablespoons of fixative for each double handful of herbs, and stir well. Store the potpourri in a covered, opaque container for six weeks to allow the scents to mingle and mellow, then divide the finished product among corked glass jars or set out in bowls.

From the Wild

Herbs from woods, fields and meadows

When I was growing up in the urban landscape of southern Ontario, my grandmother and older aunts would take to the parks and ravines every spring—always with a raft of grandchildren, nieces and nephews in tow—to collect *cicòria*, chicory and dandelions. Simmered in water until tender, the leaves cooked down into a slightly bitter dish of *verdura*, or greens. But the time spent digging and delving was about more than just food. Roving the grassy hillsides in a scattered, chattering group, my relatives were reconnected for a morning with the rhythms of "the old country," southern Italy, in a new land.

Foraging for food and medicines is an activity as old as time, one that links us with past generations of pioneers and rural folk, all the way back to the earliest humans—people who knew the land and drew on its seasonal bounty. Today, foraging remains a skill worth fostering, one that broadens our appreciation of the gifts that come from the earth and reminds us of the real source of our sustenance, even when much day-to-day gathering is done at the grocery store or farmers' market. In an age when most of life's physical necessities are supplied by hands other than our own, there remains something satisfying about collecting useful wild plants.

Today's foragers usually go for the good stuff: delectable fiddleheads, wild asparagus and berries and favorite mushrooms. But it is not much of a stretch to gather a bunch of wild leeks for a spring soup or to pick a sack of red-clover blossoms for tea. In fact, tea is the best and simplest way to derive the health benefits of herbs. And wild places provide some of the best pickings.

Before the advent of laboratory medicines, herbs were routinely collected for medicinal use. The knowledge of herbal treatments was widespread, and rural households often had a "simpling room," where herbs from the wild and gardens were dried, stored and processed to treat ailments year-round. These days, herbal products fill drugstore shelves alongside vitamins and "regular" medicines. But a number of plant-based preparations—tinctures, ointments and teas—are as simple to make now as they ever were. With some research, budding herbalists might avail themselves of the wealth of wild herbs and turn out homemade preparations on a par with store-bought. Care is called for with any medicinal, herbal or otherwise. Some herbs are extremely potent, others poisonous; but many more are mild in their effects and have been safely used throughout the ages.

Accurate identification of wild herbs is the first step, and a good guidebook such as Peterson's *Field Guide to Edible Wild Plants* should accompany you on foraging trips until you know precisely what you're after. In the hunt for wild

With sky-blue flowers on tall stems, chicory announces the arrival of summer on roadsides and in fields across the continent.

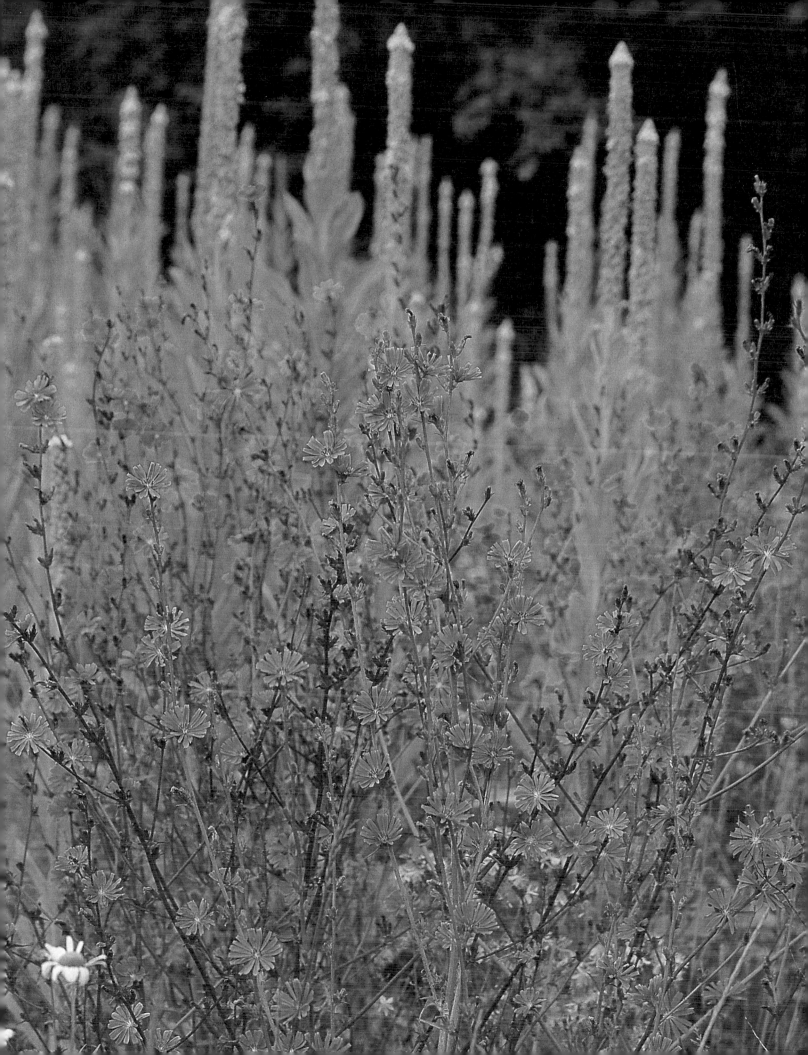

herbs, try to get away from busy roadways or cultivated fields that may have been sprayed with herbicides; instead, seek out untended meadows, old pastureland, back roads and woodlands. And even though the plants you want may be abundant, take just what you need and move around as you pick to keep from stripping an area.

TEA FROM THE WILD

Every year, our gardening friend Margot Bernard patiently gathers 20 or so different herbs for a complex one-of-a-kind herbal tea. Surrounding woods and meadows supply half of the leaves and flowers, and the rest come from her garden. "It's not difficult to get the herbs together," says Margot. "They are not all ready at once, though, so I dry little batches of this and that all summer and blend them in fall." I can attest to the tea's excellent flavor; and given the long list of ingredients, it must also be extraordinarily good for you. Interestingly, a number of the wild herbs in this tea have traditionally been recommended for "chest complaints" and upper-respiratory problems. Have this tea on hand during the chilly months, when sore throats, coughs and colds are more prevalent. A review of many of the herbs in Margot's Tea (see recipe on page 207) is a good introduction to the herbs available in the wild.

ALFALFA
Medicago sativa

A member of the bean, or legume, family, alfalfa is often planted as a field crop to provide winter fodder for livestock. In many areas, self-sown wild alfalfa springs up at the edges of uncultivated fields. Fine as a bland beverage tea on its own, alfalfa can also be blended with other herbs. Medicinally, it is reputed to improve the appetite. An aid for urinary-tract problems,

Dry mullein flowers in a dark, cool place for use in tea blends.

alfalfa tea is also said to help with the elimination of retained water.

HORSETAIL
Equisetum arvense

Horsetail is frequently found growing wild in pastures, meadows and uncultivated fields, usually in low places where water collects. You sel-

dom find just one, as this fine-leaved flowerless plant spreads quickly by means of underground rhizomes. Health-promoting virtues have been claimed for horsetail since the days of ancient Rome. A general tonic, horsetail tea has been used to treat chest ailments, anemia and kidney and urinary problems. Rich in silicic acid, minerals, vitamins and salts, it is said to enrich the blood. Collect in early summer, dry, and store in an airtight container.

Above, plantain for colds; upper right, raspberry for stomachaches; and right, red clover for nerves.

MULLEIN
Verbascum thapsus

Studded with yellow flowers, mullein stalks punctuate the wild landscape in many areas like a vegetable exclamation mark. Mullein flowers have been used as medicine in many countries, traditionally to treat chest complaints of all kinds, sore throats, asthma, dry coughs and hoarseness. Leaves, too, are considered beneficial, but an infusion made with mullein leaves must be strained through very fine cotton or muslin cloth to remove the countless fine hairs that would irritate rather than soothe the throat. For a tea blend, stay with mullein flowers, easily collected in the wild in midsummer. Dry them carefully in a dark, cool place to retain their color and medicinal properties.

PLANTAIN
Plantago major

Plantain, one of the commonest garden weeds, is a low-growing nondescript plant with simple elongated leaves and a spike of greenish flowers. Containing tannins, mucilage and silicic acid, the rather bitter leaves are regarded as helpful in the treatment of ailments of the upper-respiratory tract, such as chest colds. In the same vein, the fresh juice boiled with honey is said to be an effective cough syrup.

RASPBERRY
Rubus idaeus

Raspberry leaves from local wild stands of red raspberry form the basis of the tea. A native bramble, raspberry is widespread in thickets, woodland margins and neglected fields throughout North America. All herbalists agree that raspberry-leaf tea is an effective antidote for stomach ailments and for what has been politely described as "severe laxity of the bowels" (diarrhea). Also said to be good for chills, colds and flu—the leaves have astringent and decongestant properties—raspberry-leaf tea has long been used as a simple hot beverage.

RED CLOVER
Trifolium pratense

Red clover blossoms, said to be "very soothing to the nerves," are added in equal measure to the tea. A favorite forage for bees, the blossoms add a hint of sweetness to the blend. Red clover is a common pasture plant that often comes up in unsprayed lawns or wilder corners of a property. It also appears in natural wildflower meadows amid daisies, buttercups and hawkweed.

ST. JOHN'S WORT
Hypericum perforatum

St. John's wort has recently leaped to the forefront of ready-made herbal preparations. This common wildling of dry, sunny meadows can be recognized by its clusters of small but showy sunburst-yellow flowers in summer. In the past, the dried flowers and leafy tops were found in most country households in the Old World, where they were used as a tea herb to improve sleep, blood circulation and the workings of the gastrointestinal system.

VIOLET
Viola spp

Violet flowers and leaves carpet the ground in spring woods; in the garden, sweet violets do the same (sometimes to a gardener's cha-grin). The therapeutic value of vio-lets has been lauded for ages, and recent research has borne out the claims. Traditionally prescribed for headaches, migraines and insom-nia, sweet violets are now known to contain an element of salicylic acid. Sound familiar? This is the same compound derived from willow bark and used in the synthesis of acetylsalicylic acid, or aspirin. Violet leaves and flowers should be dried carefully in the shade in spring to preserve their color and potency.

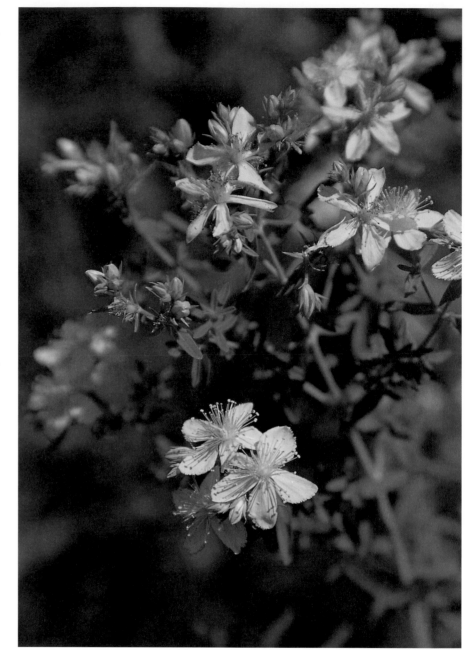

WILD STRAWBERRY
Fragaria vesca

Wild strawberry grows thickly at the margins of fields and along the shoulders of backcountry roads in many locales. The leaves brew a mild, pleasant tea, a reputed "blood cleanser" said to be "a good tonic

In the past decade, St. John's wort has gained an enthusiastic follow-ing among herbalists.

for convalescents and for children." Like those of the related raspberry, wild strawberry leaves have astrin-gent and tonic properties.

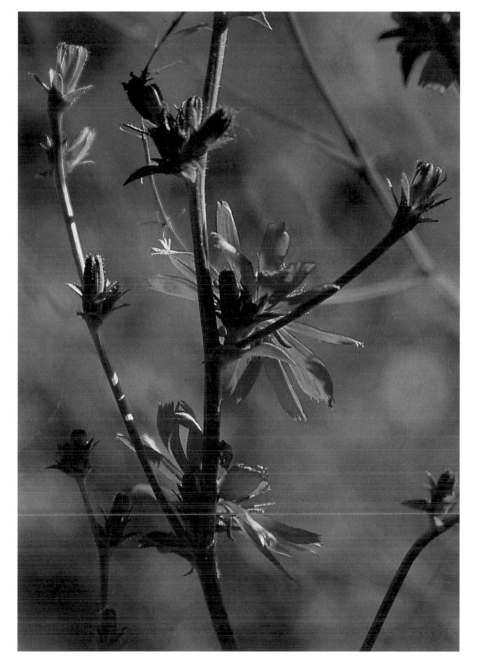

For centuries, yarrow has been a medicinal herb in good standing. Like chamomile, to which it is related in the daisy family (Compositae), yarrow benefits the digestive system. Achilles, namesake of the genus, is said to have stanched the wounds of his soldiers with yarrow leaves. Other old names—soldier's woundwort, staunchweed, sanguinary, knight's milfoil and, in very ancient times, *Herba militaris*—indicate its use as a hemostatic, an agent that helps stop the flow of blood.

Nor is its use exclusively external. An infusion of leaves and flowers (1 tablespoon dried herb to 1 cup water, simmered, then steeped for 5 minutes, with lemon juice, honey and an optional dash of cayenne pepper) is still considered a remedy for feverish colds, because it promotes sweating. A stimulating tonic for the whole system, yarrow tea has a history of use for lack of appetite, cramps, flatulence and other stomach-related ailments. While it is a good mixer in a blend, yarrow also makes a pleasantly bitter and aromatic brew on its own. But people who are allergic to ragweed, asters or other composites should avoid yarrow preparations altogether.

BEYOND TEA

The root of the widespread chicory plant can be roasted and ground to produce an ersatz coffee.

YARROW
Achillea millefolium

Yarrow, or milfoil, is such a determined spreader that it has hitched a ride from its native Britain to virtually every corner of the temperate world. In North America, this aromatic, slightly hairy herb appears in hayfields and meadows and along roadsides—indeed, any bit of unused land is likely to be colonized by yarrow. Wild white-flowering yarrow, like its colorful garden kin, sports a showy flat head composed of numerous tiny flowers.

CHICORY
Cichorium intybus

Boasting sky-blue summer flowers on tall stems, chicory is closely related to the dandelion and just as healthful. Its leaves, though, are sparser and stringier. Chicory root is better-known. Roasted and ground, it brews up a bitter ersatz coffee and can be added to real coffee to make

it go further. In some European countries, the roots are boiled as a vegetable and purported to be beneficial to diabetics. Various cultivated chicories, such as 'Witloof,' yield heads of tender, creamy white leaves, as delicious as they are expensive.

DANDELION
Taraxacum officinale

Dandelion has been extolled through the ages for its health-promoting properties. Not long ago, kids played a game of "who likes butter," holding a dandelion flower under one another's chin to see the reflected yellow glow that proved you did. Today, kids may be kept off a lawn recently sprayed with weed-killing chemicals. In some quarters, dandelions are scorned as noxious weeds. Pity the poor dandelion, despised, dug out, sprayed to death, the victim of a nutty modern obsession with unblemished green outdoor broadloom—the lawn. Better to spare the land a seasonal barrage of herbicides and learn to live amicably with this innocuous herb. Better yet, bring dandelions to the table.

North Americans have little taste for things bitter. Europeans, on the other hand, enjoy the sharpness of dandelions and other bitter leaves, such as radicchio, cooked as a vegetable or eaten raw in salads. So appreciated are dandelions in Italy and France, in fact, that new varieties with longer leaves have been cultivated. I know several city gardens where the old *paesano* in charge grows little else but dandelions, tomatoes and basil. Our garden, too, usually has a row for spring leaves that are ready to eat before most other greens are seeded.

Maligned by suburbanites, dandelions are healthful and, to some, a cheery presence.

To grow dandelions, look for the seed of improved varieties—'Catalogna,' 'Dentarella,' 'Ameliore' and others, sometimes listed as or under chicory—in catalogs or off the seed rack in supermarkets or garden centers displaying gourmet or European seed. For the best results, sow seed from mid- to late June (when seeds from lawn dandelions are blowing around) in ordinary garden soil in sun. Thin seedlings to a hand span apart. You still have to keep your weeds weed-free and watered. Pick leaves as they grow, or cut whole plants a couple of inches from the ground to encourage regrowth. Leave dandelions in place during fall cleanup, and they will come up again in early spring. We often put large inverted flowerpots over individual dandelions in April, a simple blanching technique that encourages quicker growth of tender leaves.

Before we grew dandelions, we used to head into a nearby hayfield in search of saw-toothed leaves coming up through last year's fallen grass. Stretching through the strawy patch, these field dandelions are naturally blanched, their lower leaves pale and mild for lack of sunlight. Cut dandelion clumps just below ground, then separate the individual crowns and wash them carefully before making salad or simmering the leaves. Spring dandelions are usable from first growth until the flower bud appears in the center. Later in the year, I pick tougher leaves to simmer in a mineral-rich broth, perhaps adding parsley and celery leaf from the garden, then discard the leaves before drinking the savory tea.

one contemporary herb writer says: "Eating or drinking dandelions in any form will have a beneficial effect on the body."

STINGING NETTLE
Urtica dioica

Stinging nettle is a herbal workhorse, rich in minerals and vitamins. A famous spring tonic, nettle leaves are traditionally added to soups or cooked as a spinachlike vegetable. Use only small, young leaves, and handle with care. Nettle tea is often prescribed to improve the function of the liver, gallbladder and intestinal tract and is indicated for rheumatism and gout. A hardy perennial, nettle may be found growing wild or can be grown in an outlying part of a big garden where its invasive spread will not be a menace.

The curative properties of dandelions have been recognized for centuries. Packed with protein, minerals, sugars and vitamins, dandelions are good medicine as well as fine food. Both traditional and modern herbalists agree that dandelions have diuretic and mild laxative properties and that they aid digestion, help purify the blood and act as an all around tonic. Like other bitter plants, the dandelion

Stinging nettle can be found in the wild or cultivated in a corner of the garden where its tendency to wander can be monitored.

is recommended for complaints related to the liver, gallbladder and kidneys; it is also indicated as a treatment for rheumatic and arthritic conditions. Dandelions may be an acquired taste, but as

Herbal Know-How

Propagation, preservation and growing herbs indoors

Herbs From Seed

The craft of gardening teaches observation and patience—instant gratification is seldom the way, and you can't hurry growth. Raising herbs from seed is one of the most intriguing processes, asking for a measure of care and watchfulness beyond the ordinary. You learn a lot about plants as you see them through the early stages; and a singular satisfaction comes with nurturing something from a dry, dark speck to full flowering.

If you find yourself shying away from seed, take heart. Even experienced gardeners can be intimidated by seeds. "I never quite get over the wonder of my early gardening years," wrote Louise Beebe Wilder, "that seeds come up at all." It takes an imaginative leap to picture several hundred basil bushes locked inside those inert-looking seeds rolling out of a packet. Faith falters when an envelope labeled "sweet marjoram" seems to hold just a few shakes of pepper,

despite the catalog's assurance that "a packet contains 300 seeds." Seeds in hand, otherwise sensible gardeners turn into doubters and are moved to pour the entire contents of a packet over a flat or a flowerpot in the vague hope that a few seeds will prove lively. Given warmth and water, the seeds, of course, do what fresh seed cannot help doing: 86 percent of them (as promised on the envelope) sprout. The astonished gardener is left wondering what to do with hundreds of basil babies or a flowerpot covered with a little turf of marjoram. Rare is the gardener strong-willed enough to thin 200 seedlings to the needed 12. One neighbor routinely calls on my partner to thin seedlings for her because "he's so ruthless" ("Just realistic," says he). An old farmer friend has another maxim: Sow thick, thin quick. No plant gets off to a good start if jammed together with scores of others in a small container—but more about that later.

Why grow from seed at all when

you can find plants ready-grown, past their tricky infancy, in nurseries? For one thing, seeds are the least expensive way to acquire any herb in quantities greater than one or two. And seeds open the door to variety: Nurseries may have sweet basil, period; but one seed catalog lists 16 variations on that theme—lemon, spicy globe and holy basil among them. Finally, seeds connect us in a special way with the whole cycle of plant life.

Seed in hand, the first decision is whether to sow indoors or out. The location depends on what you are growing. Many herbs sprout as quickly as do radishes and lettuce, so not much is gained by an indoor start. Some herbs, in fact, do better when sown directly in the garden. Anise, borage, chervil, coriander, dill, fennel and summer savory,

Arugula seedlings, famously agreeable, grow in almost any type of soil and germinate even during a cold, wet spring.

annuals all, are among the easiest culinary herbs for sowing outside. With luck, they will spare you the work in subsequent years and pop up on their own—we haven't seeded coriander or dill for ages and always have plenty of both. Parsley and leaf celery are outdoor possibilities, but both are slow from seed and tempting to insects when small. Basil sprouts readily enough in warm soil, but if you've ever seen an earwig in your garden, don't waste your time seeding basil outdoors—earwigs will undo your best efforts. Most of the salad herbs (see Chapter 9 for details) grow well when seeded in the garden. Nonculinary herbs for outdoor sowing include calendula and poppies of all kinds; these will also self-sow if you don't deadhead every last flower.

In general, annual herbs are the best candidates for outdoor seeding. Perennials, as a rule, are slower to germinate, but several can be sown outside with reasonable hopes of success. These include anise-hyssop, chamomile, foxglove, lemon balm, lovage, mallows of various kinds, mulleins and sweet cicely. All self-sow in our garden with more abandon than we like.

Spring is the time for seeding indoors, starting four to six weeks before the last spring-frost date in your area. First decide how many plants of one kind are needed. For most herbs, three to five will usually suffice; but a dozen basil plants is not too many for a large family of pesto lovers. Having decided on numbers, the next step is to assemble suitable containers. Seedlings are started in all sorts of quirky things, from egg cartons to half-eggshells to used take-out coffee cups. More traditional are small containers such as clay, plastic

Seeds sown indoors can be coddled in a sunny window or placed under fluorescent lights and kept warm with soil-heating cables.

or peat pots, divided cell-paks and rolled paper pots.

Most gardeners have (or find) a method for starting seedlings that suits them. Spring is a busy time, so I like to keep things simple. Everyone has leftover plastic pots, cell-paks and trays from nursery plants,

and these can be reused to start herbs. When I want from 3 to 12 of a particular herb, I sow several seeds in as many 2-to-4-inch pots and thin eventually to the strongest single seedling. This procedure eliminates the time-consuming, all-thumbs task of "pricking out," shifting tiny bunched-together seedlings into individual pots.

The growing medium is the next consideration. Doug Green, a commercial grower of flowers and herbs, recommends a half-and-half

Fill the containers with the growing medium, tamp lightly to firm and settle the soil, and top up with more earth. Make a shallow fingerprint indentation in the soil, and drop in several seeds, before covering lightly—small seeds need just the barest cover. As one writer notes, "Most gardeners should play the last post as they bury their seeds"—sown too deep, they may never see the light of day again. Water gently before putting seeded pots in a warm place. Warmth can come from soil-heating cables, a radiator or a woodstove. One gardener I know sets pots on saucers on an electric heating pad. A sunny window in a room of normal temperature usually provides warmth enough; a sheet of clear plastic draped over containers retains both moisture and warmth. In general, seeds of hardy perennials germinate at lower temperatures than seeds of the heat-loving annuals.

Only a jaded gardener (if such a species exists) is not a little entranced by the slow dance of seed sprouting—"one of the most bewitching sights in the world," according to Nathaniel Hawthorne. As soon as small green backs show through, light is the greatest necessity: at least six hours of sunlight per day or an artificial substitute such as fluorescent grow lights suspended several inches over the emerging seedlings. Never allow the soil to become completely dry. If the soil mix is fairly nourishing, fertilizing is not necessary.

As the spring warms up, seedlings might spend fine days in a cold frame or on the deck. But don't put indoor-grown seedlings outside for a full day in the blazing sun. Gradual exposure to outdoor sun and wind, a process called hardening off, is essential—perhaps a Saturday

mixture of bagged potting soil and perlite, ingredients that are readily available in March when the ground outside may still be winter-crusty. Such a mix is lightweight and porous but water-retentive. It's also weed-free, so you are not left peering at bits of green wondering what is basil or sage and what is not. Finally, potting soil and perlite are free of plant diseases, eliminating the disheartening prospect of seedlings keeling over from damping-off, a fungus often carried in

Seedlings can be placed in a cold frame for hardening off, but allow for ventilation on a sunny day if you're going to be away.

unsterilized soil. That said, we have grown many herbs, vegetables and flowers from seed in ordinary (but quite sandy) garden soil mixed with one-third sifted compost—and by now, we know our basils from burdock. Still, I would recommend Green's mix for the reasons given.

morning and a Sunday afternoon to start. If you are leaving seedlings out for the day, be sure to soak them in the morning; one drying could put paid to the whole process. Sun from morning until 2 p.m. is better than noon till 6 p.m. A cold frame is useful for hardening off, but if you are going to be away for the day, be sure you open the frame in the morning; seedlings that are shut in on a sunny day will surely fry. Seedlings can also be grown in a sunny cold frame from the time they germinate. Ventilation is important, and there are mechanical devices available that will automatically raise and lower the frame lid in your absence.

Eventually, the time comes for transplanting. Around the date of the last frost, gardeners across the land enact the same rite of spring: rushing in circles trying to fit too many small green things—waiting in the cold frame, sitting on the deck, impulsively brought back from a nursery—into rapidly shrinking space. Some gardeners become terribly timid at transplanting time—digging a small hole, squeezing in the seedling and pushing a few crumbs of soil over the roots—and miss the opportunity to get some organic matter into the ground. In preparation for transplanting, we always have a bucket of "good stuff" on hand: sifted compost and/or very old manure, sometimes mixed with damp peat moss and usually whitened with bonemeal.

Transplanting is best done on an overcast day or in the late afternoon, if there is a chance that roots will be disturbed. For each seedling, trowel out an oversized hole and scoop in a double handful of the nourishing mix, stirring it well into the surrounding earth. This

Plan your herb garden carefully, then transplant seedlings in late afternoon or on an overcast day.

makes a zone of fertility for each transplant. Firm the ground with your fist, before setting in a young plant at the depth it was growing or fractionally lower. Backfill with earth, and firm the soil with fingers or a blunt stick—I use the end of the trowel handle—to ensure close contact between roots and soil. Leave a shallow earth saucer around each transplant, and flood with water. When an area has been planted and the water has drained away, scratch the soil around the young plants with a hand cultivator. Nothing looks nicer than a freshly planted bed, fluffed and leveled and ready to grow.

Press down on the seeds with the back of a rake so that they are in tight contact with the soil.

Dividing Plants

Some herbs, such as French tarragon and peppermint, cannot be grown from seed. Others, like sweet woodruff and lady's mantle, take so long to germinate that a gardener can lose patience, especially when a starter plant can be conjured into six or eight after one season. Division of the rootstock—splitting the roots up—is the obvious way of increasing any perennials that proliferate underground from year to year.

Division is done not only to increase a plant but also to rejuvenate a deteriorating older clump, starting over with lively side shoots while discarding the spent center. Cutting away chunks of wandering mint is a rough-and-ready division meant to curb its spread.

Throughout many areas, April and May and September and October are the months to divide most perennials. As a rule, later-flowering plants are split in spring, while those which bloom in spring and early summer are divided in fall. With many perennials, you have some discretion, but primroses are best divided in June and irises in July, after they have finished flowering; peonies are split in fall only.

Cuttings

A cutting is any plant part—stem, root, leaf—that under certain conditions will regenerate into a new plant identical to the parent. African violet fans are familiar with rooting leaf cuttings, while a gardener who takes a tiller through a patch of horseradish knows that

MULTIPLICATION BY ROOT DIVISION

❖ With a spading fork, pry up and lift a clump out of the ground.

❖ Shake, brush or wash away some of the earth from the clump to expose more shoots and roots, the better to see where the plant splits naturally into separate crowns. Some plants start to untangle themselves as you lift them; these can be further pulled apart by hand into separate pieces. To split more tightly woven species, slice down between the shoots and right through the roots with a sharp knife or sever the necessary ties with pruning shears before prying sections apart with a hand-fork (inserting two hand-forks back-to-back in a clump, then wrenching them sharply outward usually does the trick).

❖ Do not replant everything you have just dug up. Pieces from the outer edges of a clump are always livelier and reestablish more quickly in a new locale. Discard the woody middle.

❖ Two to five shoots with roots make a good new division, but rare plants can be split into as many single-crowned bits as they yield. Just be sure the plant is, in fact, divisible—I once carefully dissected a favorite seed-raised gentian and lost it completely. A large clump may yield 20 to 30 divisions, some better than others, as well as a mound of broken roots, severed shoots and other debris. Select as many divisions as you need—and resist the impulse to keep every last shoot—then compost, give away or sell the rest.

❖ Replant the divisions firmly in ground enriched with humus (as for transplanting); fine-textured organic matter hastens the formation of new roots.

Plant division not only provides you with more plants but rejuvenates an old plant by giving it new opportunities.

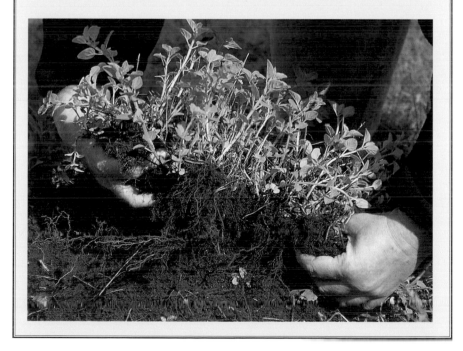

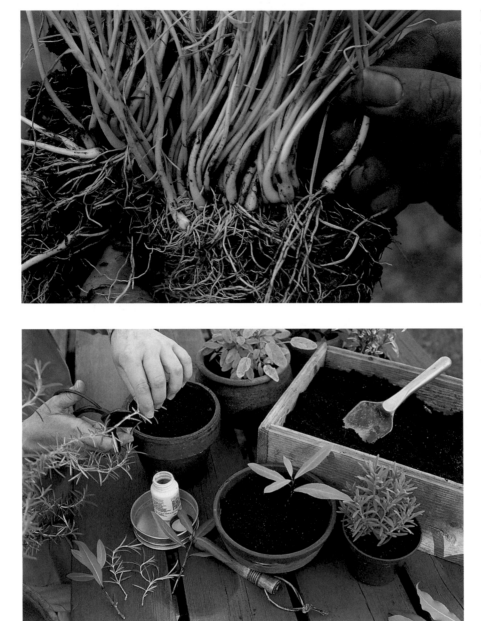

branch, cutting just below a leaf.

❖ For softwood cuttings, pick the leaves from the bottom one-third of the cutting, and dip the stem end in a rooting hormone powder.

❖ Have ready a clean 4-inch flowerpot—one for each three to five cuttings of the same species—filled with equal parts sand and damp peat moss.

❖ For each cutting, poke a small hole in the rooting medium with a pencil point, and insert the leafless third of the cut stem into the medium. Firm gently around each cutting, and water.

❖ Slip a roomy transparent plastic bag over each pot, and slit a few air holes in the bag with scissors. See that the bag does not touch the cuttings.

❖ Keep the pots of cuttings in a moderately warm place in the light but out of direct sun.

❖ Softwood cuttings usually take 10 to 20 days to put out roots, at which time they can be potted individually.

Layering

A "layer" is like a cutting still attached to the parent plant; and layering is perhaps the easiest way to increase a herb. Examine a tuft of lemon thyme or winter savory or a sage bush, and you will likely find that the outer branches lying on the ground have put down a few roots where they touch the earth. This natural tendency to layer can be encouraged.

❖ Select an outer branch inclined toward the ground, and press it against the soil. Pick the leaves from the section of stem touching the ground and scrape the underside of this section with a knife. (Actually,

Bulbous perennials such as chives, top and facing page, are easily separated. Another way to encourage new life from an old plant is with cuttings, above.

every cut root will give rise to more horseradish. For the herb grower, stem cuttings are a practical method of increasing certain herbs: rosemary, tender tropical sages, cooking sage, winter savory, lavender

and the like. Seed-grown lavender plants, for instance, often vary in habit and flower color, but it is possible to perpetuate the best of the lot with cuttings. Here are the steps:

❖ Young spring growth—technically known as softwood cuttings—are the easiest to root. Select shoots about 3 inches long, and being careful not to crush their stems, detach them from the main stem. Alternatively, snip the top 3 inches from any vigorously growing

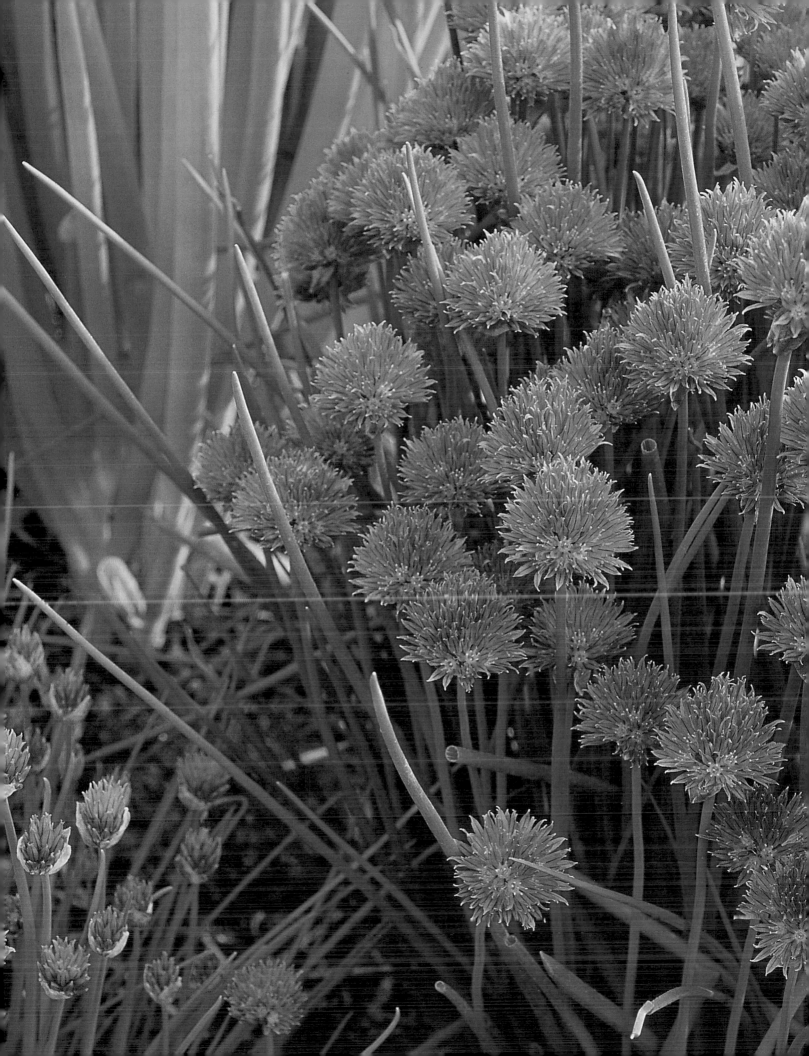

raised from seed. Any gardener who grows a flat of lemon basil or splits a favorite clump of red bergamot always has extras to hand along to appreciative friends—a lively circle of plant growth and exchange.

Bring Them In

Culinary herbs may be best fresh, but fresh in winter is no easy feat —magazine photos of windows packed with green herbs while icicles hang from the eaves are more fantasy than reality. A thriving indoor herb garden depends on good sunlight—a sun room, greenhouse or large south-facing window—but many herbs need winter rest. Obvious choices for wintering indoors are tropical herbs or Mediterranean plants—fruit and pineapple sage, scented geranium, rosemary, bay and such—that hail from lands where winter is mild to nonexistent. Parsley uprooted from the garden in September and squeezed into a small flowerpot cannot be expected to yield a crop worth the bother, but some herbs, given sun and root room, will grow indoors, albeit at a reduced rate during the darkest months.

Here are some of the most successful herbs for fresh winter use and some tips for growing them:
❖ *Basil*. Rather than digging up seedy and bug-riddled basil plants in fall, a second seeding in mid-August is the way to go. Sow about a dozen evenly spaced basil seeds around the edge of an 8-to-10-inch flowerpot filled with good soil. As seedlings develop and touch, thin them to five well-spaced plants, and bring them in to your sunniest indoor window before the first frost. Young plants will provide a modest

Propagation without seeds can also be accomplished by layering.

I've never followed this scraping step, and things layer just fine.)
❖ Loosen the ground, and press the stem into the earth. If the soil is heavy clay, lay down some sandy soil or compost under the contact spot, and push the stem into this. Press earth firmly over the stem to a depth of at least an inch.
❖ As layered branches have a tendency to spring back up, peg them down with a small stone, a forked stick, a bent bit of wire or a hairpin.

Then forget the layers for a while. In the variable heat and humidity of the garden, layers often take as long as two months to root. And since they are being supplied with

nutrients from the mother plant, there is no rush for them to establish an independent root system. Early-summer layers can stay in place until September or the following spring, when they are snipped from the parent plant and transplanted to a life of their own.

By taking a hand in the various processes of procreation, a gardener ensures a steady supply of plants at little or no cost. Perennials are renewed occasionally by division; annuals and biennials, like dill or parsley, become full-time garden residents if you gather seed for another season. Bare corners of the garden are quickly filled with a few slips of something from across the path; one clump of thyme becomes five or six, and intriguing herbs, rarely found in nurseries, can be

BEASTS AND BEAUTIES IN THE GARDEN

The swallowtail caterpillar will voraciously devour your fennel.

The four-line plant bug damages plants by sucking their sap, which in turn causes stunted growth and unsightly brown spots.

The gardener's friend: a tiny tree frog (*Hyla versicolor*) makes short work of small plant-harming insects and other pests.

White admiral butterflies help pollinate angelica.

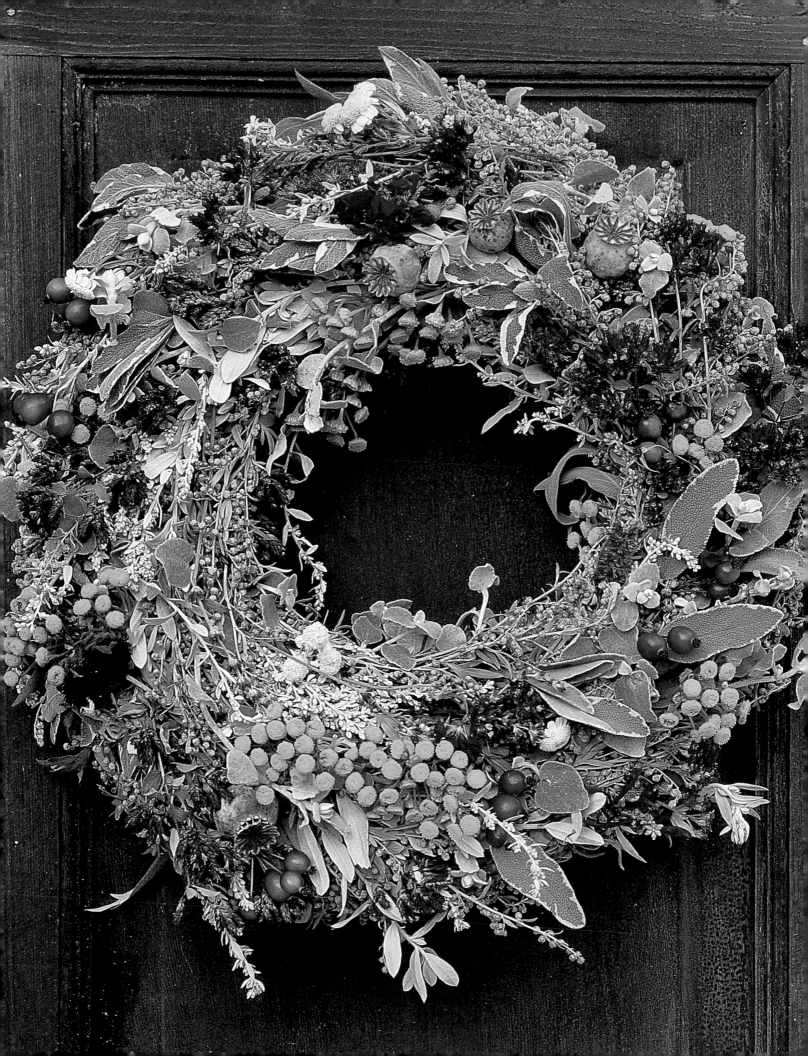

harvest well into fall and may come through the winter if light conditions are ideal. A late-summer re-seeding is also appropriate for other annuals, such as chervil, coriander, dill and summer savory.

❖ *Parsley*. This useful herb has ranging roots that cannot be restricted to a small container. For a pot of parsley on the windowsill in winter, start a parsley pot in spring. Sometime in May, tuck three small plants around the edges of a large container and sink it up to its rim in the garden; the parsley is watered, fed and moderately harvested over the summer. By October, you'll have a lush ball of greenery that comes into the house with no shock at all.

❖ *Tarragon, oregano, mints and hardy savories*. For fresh winter use, divisions of these plants can be set in large pots in spring and tended outdoors during the summer, as one does parsley. All respond to moderate pinching and pruning by becoming bushy and compact. A thyme or sage seedling (rather than a division) can be treated in the same manner. To simulate a brief spell of winter, leave perennial herbs outdoors until early December; this gives them a rest before they carry on growing indoors, long past the usual season.

❖ *Chives and garlic chives*. Like tulips, alliums grow from bulbs; and, also like tulips, they can be forced for fresh greens in the dead of winter. Sometime in September or October, plant up large pots

This decorative herbal wreath has 'Silver King' artemisia as its base and features other herbs such as tansy, scented geranium, hyssop, sage, rosehips, poppy-seed pods and marjoram.

with divisions of chives or garlic chives. Set the containers anywhere that is uniformly cold—just above freezing is ideal, but an occasional dip below does no harm. Early in the New Year, bring the containers in to a sunny window, and watch them sprout.

❖ *Tender herbs*. Rosemary, tropical sages, bay, lemon verbena and all the scented geraniums must winter indoors if they are to survive. These tender sorts are easier to manage if they are pot-grown year-round and shifted indoors before the first fall frost. Scented geraniums and tender sages appreciate all the sun they can get. Rosemary is a particularly amenable house herb, adapting better to lower light, provided the room is not overly hot or dry; regular misting keeps its foliage fresh. I have also dug pretty sweet marjoram from the fall garden and planted it in a flowerpot slightly larger than its root ball—it makes a small fragrant houseplant in a coolish, sunny place indoors.

Preserving Herbs for Winter

Freezing

In the garden, parsley, sage, winter savory and others thaw out after months in winter's deep freeze and are perfectly edible. It is no surprise, then, that many herbs can be squirreled away in the freezer for winter seasoning. Pick herbs in their prime, rinse them, and shake off excess water. Large leaves such as lovage can be packed loosely into plastic freezer bags and put straight into the freezer. Small stems of thyme can be frozen as they are, then tossed whole into a simmering winter stew and fished out before

serving. Bunches of chervil, dill, fennel, parsley, sage, sorrel, summer savory, sweet cicely and tarragon can be pressed and rolled together into a tight, thick herbal "cigar," which is then enclosed in aluminum foil or plastic wrap and placed in the freezer. To use, peel the wrapper back and shave the frozen herb as needed with a sharp knife. Herbs can also be minced, mixed with a little water and frozen in ice-cube trays; store the herbal cubes in a bag in the freezer, and pop them into simmering winter dishes. Use frozen herbs in roughly twice the quantity of dried, mincing them finely into stews, stuffings, stir-fries, sauces and soups.

Drying

The first herbs that most cooks encounter are dried—a pinch of oregano in spaghetti sauce, dried sage in turkey stuffing. Drying is a time-honored way to ensure that there will be garden-grown lovage to flavor winter soups, tarragon to crumble into salad dressings, and balm, mint and bergamot for tea. One's own dried herbs are superior to costly supermarket alternatives, free of the chemicals routinely used to grow and preserve commercial herbs and probably more flavorful. The process is simple—cut and dried, you might say.

Remember, you don't owe your herbs anything: It is a mistake to think you must dry every last one you grow. Consider what you will use through the fall and winter, the dishes that are a mainstay of your everyday cooking, and dry herbs to match. I make a lot of soup during the cold weather, so lovage is always on my list; thyme, savory or oregano are needed for tomato-based minestrone; and a big jar of peppermint keeps us in tea. A cloth

Herbs can be spread out in a basket to dry, as with the scented geranium, lemon verbena, yarrow, lavender and rosemary shown here.

bag filled with lavender is nice in the sheet drawer. Out of the scores of herbs we grow, these may be the only ones we dry some years; seeds (see Chapter 7) dry themselves on the plants, and all we do is pick and store. Wreath and potpourri makers will dry accordingly. A herbalist friend recommends drying parsley to brew into a bouillonlike winter tea rich in minerals.

Pungent herbs such as lovage, oregano and savory produce the best dried product. Harvest just before flowering, when the plant's aromatic oils are at their height.

Avoid beginning the drying process on a day that may be the first of a humid or rainy spell. Cut branches as soon as the morning dew has evaporated—if you don't get to the job until after dinner, no matter —and pick off insect-nibbled or yellow leaves.

There are two ways to dry herbs. Individual leaves can be plucked from their stems and laid out in a single layer on a clean window screen, elevated a few inches off the floor by books or bricks. We set the screen in front of a sliding glass door that gets no direct sun; with the door open during the day, a summer breeze wafts through and dries them quickly. (This presumes there are no small children or unruly pets to topple things.) Alternatively, bunches of three or four

stems are fastened together at their ends with an elastic band and hung upside down in an airy, shaded place. In the fall, we often hang herb bundles from a dowel suspended above the woodstove, where the rising heat crisps them perfectly in three days. A neighbor hangs herbs from the rafters of her unfinished attic. A barn, garden shed or shady screened porch is also a good drying space. The enemies of drying are humidity and sunlight; damp air slows the process and encourages mold, while the sun robs drying herbs of both color and flavor.

Turid suggests drying herbs in a microwave oven, especially during very humid or rainy weather. Spread individual leaves in a single layer on a paper towel. Dry on a

the stalks between your palms to get the last crumbs—you'll find yourself inhaling deeply. Funnel the herbs into clean, dry jars for storage in a dark, preferably cool cupboard.

Screen-drying (as described above) is the most efficient way to handle a quantity of lavender spikes and the only way to dry calendula or other flower petals for flavorings or potpourris. Pluck leaves from their stems and flower petals from their calyxes, and spread them in a single layer over the screen—it is important that air circulate all around. Jiggle the screen from time to time to turn the herbs. A small screen can be set near the stove during a baking session to take advantage of the rising heat.

Some herbs yield flowers and seedpods that dry easily as ornamentals, without special sand or silica gel. The flat heads of yarrow are practically dry when you pick them. Hung upside down for a week or two, they lose all moisture but hold their color and shape, as do sea hollies, the decorative round heads of flowering onions, opium-poppy pods and the big cartwheel seed-heads of lovage and angelica—they will drop their dried seeds, though. Classic for herbal wreaths are dried wands of silver artemisias, as well as flowering stalks of oregano, green or golden. These may be called everlastings, but in this house, dried bouquets and wreaths hit the compost heap the day the snowdrops hang out their first bell, ringing in a new season.

low setting for two minutes; turn the leaves, and repeat for two minutes more. Do this until the leaves are nicely desiccated. A quick dry, the microwave method preserves the aroma and color of delicate herbs such as basil, chervil and tarragon.

Leafy herbs are thoroughly dry when they crackle and flake into small bits when rubbed. Decorative as they may be hanging by the fire-

To ensure that you have the best-tasting dried tarragon, thyme, bay and dill, hang herb bundles from a suspended dowel in a dry location out of direct light.

place, there is no point leaving them there to gather dust. Spread them out on a clean sheet of paper or a countertop, strip the leaves from the stalks by hand, and roll

In the Kitchen

Cooking with fresh herbs

After the first edition of this book was published, I often heard some variation on this remark: "I grow a lot of herbs but don't really use them much. I make pesto, but otherwise, I'm not sure which herbs go with what—especially fresh."

Most of us are not overly adventurous in the kitchen. We tend to stick to our standbys, a revolving repertoire of foods we enjoy and can cook with little thought. A four-course Moroccan feast, brimming with exotic flavors, is fine for a special occasion, but from day to day, we generally fall back on what can be made quickly without rummaging around for that bottle of cardamom seeds (probably years old) or making a special trip to the store.

Many cooks enjoy reading recipes, but few want to pore over cookbooks, dirty a sinkful of pots and pans or do a lot of precise measuring every night—especially in summer. Still, the palate welcomes a change, and there is no simpler way to enjoy a variety of tastes than to add a few fresh herbs.

Anxiety may prevent a cook from experimenting: What if I overdo it? What if my family and friends turn up their noses at strange flavors? And yet when you try something new, you are more likely to garner compliments and recipe requests.

Fresh herbs need not be associated with complicated cooking; indeed, their flavor may best be appreciated in simple everyday dishes. Salads take on a delightful fresh appeal when a little tarragon or basil is whisked into the dressing. Potato salad, a summer staple, is raised a notch by throwing in a handful of minced parsley, chives, leaf celery and dill. Yogurt-based dips and dressings are improved with flecks of dill or chervil, and bean purees develop more character when cumin, garlic and coriander are added. Often, foods that are rather neutral-tasting on their own—ordinary items like pasta, potatoes, rice, eggs, cream cheese, yogurt, tofu, fish, breast of chicken—benefit most from the addition of fresh herbs. After years of cooking with

herbs, I find fish fillets rather naked-looking without a green and garlicky topping; and potatoes seem bland and egg dishes one-dimensional without some flavorful green. Tossing in a few herbs turns a familiar dish into a little journey of discovery for the taste buds.

Fresh herbs are used on their own or in combination. When a single herb is featured—tarragon chicken, rosemary roasted lamb or potatoes, basil pesto, coriander salsa—you delight in its unique savor and complexity. In the same way, certain combinations work better than others. In the recipes that follow, there may be a list of herbs, with instructions to choose three to five. None of this is very precise. Use what you have and what you think might be good together; use less rather than more at

Fresh herbs such as rosemary, marjoram and savory can turn an everyday dish into a little journey of discovery for the taste buds.

first (but not so little that the flavor is lost). At best, the dish will be delicious; at worst, you've learned something.

Very little special equipment is needed to cook with fresh herbs. Mincing is the basic technique. A sharp knife with a good rocking action is essential, as is a good-sized cutting board. Herbs stain a cutting surface (whether wood or plastic), so you may want to reserve a special board just for herbs. I use a big maple cutting board for onions, garlic, vegetables and herbs, and handle meat, chicken and fish on another surface.

Lately, I have been using a mini food processor for chopping herbs, as well as making pesto, marinades and dressings and pureeing cooked beans. The little processor makes short work of "prep" steps and is ideal for whizzing up ginger, garlic, onions and herbs at the start of a stir-fry or chopping onions, celery and carrots to begin a soup. A small processor quickly turns out a cupful of parsley for tabbouleh (recipe follows); but it doesn't mince herbs as finely as needed for some dishes. Whether chopping on a board or in a processor, it's best to remove herb leaves from their stems to avoid stringy bits.

Mulling over what to cook, I usually give some thought to which herbs "go with." To learn about herbs, you have to make a point of picking and using them. And once you develop the fresh-herb habit, you will probably keep it. It's a healthful habit: Parsley, for example, is packed with vitamins and minerals, and anything fresh and green is bound to be good for you. Start with herbs you already like, and branch out. In time, herbs may become as basic in your meal preparation as salt and pepper.

Tabbouleh

Packed with parsley and tart with lemon juice, this cool and nourishing Middle Eastern grain salad begins with bulgur wheat, precooked and dried cracked wheat that plumps up in boiling water without cooking and develops a nutty taste. Parsley is the key herb—in fact, some versions are more parsley than bulgur—and a little spearmint adds extra flavor. Tabbouleh can be made ahead of time and kept in the refrigerator, ready for picnics or outdoor summer meals. Round out a meal with a green salad, bean puree, olives, pitas or other breads and some cold meats, cheeses or fish.

1 cup	bulgur wheat
1–1½ cups	finely chopped parsley (stems removed)
1–2 Tbsp.	finely chopped spearmint
1	tomato, chopped
1	cucumber, peeled, seeded and chopped (optional)
5 Tbsp.	lemon juice
2 Tbsp.	olive oil
	Salt to taste

In a lidded pot, bring 2 cups water and a pinch of salt to a rapid boil. Add the bulgur, cover and remove from the heat. Let stand, unstirred, until the bulgur has absorbed all the water, plumped up and cooled (a couple of hours). Transfer the bulgur to a large mixing bowl. Stir in the parsley and mint, mixing well. Add the tomato and cucumber, if using.

Whisk together the lemon juice, oil and salt, and pour over the salad; mix thoroughly. Transfer the bulgur mixture to a serving bowl, cover and refrigerate until ready to use.

Variation: Dress cold cooked rice and lentils (twice as much rice as lentils) in a similar way, using less parsley and adding a little minced dill.

Crunchy Cabbage Salad With Herb Dressing

Coleslaw ought to be both sweet and tart, but sugar and vinegar often predominate. This lighter version features dill and basil in a yogurt-based dressing with lime juice and vinegar for added zing. Use the freshest cabbage you can find. Snow peas and carrots add sweetness and crunch. Let the dressed salad sit before serving to infuse and tenderize the cabbage.

DRESSING

2 Tbsp.	mayonnaise
5 Tbsp.	plain yogurt
1 Tbsp.	cider (or other) vinegar
1 Tbsp.	olive (or vegetable) oil
1 Tbsp.	minced onion (Spanish, red, fresh green, chives or other)
1 tsp.	lime juice
4 Tbsp.	minced dill
1–2 Tbsp.	minced basil and parsley
	Salt to taste
1	small green cabbage, or ½ large
2	carrots
	Handful of snow peas or sugar snap peas, cut into bite-sized chunks

In a large bowl, whisk together the dressing ingredients.

Into the same bowl, grate the cabbage and carrots. Add the peas. Gently stir the salad ingredients and dressing together, and let stand in the refrigerator for 15 minutes before serving.

Whether grown from seed or starter plants, left, fresh herbs are available from early spring to late fall. Facing page, served in edible nasturtium-leaf "bowls," Tabbouleh is packed with parsley and cool with mint.

Fish Fillets With Herb and Tomato Topping

Fillets of fish—whether salmon, whitefish, orange roughy, perch, trout or other mild fish—are quick-cooking, flavorful and nutritious. Fresh sweet herbs marry perfectly with fish, complementing its mild taste. This simple recipe calls for coating one side of the fillets with a herb mixture, baking the fish in the oven, then finishing it under the broiler. Various combinations of herbs will work, depending on what is available and what you like. Choose three to five of the following sweet herbs: basil, bronze fennel, chervil, chives or garlic chives, dill, lemon basil, lemon thyme, parsley, tarragon.

5 Tbsp.	minced fresh herbs, stems removed
1–2	garlic cloves, finely chopped, or equal amount of minced fresh garlic tops
1 tsp.	minced fresh ginger
1 tsp.	lime juice
1 tsp.	tamari
1 Tbsp.	olive oil
1 cup	coarse fresh breadcrumbs
1	tomato, chopped
3 Tbsp.	grated Parmesan cheese
1 lb.	mild fish fillets

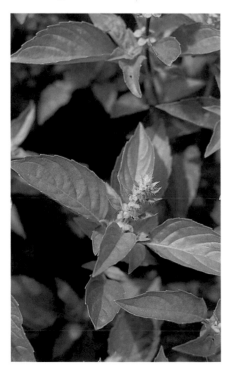

Lemon basil, below, and garlic, right, are both ideal summer flavorings for fresh fish.

Preheat the oven to 400°F.

In a small bowl, combine the herbs, garlic or garlic tops and ginger. Add the lime juice, tamari and oil, whisk together, and set aside.

In a food processor or a blender, gently pulse together the breadcrumbs, tomato and cheese, just until mixed. Lightly oil the bottom of a shallow baking dish or tray large enough to hold the fillets in a single layer.

Place the fillets in the prepared dish, and spoon the herb mixture evenly over them. Top with the breadcrumb mixture. Cover loosely with aluminum foil, and bake on the top rack of the oven for 10 minutes, a little longer for thick fillets. Remove the foil, place the dish a few inches away from the broiler, and broil for 2 minutes, or until slightly browned.

Herbed Potato Salad

Potato salads vary with geography. Europeans like waxy yellow potatoes, such as 'German Fingerlings,' dressed with a sharp mustardy vinaigrette. North Americans traditionally prefer meltingly soft potatoes with hard-cooked eggs in a sweet mayonnaise dressing sparked with bits of pickle. This version falls somewhere in between, with cider vinegar adding tang and yogurt lending creaminess in place of some of the mayonnaise. Radishes are a crunchy counterpoint, and fresh herbs bump up the flavor. Any of the following herbs can be used in combination: basil, bronze fennel, leaf celery, chervil, chives, dill, lemon basil, lemon thyme, parsley, spearmint, tarragon. But parsley, leaf celery (or a celery stalk), lovage and something oniony (chives, shallots or green, Spanish or red onion) are a must. After that, I lean to dill, basil and one of the anise-tasting herbs, such as bronze fennel, tarragon or chervil. Vary quantities of any ingredients, especially the herbs, to suit your taste.

DRESSING

½ tsp.	mustard
3 Tbsp.	mayonnaise
6 Tbsp.	plain yogurt
2 Tbsp.	apple cider (or other) vinegar
½ tsp.	salt
	Freshly ground black pepper
5 Tbsp.	minced chives or green, red or Spanish onion
2 Tbsp.	minced basil
2 Tbsp.	minced leaf celery, or 1 tsp. minced lovage
2 Tbsp.	minced parsley
1 Tbsp.	each minced tarragon, spearmint and dill, or other fresh herbs
6 cups	sliced or cubed cooked peeled potatoes (warm or cold)
	Radishes, sliced

GARNISH
Choose one of: sliced radishes, chopped cucumbers, sliced hard-cooked eggs, diced pickles or tomato wedges

Whisk or shake together all the dressing ingredients.

Place the potatoes in a large mixing bowl. Add the dressing and radishes, and gently fold together. Spoon the potato salad into a serving bowl, and chill until ready to serve. Garnish just before serving.

Ordinary potato salad is extraordinarily good when flecked with freshly chopped herbs.

Grilled Marinated Chicken

This is a quick, tasty dish for a summer evening and is good served hot or cold. Choose three to five herbs from the following: lemon or sweet basil, chervil, cilantro, fennel, garlic chives, tarragon, lemon or common thyme. For spicier chicken, increase the cayenne and garlic and add a minced chili pepper and some cumin seeds.

MARINADE

5 Tbsp.	minced fresh herbs
1–2	garlic cloves, pressed
1 tsp.	minced fresh ginger
1–2 tsp.	tamari
1 tsp.	lime or lemon juice
2 Tbsp.	olive oil
3 Tbsp.	plain yogurt
	Pinch of cayenne pepper
	Dash of Worcestershire sauce
	Daub of prepared mustard
	Freshly ground black pepper to taste
2–4	boneless, skinless chicken breasts

In a medium bowl, stir together the marinade ingredients, and set aside.

Cut the chicken breasts into chunks of about two bites each—kitchen scissors work well. Add the chicken to the marinade, and toss to coat thoroughly. The chicken can be cooked now or placed in a resealable plastic bag and marinated in the refrigerator for several hours, or overnight.

Skewer the chicken pieces, and grill on a barbecue for about 6 minutes, turning for even cooking. Or preheat the broiler, and place the chicken pieces in a single layer on a baking tray or directly on the broiling pan. Broil for 5 minutes; turn and broil for 3 minutes, until lightly browned.

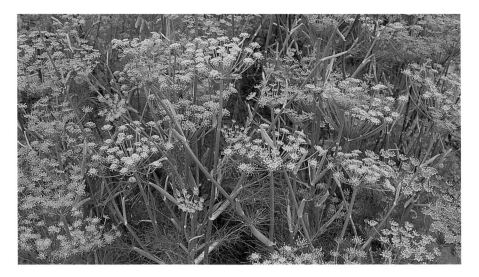

Fresh fennel, right, and garlic chives, above, are tasty ingredients in a marinade used to season boneless chicken before grilling.

Bean Dip With Garlic, Cumin and Cilantro

Hummus, a Middle Eastern chickpea spread, is well known. But any bean, home-cooked or canned, can be turned into a dip or spread. Make this recipe with red kidney beans, black beans, pinto beans or even lentils. (If you use canned beans, you may not need to add salt.) Corn chips are favorite dippers, but cucumber rounds or spears, other raw vegetables, pitas and crackers are also good. Black olives are a classic accompaniment. A mini food processor is ideal here. Rather than use ground cumin, I "chop" whole cumin seeds into tiny bits with a sharp knife before adding them to the processor.

1–2	garlic cloves
½ tsp.	cumin seeds, ground
1 Tbsp.	coarsely chopped cilantro
1 Tbsp.	coarsely chopped leaf celery (optional)
2–3 Tbsp.	olive oil, plus extra for drizzling
2 tsp.	lemon or lime juice
	Pinch of cayenne pepper
	Salt to taste
2 cups	cooked beans, or 1 can (19 oz.) beans, drained and well rinsed
	Black olives (optional)

Put the garlic, cumin, cilantro, leaf celery (if using) and oil in a food processor, and pulse until finely chopped. Add all the remaining ingredients, except the olives, and process until a smooth paste forms. If the mixture is too thick, add a little bean cooking liquid or water. Spoon the mixture into a serving bowl, or spread it on a platter. Chill for a few hours, if time permits. Garnish with olives, if desired, and drizzle with oil before serving.

Fresh coriander leaves, or cilantro, stand out in a dip or spread made with chickpeas or other beans.

Carrot Puree

Served with bread sticks, pitas, crusty bread or raw vegetables, this vivid orange dip is a tasty appetizer. Garden-grown or organic carrots are best.

2 cups	thickly sliced carrots
1 Tbsp.	olive oil
½ tsp.	lime juice
½ tsp.	cumin seeds, ground
1 Tbsp.	minced spearmint leaves
	Salt and freshly ground black pepper

Cook the carrots in enough lightly salted water to cover, simmering rather than boiling to retain flavor and nutrients. Drain the carrots, reserving the cooking liquid, and let cool.

In a food processor, pulse together the oil, lime juice, cumin and spearmint for a few moments before adding the carrots. Process into a coarse-textured puree. Add salt and pepper to taste. If the puree is too thick, add a little of the reserved cooking liquid.

Compared with ginger mint, apple mint and peppermint, spearmint is best for fresh flavoring.

Herb-Dressed Roasted Peppers and Bocconcini

When I was growing up in the city, our next-door neighbors would bring out the charcoal grill in August and spend a few days roasting peppers picked fresh from their small back garden. Roasted red peppers are adult fun food, slurpy and sweet.

The time to prepare this dish is in late summer, when bell peppers are plentiful and as cheap as they get. I roast peppers under the broiling element of a gas stove, but outside is still the best place, and a gas grill works as well. This is a case where burnt is best.

Roast the whole peppers on the grill, turning them occasionally, until the skin is uniformly charred and black. Don't worry, the inside becomes soft and delicious. Remove the peppers from the grill, and let cool. I never put them in a paper bag to "sweat," as is often recommended; I find that the skin comes off easily once the peppers have cooled.

Slip off the skins, and remove the seeds, holding the peppers under running water as you do. Cut or tear the peppers into strips, and let them drain in a sieve for a minute before dressing.

Dress the roasted peppers with olive oil, balsamic vinegar, minced rosemary, basil and parsley and salt and freshly ground black pepper to taste. Let dressed peppers sit for a while to marry the flavors.

Bocconcini are balls of fresh mozzarella cheese; if unavailable, use slices of mozzarella. Toss bocconcini with olive oil, balsamic vinegar, minced thyme, oregano, basil and lemon basil (if you have it) and some grated lemon zest. Season to taste with salt and freshly ground black pepper, and let the cheese sit at room temperature for up to an hour, or longer in the refrigerator.

To serve, arrange the peppers and bocconcini on a lettuce-lined serving platter or individual plates. Crusty bread is a must.

Whether flat-leaved or curled, fresh parsley is both flavorful and nutritious.

Penne With Herb-Roasted Summer Vegetables

Easy to assemble, this wonderful summer medley of eggplant, zucchini, onions, garlic, tomatoes and herbs cooks in the oven while you do something else. Start the pasta 10 minutes before the robust herb-infused sauce is done.

1	medium eggplant
1	large zucchini, or 2–3 small
2–3	onions, red or yellow
5–10	garlic cloves
	Olive oil
	Handful of finely chopped rosemary, oregano, thyme and marjoram
	Salt and freshly ground black pepper
3–5	ripe tomatoes, cored and quartered
	Handful of whole basil leaves
10–15	cured black olives, pitted and halved (optional)
16 oz.	penne (or other pasta)

Preheat the oven to 350°F.

Cut the eggplant into chunks. Cut the zucchini into thick rounds. Cut the onions into quarters or sixths. Peel the garlic cloves, and leave whole. In a large bowl, toss the eggplant, zucchini, onions and garlic with a liberal amount of oil to coat thoroughly. Add the chopped herbs and a generous amount of salt and pepper, and toss again. The herbs will adhere to the oil-coated vegetables. Spoon the vegetables into a glass casserole dish or a roasting pan large enough to hold them in more or less a single layer.

Roast, covered, for 45 minutes. Add the tomatoes, basil and olives, if using, and stir gently. Continue to roast, uncovered, for about 30 minutes, or until the tomatoes are partially "melted down"; the sauce may look a little watery. Adjust the seasonings.

In the meantime, cook the penne in boiling salted water until al dente. Drain and place in a large serving bowl or on a platter. Spoon the sauce over the hot penne, and drizzle with a little oil, if desired. Serving this dish without Parmesan cheese allows the herb flavors to shine through.

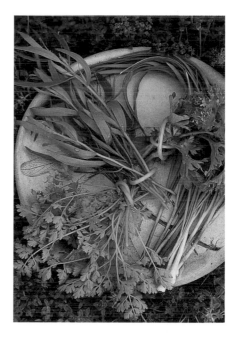

Fresh herbs such as parsley, chervil, tarragon and chives can be used liberally in a variety of delicious summer dishes.

Herb-Roasted Potatoes

Potatoes are seldom eaten unadorned; we like them "fattened up" and flavored—and preferably crisp. Oven-roasting with olive oil and herbs does all that. The secret is to partially boil the potatoes before roasting.

Preheat the oven to 400°F.

Use unpeeled, small, whole new potatoes or larger spuds cut into chunks. Boil the potatoes in salted water until the tip of a knife goes easily through the outer part but the centers are still crisp, 10 to 15 minutes. Drain the potatoes well, peel, then toss with olive oil, a liberal amount of finely chopped rosemary, thyme and marjoram and salt and freshly ground black pepper to taste. Place the potatoes in a casserole dish wide enough to hold them in a single layer, and roast, uncovered, for 20 to 30 minutes, or until they are golden brown and crisp.

Rosemary Garlic Lamb Chops

I have a hunch that there are a lot of "almost" vegetarians around, people who go for days or weeks on end without eating any meat, poultry or fish, folks (like me) who actually like tofu but every so often hanker for a steak, a piece of fish or a chop. This dish is simplicity itself and every bit as good as a more complicated and time-consuming roast, especially as a dinner for two, when a leg of lamb would be too much. Use the freshest garlic you can find.

3–4	garlic cloves
	Salt
2 Tbsp.	minced rosemary
	Freshly ground black pepper
4–8	loin-cut lamb chops

Preheat the broiler.

Crush, then mince the garlic with salt to taste. In a small bowl, stir together the garlic, rosemary and pepper to taste. Press some of the herb mixture onto each side of the lamb chops. Place the chops on a broiler rack, and broil for 5 minutes on one side; turn the chops and broil for about 3 minutes on the other side, or until done to your liking. Although some of the coating falls off, the flavor remains.

Thyme, bay leaf, chervil and parsley form a classic bouquet garni to simmer in homemade soups and stews.

Tzatziki

In the heat of summer, cool cucumbers team well with equally cool dill and yogurt, with garlic adding bite to a side dish that is not quite soup, salad, sauce or dip. For thicker tzatziki, drain some of the liquid from the yogurt through a cotton-lined sieve or start with thicker Balkan-style yogurt. Double or triple the ingredients as you like.

1	cucumber
1	mild onion (optional)
1–2	garlic cloves
¼ tsp.	salt
1 cup	plain yogurt
1–2 Tbsp.	olive oil
1–2 Tbsp.	finely minced dill
	Pinch of cayenne pepper

Peel the cucumber or score it with the tines of a fork; halve it and remove the seeds, if necessary. Thinly slice the cucumber and the onion, if using. Press or finely mince the garlic. In a small bowl, mix together all the ingredients. Chill the tzatziki for at least several hours to allow the flavors to meld; it will keep for a day or two in the refrigerator. Stir before serving.

Variation: Turn this Greek standby into a spicy Indian raita, an accompaniment to curries and such, by adding ½ teaspoon ground cumin seeds and more cayenne pepper.

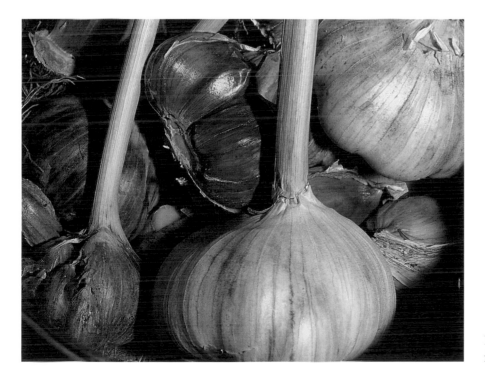

Homegrown garlic can be pulled for use from midsummer on.

Spicy Tofu

When I feel a bout of sniffles coming on, I load this dish with ginger and garlic and make it extra-hot with chilies. It seems to knock back an incipient cold. Adjust the spices to your liking, and serve with rice and steamed greens.

1	block tofu, regular or firm
1 Tbsp.	olive oil
1 tsp.	minced fresh ginger
2	fresh red chili peppers, chopped, or ½ tsp. dried red chili flakes, or more to taste
2	garlic cloves, crushed and chopped, or more to taste
½ tsp.	curry powder (optional)
½ tsp.	tamari
1 Tbsp.	water

Cut the tofu into bite-sized cubes or strips, and set aside.

Heat the oil in a frying pan. Add the ginger, chili peppers or flakes and garlic, and cook for a minute or two, stirring to prevent the garlic from browning. Add the tofu, and stir-fry for 3 to 4 minutes, until the tofu turns slightly golden. (Unless you are using a well-seasoned, cast-iron or non-stick frying pan, you may have to add a little more oil to keep the tofu from sticking.) Add the curry powder, if using, and stir for 1 minute. Add the tamari and water, and bring to a high simmer. Serve hot.

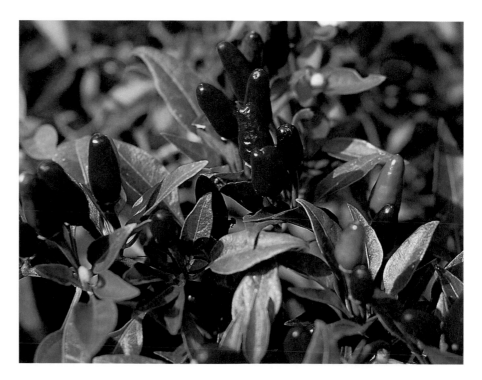

Fresh or dried chili peppers, right, add a welcome heat and bite to a variety of dishes. Facing page, fresh garlic, in sufficient quantities, has the same effect.

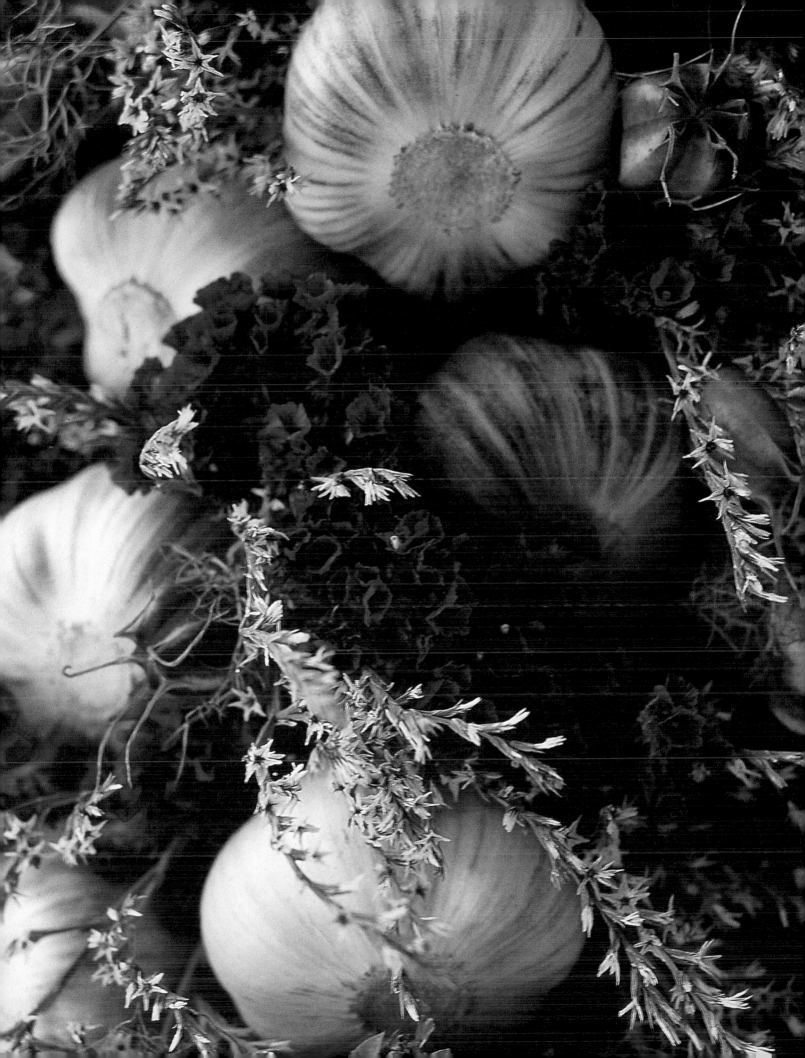

Sweet Corn, Bean and Tomato Stew With Herbs

Corn, beans and tomatoes are all native to the Americas and team up well with cilantro, parsley and something oniony. Fresh-shelled green lima beans are lovely in this dish, but frozen baby limas can be used. Any other dried, cooked bean, whether canned or home-cooked, will also work well. But there are no substitutes for just-picked sweet corn, juicy ripe tomatoes and fresh herbs.

1 Tbsp.	butter
1 Tbsp.	vegetable oil
1	onion, diced
2 cups	corn kernels, cut from 4 cobs
1 cup	lima beans, fresh-shelled or frozen, or 1 cup dried cooked kidney or black beans, or 1 can (19 oz.) kidney or black beans, drained and well rinsed
2	tomatoes, chopped
	Salt and freshly ground black pepper
	Pinch of cayenne pepper (optional)
	Handful of finely chopped parsley and cilantro

Heat the butter and oil in a large skillet. Cook the onion until soft, a few minutes. Add the corn, and cook for 1 to 2 minutes. Add the beans, and continue cooking for about 5 minutes. (Frozen limas will slow the cooking momentarily, but they will thaw quickly.) Add the tomatoes, salt and pepper to taste and cayenne, if using, and cook for another 5 minutes. Stir in the herbs, and cook for 1 to 2 minutes. Turn off the heat. You can let the stew sit, covered, while you prepare the rest of the meal.

Serve with rice or as a hefty side dish with grilled meat or poultry.

Variation: Make a cold version of this dish. In a medium saucepan, stir together 1 can (19 oz.) beans (drained and well rinsed) with 1 cup corn kernels (cut from 2 cobs). Add just enough water to cover, bring to a boil, and cook for 2 minutes. Drain and let cool. Stir in 1 chopped tomato, some minced green onions or chives and 2 tablespoons minced parsley and cilantro. Dress with 3 tablespoons lemon juice mixed with 2 tablespoons olive oil and salt, freshly ground black pepper and cayenne to taste. Chill before serving on crisp lettuce leaves.

Iced Herbal Lemonade

Summer is the time for iced herbal teas. Nothing could be easier—no brewing required.

Pick two large handfuls of leaves, using a combination of three or four of the following: anise-hyssop, lemon balm, basil, lemon basil, bergamot, lemon or rose geranium, peppermint, fruit or pineapple sage, spearmint, sweet cicely, lemon verbena. Coarsely tear the leaves, and toss them into a pitcher one-quarter filled with water. With the end of a wire whisk, crush and macerate the leaves until they are broken up and the water has turned green.

Add the juice of one lemon or one lime (or half and half). Dissolve 3 tablespoons honey or sugar in a little hot water, and add to the pitcher. Stir well.

Strain out the leaves, and pour the pale green, herb-infused water back into the pitcher; top up with more water. Chill and serve over ice.

Margot's Tea

2 parts each: raspberry leaves, red clover flowers

1 part each: strawberry leaves, St. John's wort flowers, crushed rosehips, common yarrow leaves and flowers, garden sage, horsetail leaves, black-currant leaves, lemon balm, bearberry leaves, twitch-grass roots, common plantain leaves, common or lemon thyme, dried apple peel

½ part: bergamot leaves

¼ part each: oregano leaves, violet flowers, rose petals, chamomile, mullein, calendula flowers

Alone or in combination with other herbs, lemon bergamot brews an excellent tea.

Sources

HERB SEEDS & PLANTS: CANADA

Customers in the United States will have no difficulty importing seeds from Canadian sources, but other plant materials must be shipped with a Phyto-Sanitary Certificate supplied to the nursery by Agriculture Canada.

Butchart Gardens
Box 4010, Station A
Victoria, British Columbia V8X 3X4
www.butchartgardens.com
Seeds for old-fashioned flowers.

Cruickshank's Inc.
1015 Mt. Pleasant Road
Toronto, Ontario M4P 2M1
Flower bulbs, seeds and plants.

Dacha Barinka
46232 Strathcona Road
Chilliwack, British Columbia
V2P 3T2
Seeds for garlic, herbs, oddities.

Dominion Seed House
Box 2500
Georgetown, Ontario L7G 5L6
www.dominion-seed-house.com
Vegetable and flower seeds, some herbs; to Canada only.

Ferncliff Gardens
8502 McTaggart Street
Mission, British Columbia V2V 6S6
www.ferncliffgardens.com
Irises, peonies.

Fish Lake Garlic Man
RR2
Demorestville, Ontario K0K 1W0
Organically grown garlic bulbs.

Gardenimport Inc.
Box 760
Thornhill, Ontario L3T 4A5
www.gardenimport.com
Bulbs, seeds of flowers, vegetables, herbs.

Happy Herbs
RR2
Uxbridge, Ontario L9P 1R2
Medicinal and culinary herb seeds, wildflowers; to Canada only.

The Herb Farm
RR4
Norton, New Brunswick E0G 2N0
Herb plants and seeds; to Canada only.

The Herbal Touch
30 Dover Street
Otterville, Ontario N0J 1R0
www.theherbaltouch.com
Herb seeds, related products and workshops; to Canada only.

Hortico
723 Robson Road, RR1
Waterdown, Ontario L0R 2H1
www.hortico.com
Perennials, including roses.

Maitland Greenhouses
Box 92
Maitland, Nova Scotia B0N 1T0
Wide selection of herb plants,
seeds and scented geraniums;
to Canada only.

Carl Pallek & Son Nurseries
Box 137
Virgil, Ontario L0S 1T0
Roses; to Canada only.

Pickering Nurseries Inc.
670 Kingston Road
Pickering, Ontario L1V 1A6
www.pickeringnurseries.com
Roses.

Richters
357 Highway 47
Goodwood, Ontario L0C 1A0
www.richters.com
Herb seeds and plants, unusual
plants.

Stirling Perennials
RR1
Morpeth, Ontario N0P 1X0
Groundcovers.

Stokes Seeds Ltd.
Box 10
St. Catharines, Ontario L2R 6R6
www.stokeseeds.com
Seeds of herbs, vegetables, flowers.

HERB SEEDS: ENGLAND

Chiltern Seeds
Bortree Stile
Ulverston, Cumbria LA12 7PB
England
www.edirectory.co.uk/chilternseeds
Seeds of unusual herbs, flowers,
shrubs, trees.

HERB SEEDS & PLANTS: UNITED STATES

Canadians ordering plant materials
from the United States—that is,
anything other than seeds, which
can be imported without diffi-
culty—will need an "Application
Form for Permission to Import"
from the Permit Office, Plant
Health Division, Agriculture
Canada, Ottawa, Ontario K1A 0C6.
Obtain one application form for
each U.S. company. When paying
for imported goods, use a money
order in the appropriate currency.
These can be purchased at any bank
or post office.

Abundant Life Seed Foundation
Box 772
Port Townsend, Washington 98368
www.abundantlifeseed.org
Nonprofit organization specializing
in seeds of the Pacific Northwest;
also herbs, flowers, vegetables, trees.

Bee Skep Herbary, Inc.
Box 146
Lahaska, Pennsylvania 18931
Herb seeds, vinegars, honey, books,
products.

Burpee Seed Co.
300 Park Avenue
Warminster, Pennsylvania 18974
www.burpee.com
Seeds of vegetables, flowers, herbs;
to U.S. only.

Catnip Acres Farm
67 Christian Street
Oxford, Connecticut 06478
Herb seeds, plants, scented gerani-
ums. Write for information.

Companion Plants
7247 N. Coolville Ridge Road
Athens, Ohio 45701
www.companionplants.com
Common and rare herbs,
scented geraniums. Only seeds
to Canada.

The Cook's Garden
Box 535
Londonderry, Vermont 05148
www.cooksgarden.com
Exotic salad greens and culinary
herbs.

Cook's Geranium Nursery
712 North Grand, Highway 14 N
Lyons, Kansas 67554
Geranium plants, including scented
species.

Cricket Hill Herb Farm Ltd.
74 Glen Street
Rowley, Massachusetts 01969
www.crickethhf.qpg.com
Common and uncommon herb
seeds and plants, herbal gifts and
books; to U.S. only.

Elixir Farm Botanicals
General Delivery
Brixey, Missouri 65618
www.elixirfarm.com
Organically grown seeds of
medicinal plants.

Far North Gardens
15621 Aurundale Avenue
Livonia, Michigan 48154
Seeds and plants of herbs, flowers,
primroses.

**Fox Hollow Herb & Heirloom
Seed Co.**
Box 148
McGrann, Pennsylvania 16236
Herbs, flowers and heirloom
vegetables.

The Fragrant Path
Box 328
Fort Calhoun, Nebraska 68023
Seeds for fragrant, rare and
old-fashioned plants.

The Gourmet Gardener
12287 117th Drive
Live Oak, Florida 32060
www.gourmetgardener.com
Seeds of herbs, gourmet vegetables.

Hartman's Herb Farm
1026 Old Dana Road
Barre, Maine 01005
Three hundred varieties of herbs,
perennials, annuals.

Heirloom Garden Seeds
Box 138
Guerneville, California 95446
Seeds of herbs, unusual vegetables.

Heritage Rose Gardens
40350 Wilderness Road
Branscombe, California 95417
Roses.

High Country Roses
9122 East Highway 40
Box 148
Jensen, Utah 84035
www.easilink.com/~smf
Roses wholesale; to U.S. only.

J.L. Hudson, Seedsman
Star Route 2, Box 337
La Honda, California 94020
www.jlhudsonseeds.net
Seeds of herbs, flowers, unusual
plants.

Jackson & Perkins
Box 1028
Medford, Oregon 97501
www.jacksonperkins.com
Roses, perennials.

Johnny's Selected Seeds
Foss Hill Road
Albion, Maine 04910
www.johnnyseeds.com
Seeds of vegetables, herbs.

Lily of the Valley Herb Farm
3969 Fox Avenue
Minerva, Ohio 44657
Almost 800 varieties of herbs,
everlastings, scented geraniums
and perennials.

Logee's Greenhouses
141 North Street
Danielson, Connecticut
06239-1939
www.logees.com
Herbs, geraniums, rare
ornamentals.

Lowe's Own Root Roses
6 Sheffield Road
Nashua, New Hampshire
03062-3028
Ungrafted roses shipped in
fall only.

Le Marché Seeds International
Box 190
Dixon, California 95620
Gourmet seeds.

Meadowbrook Herb Garden
93 Kingstown Road, Route 138
Wyoming, Rhode Island 02898
More than 150 varieties of herb
seeds.

Merry Gardens
Box 595
Camden, Maine 04843
Herbs, scented geraniums.

Milaeger's Gardens
4838 Douglas Avenue
Racine, Wisconsin 53402-2498
Herb and perennial plants;
to U.S. only.

Mountain Rose Herbs
20818 High Street
North San Juan, California 95960
www.mountainroseherbs.com
Organic herbs, oils, herbalist
supplies.

Nichol's Garden Nursery
1190 Old Salem Road NE
Albany, Oregon 97321-4580
www.nicholsgardennursery.com
Herb seeds and plants.

Park Seed Company
1 Parkton Avenue
Greenwood, South Carolina 29649
www.parkseed.com
Herb, vegetable, flower seeds.

The Pepper Gal
Box 23006
Fort Lauderdale, Florida 33311
Chili pepper seeds.

Prairie Nursery, Inc.
Box 306
Westfield, Wisconsin 53964
www.prairienursery.com
Seeds and plants of wildflowers,
native perennials.

Rabbit Shadow Farm
2880 E. Highway 402
Loveland, Colorado 80537
Large selection of herbs and scented
geraniums, topiary.

Rasland Farm
6778 Herb Farm Road
Godwin, North Carolina
28344-9712
www.alcasoft.com/rasland
Herb plants, scented geraniums,
herbal products. Only herbal
products to Canada.

Redwood City Seed Co.
Box 361
Redwood City, California 94064
www.batnet.com/rwc-seed
Seeds of herbs, flowers, vegetables.

Renaissance Acres
4450 Valentine Road
Whitmore Lake, Michigan
48189-9691
www.apin.com/herbs
Wide selection of organic plants
and seeds.

Sandy Mush Herb Nursery
316 Surrett Cove Road
Leicester, North Carolina
28748-9622
www.brwm.org/sandymushherbs
More than 1,100 different herbs
and perennials.

Seed Savers Exchange
3076 North Winn Road
Decorah, Iowa 52101
www.seedsavers.com
Heirloom plants and seeds.

Shady Hill Gardens
821 Walnut Street
Batavia, Illinois 60510
www.shadyhill.com
Geranium plants and seeds.
Only seeds to Canada.

Stokes Seeds Ltd.
Box 548
Buffalo, New York 14240-0548
www.stokeseeds.com
Seeds of vegetables, flowers, herbs.

Sunnybrook Farms Nursery
9510 Mayfield Road
Chesterland, Ohio 44026
sunnybrook.e2grow.com
Perennials, herbs, houseplants;
also holds workshops.

Thompson & Morgan, Inc.
Box 1308
Jackson, New Jersey 08527-0308
www.thompson-morgan.com
Extensive selection of herb, flower
and vegetable seeds.

**The Thyme Garden Herb
Company**
20546 Alsea Highway
Alsea, Oregon 97324
www.thymegarden.com
Common and exotic herbs.

Tinmouth Channel Farm
RR1, Box 428B
Tinmouth, Vermont 05773
More than 150 varieties of organi-
cally grown herb plants and seeds.

MISCELLANEOUS

Dominion Herbal College
7527 Kingsway
Burnaby, British Columbia
V3N 3C1
www.dominionherbal.com
Correspondence courses in
herbalogy since 1926. Brochure
and application forms free.

The Herb Companion
201 East 4th Street
Loveland, Colorado 80537
Beautiful bimonthly publication
on everything herbal: articles,
recipes, sources and more.

Herb News
Box 12602
Austin, Texas 78711
Quarterly magazine for herb
businesses and individuals,
published in conjunction with
the Herb Research Foundation
and the American Herbal Products
Association. Contact for subscrip-
tion information.

The Herb Quarterly
Box 689
San Anselmo, California 94960
www.herbquarterly.com
Elegant magazine for herb fanciers.

The Herb Society of America
9019 Kirtland-Chardon Road
Kirtland, Ohio 44094
www.herbsociety.org
Membership by invitation only;
provides scholarships, develops
herb gardens. Publishes an annual
journal, *The Herbalist*. Contact for
information.

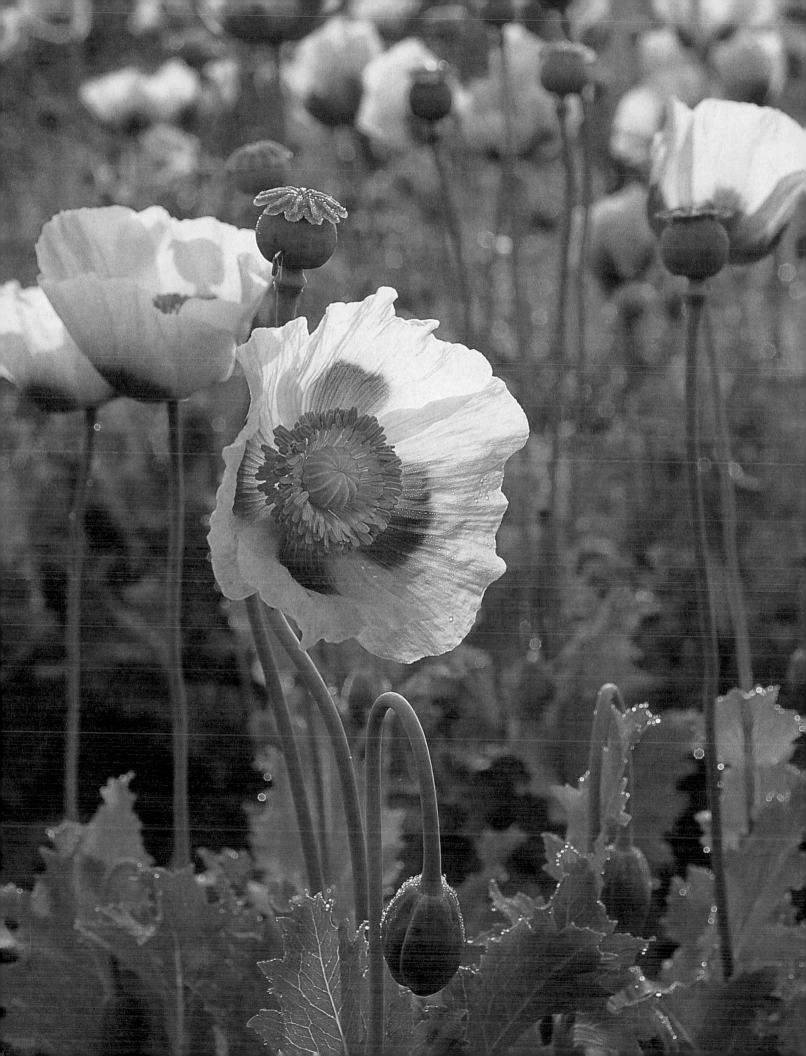

Index